Visual Literacy Workbook

For Graphic Design and Fine Art Students

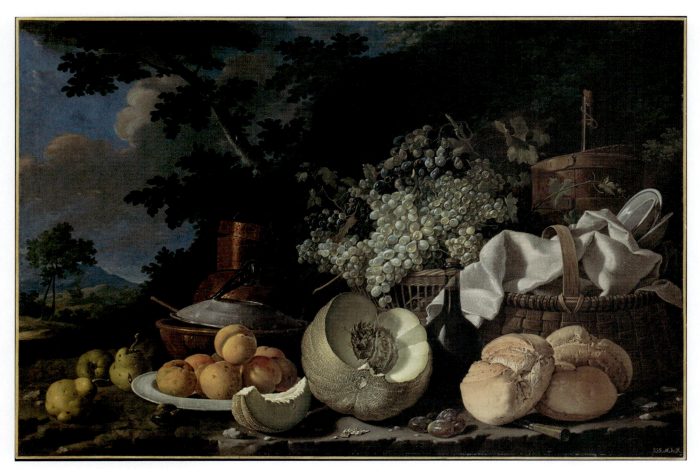

Frontis: *The Afternoon Meal (La Merienda)*, Luis Meléndez

Visual Literacy Workbook

For Graphic Design and Fine Art Students

David Moyer

Brian Flynn
Pennsylvania College of Technology

New York Oxford

OXFORD UNIVERSITY PRESS

Oxford University Press is a department of the University of Oxford.
It furthers the University's objective of excellence in research, scholarship,
and education by publishing worldwide. Oxford is a registered trademark of
Oxford University Press in the UK and certain other countries.

Published in the United States of America by Oxford University Press
198 Madison Avenue, New York, NY 10016, United States of America.

© 2020 by Oxford University Press

For titles covered by Section 112 of the US Higher Education
Opportunity Act, please visit www.oup.com/us/he for the latest
information about pricing and alternate formats.

Library of Congress Cataloging-in-Publication Data

Names: Moyer, David, author. | Flynn, Brian, 1959-author.
Title: Visual literacy workbook for Graphic Design and Fine Art Students / David
 Moyer, Brian Flynn.
Description: [First edition]. | New York : Oxford University Press, [2020] |
 Includes bibliographical references and index.
Identifiers: LCCN 2018034021 | ISBN 9780190853426 (pbk.)
Subjects: LCSH: Art—Textbooks.
Classification: LCC N7425 .M85 2020 | DDC 700—dc23 LC record available
at https://lccn.loc.gov/2018034021

9 8 7 6 5 4 3 2 1
Printed by LSC Communications, United States of America

For Gretchen

For Jack Flynn

. . . art is mysterious. It reaches us in ways we don't fully understand.

—Dana Gioia

Table of Contents

Preface

Visual Literacy Workbook was developed from teaching our Visual Literacy course as part of the foundations curriculum in the Graphic Design program at Pennsylvania College of Technology. Visual Literacy was newly developed to serve as an introduction to the study of design. Our students had started their foundation studies with Two-Dimensional Design, a course in which the formal exploration of design theory and practice is heavily tilted to the abstract. Understanding design theory while putting it into practice can be a tall order for a first-semester freshman. The new course was conceived as a bridge to the world of design and has in practice greatly increased student success in the competition and quality of work in our foundations courses.

The Analysis Outline serves as a conceptual armature for the course and, by extension, the *Visual Literacy Workbook.* The Outline provided a basic structure for the book, there being a very close relationship between chapter content order in the book and the Outline. The Analysis Outline guides the student through a process of written reflections of visual imagery. This approach to the subject grew out of an in-class process of identifying design and content elements in projected visual imagery. The process became one of discovery for the students and instructors, generating a lot of enthusiasm for the subject matter.

In addition to the exploration of design theory and visual content, the analysis process served to bridge the gap between representational and abstract imagery. Design students all too often are only able to apply their formal knowledge in an abstract visual environment. The ability to perceive one's surroundings in its formal qualities is extremely important for the artist and designer and can take considerable time to develop. Through focusing on representational imagery, the Analysis Outline has accelerated the student's development of an abstracting vision.

The individual sections of the Analysis Outline in Part I were developed from design theory, and a procedure that promotes careful observation of design elements as a prerequisite for reaching conclusions about a visual image. The Outline sections in Part II emphasize a similar procedure as an aid to formulating judgments about image content. Through the process of teaching the Visual Literacy course, the Outline sections have been modified with additions or subtractions in their form as well as adjustments in their sequencing based on student interaction with the material so as to better guide students through the learning process.

Acknowledgments

We would like to thank all our friends and colleagues who have shown their enthusiasm and given advice and support for this project. In particular, special thanks to Dr. Tom Ask and Levi Woodward for their publishing advice, our colleagues Keith Vanderlin and Mark Wilson for their excellent photographic work and the permission to publish their images. Also, a nod of appreciation is due to my old college friend clinical psychologist Dr. Jack Dettwyler for reviewing the Gestalt chapter and his loan of reading material on the subject, and to art historian Dr. Margaretta Frederick for her encouragement and review of the visual content chapter. Karis Reitzman proofread the manuscript prior to submission. The following is a list of people who kindly gave permission to publish their images: Brad Holland, Ainsley Bennett, Meredith Long, Hailie Montgomery, Andrea Neff, Ashley Tate, Minh Tu, Ed Wong-Ligda, the Enesco Corporation, and the Odd Nerdrum Museum. Thanks to Joanna Flynn for her support and our Dean, Dr. Mike Reed, and Assistant Dean, Tom Heffner, for their much appreciated encouragement.

Thanks are also due to the following reviewers:

Alma Mary Anderson,
Indiana State University,

Nancy Ciolek,
Rochester Institute of Technology,

Meaghan Anne Dee,
Virginia Tech,

Melanie Rodgers,
York College of Pennsylvania; and

Kelli Evans,
Loyola University Chicago.

Introduction

Visual Literacy provides a step-by-step approach to understanding visual imagery. The process starts with developing one's ability to observe through a close examination of what one sees. This ability serves as a foundation from which to examine more complex visual issues.

The text starts with a very basic examination of imagery and transitions to more complicated ideas through a series of written analyses that consist of topics that build on one another. As students cover new material, they reinforce and synthesize what they have learned and gain a comprehensive understanding of form and content in visual imagery. Upon completion of the course, students are well prepared to participate in the design process or to further their investigation and interpretation of image content.

The *Visual Literacy* text is a classroom in a book composed of two parts. Part I contains form and content theory along with pictures that serve as examples and a method of classroom exploration of the theory. Part II includes the Visual Analysis Outline, lists of artists and resources for analysis, and detailed explanations of theory application using the analysis outline.

This book will serve as a good foundational text for a broad field of design and interpretive studies, including Fine Arts, Graphic Design, Web Design, Industrial Design, Art History, Museum Studies, as well as Hermeneutics and Semiotics.

Visual Literacy Workbook

For Graphic Design and Fine Art Students

Visual Literacy: Form and Content

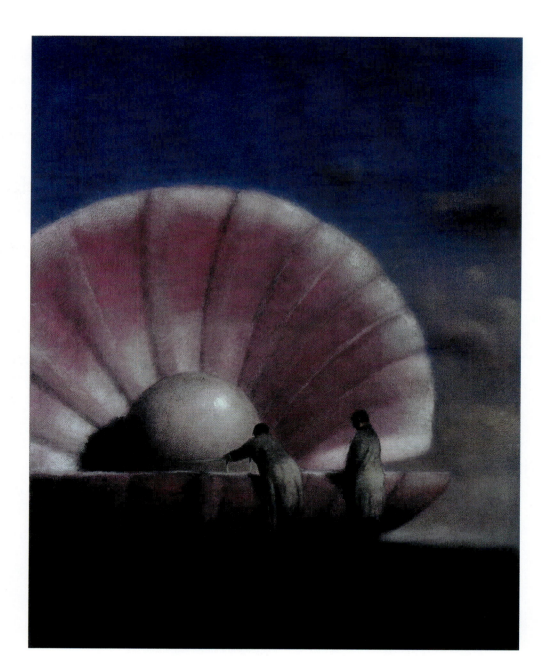

The Pearl, Brad Holland
©Brad Holland

CONTENTS

Visual Literacy

We are exposed to an abundance of visual imagery on a daily basis and may easily look but not really see. What is visual literacy?

Visual Literacy is the ability to see a **Visual Image** and understand its **Form** and **Content,** much like reading the text of a book or electronic screen. It is not uncommon for artists and designers to talk about reading a visual image. *Is the image understandable?* The visual image is composed of **Design Elements** or **Unit Forms** that are the equivalent of the letter forms, grammar, and syntax of the written text and serve as the vessels for communicating the image's meaning.

Form is an abstract quality or property expressed in matter. If we compare a grape and a baseball, we can see that they share the abstract quality of roundness in their shapes. The quality or property of roundness is being expressed in the matter of the grape and the baseball (fig. 1.1). In order to understand the form of a visual image, it is necessary to abstract the properties of form from what we see. Matter may express multiple formal qualities. The grape is round in its shape, purple in its pigmentation, and dark in value.

a

b

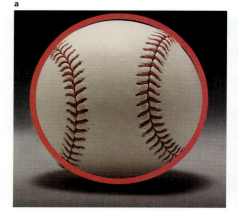

Figure 1.1a, 1.1b The tracing of the single grape and the baseball isolates the abstract quality of roundness that is being expressed in the matter of each. Roundness is not the only formal quality they possess, as there are differences in their color and value.

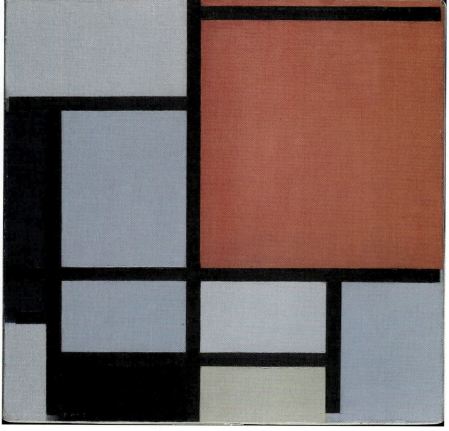

1.2

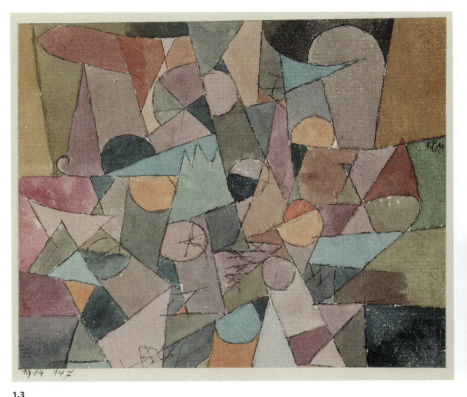

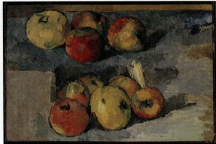

1.3

1.4

Figures 1.2–1.4 Piet Mondrian's *Composition* (previous page bottom right), Paul Klee's *Untitled* (top left), and Paul Cézanne's *Apples* (top right).

Visual Content is the message communicated to the viewer by a visual image. **Formal, Symbolic,** and **Narrative** are three types of visual content that are at work in an image, either separately or in combination with one another. **Formal Content** relies on the abstract properties of the design elements and their interaction with one another to express its content. Every visual image to a certain degree will be part of this category, for without its form a picture is not a visual image. The primary examples of this type explore purely visual speculations in the expression of their content. There may be no visual reference to the real world or those references may defer, to varying degrees, in their appearance to abstract explorations of the properties of form (figs. 1.2–1.4). These images are very different from one another in their outward appearance but are all good examples of *formal* content. The Klee and Mondrian paintings avoid any recognizable imagery but confine their exploration to the interaction of their visual components. Both pieces rely heavily on the repetition of *shape* and color. The Cézanne still life presents the viewer with recognizable objects, but the repetition of *shape* and the interaction of colors are of primary importance in the artist's exploration of a formal idea. **Symbolic Content** represents an idea that is beyond the element's appearance, that is, an image of a skull representing death (fig. 1.5). **Narrative Content** tells a story and may be historical, religious, mythological, commercial, and so on (fig. 1.6).

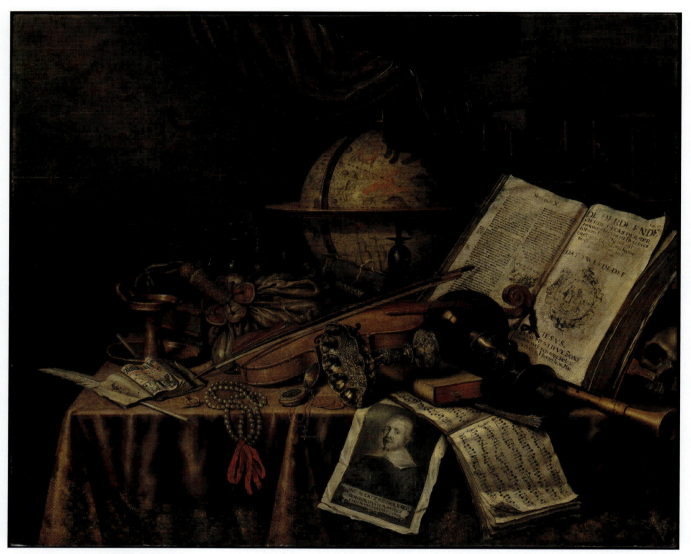

Figure 1.5 *Vanitas Still Life,* Edwaert Collier.
This painting is primarily *symbolic* with its hidden human skull, overturned vessels, and fallen drapery, all *symbols* of an end, which is death. These *symbols* are designed to make the viewer reflect on how they are living their lives, for all of us will die one day. The artist is also exploring the interplay of force and counterforce in the placement of opposing diagonal forms.

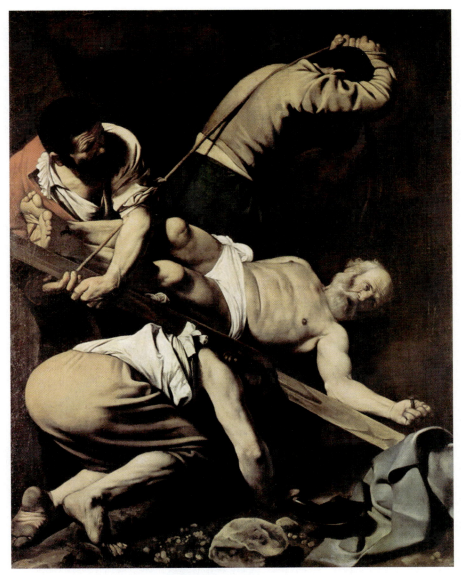

Figure 1.6 *The Crucifixion of St. Peter,* Caravaggio.
This is primarily a *narrative* image showing an historical event of religious significance, the martyrdom of the Apostle Peter by the Romans in the 1st century AD. It is also a *symbolic* image as Peter insisted on being crucified upside down because he was not worthy to follow Christ. St. Peter's upside-down cross is a *symbol* of his humility. This image also exemplifies the artist's *formal* exploration of light, shadow, the human figure, and the dynamics of weight and motion conveyed by those figures.

CHAPTER 2

The Visual Image

Visual Analysis Outline: CHAPTER 13

VOCABULARY

Abstraction: Rendering a visual element or image less realistic through the elimination of visual information and simplification of form.

Closed Composition: All the visual unit forms are contained within the image format.

Contrast: The amount of difference between a visual unit form and its immediate surroundings.

Curvilinear Shapes: Shapes made up of rounded flowing edges.

Figure: Another name for positive space.

Format/Frame of Reference: The outside edge of the picture plane. The format, or frame of reference, defines the overall size and shape of the image or design. It may be any shape but is most commonly a rectangle.

Ground: Another name for negative space. *Note:* The terms are used in pairs, positive/negative space or figure/ground.

In this chapter, we will become familiar with the vocabulary used to describe the basic parts of a visual image.

The **Visual Image** is composed of visual unit forms or design elements that possess a **Visual Attractiveness** or ability to draw the viewer's attention. A design element's attractiveness is determined by its **Contrast**, which is its degree of difference from its surroundings. The attractiveness of an image's design elements are ordered in a **Visual Hierarchy** from most attractive to least attractive based on each design element's degree of *contrast.* Design elements must harmonize with one another to form a *unified* whole. There must be agreement or **Unity** between the design elements comprising an image for it to be viable.

The visual image is composed on an area called the **Picture Plane** (fig. 2.1). It may be of any shape, but the most common is the rectangle. The edge of this surface is referred to as the **Format** or **Frame of Reference**. Any design element whether it be a large shape or the smallest dot or dash is called **Positive Space** or **Figure**. Any area of the picture plane not covered by positive space or figure is called **Negative Space** or **Ground. Positive/Negative Space** or **Figure/Ground** are the common pairings of these terms. Every part of the picture plane is a participant in the visual image and has the ability to attract the gaze of the viewer to some degree, whether it be *positive* or *negative space.*

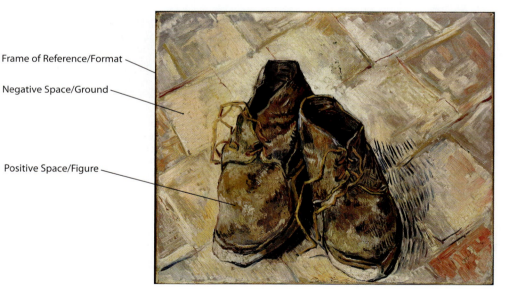

Frame of Reference/Format

Negative Space/Ground

Positive Space/Figure

Figure 2.1 *Shoes,* Vincent van Gogh.

Images that contain all the design elements within the *frame of reference* are **Closed Compositions** (fig. 2.2). Visual images with design elements that appear to extend beyond the picture plane's format are **Open Compositions.**

A **Shape** is a clearly defined area that one can see delineated by a line or a change in value or color. The edge of a *shape* whether defined by line, color, or value is its most active part. *Shapes* can be classified by their form and by what they do or do not represent. **Curvilinear Shapes** are rounded and flowing in their contours.

Negative Space: Any part of the picture plane not covered by positive space. Negative space is also referred to as ground.

Non-Representational Shape: A shape that does not replicate or refer to an object in the real world.

Open Composition: Visual unit forms appear to extend beyond the edge of the picture plane. They are cut by the format.

Picture Plane: The area to be designed. The picture plane can be paper, canvas, or other materials.

Positive Space: Any design element in the picture plane whether it be a large shape or the smallest dot or dash.

Rectilinear Shapes: Shapes made up of straight edges.

Representational Shape: A shape that replicates or refers to an object in the real world.

Shape: A clearly defined area that one can see. It may be defined by a line or a change in value or color.

Stylization: Emphasis or the exaggeration of visual form.

Unity/Harmony: The agreement between the visual unit forms that comprise a visual image. Unity/Harmony creates a visual whole or oneness.

Visual Attractiveness: The ability of a visual unit form to draw attention to itself based on its degree of contrast.

Visual Hierarchy: An ordering of visual unit forms from greater to lesser, based on the visual attractiveness of the unit forms. An element or unit form's degree of contrast determines its place on the visual hierarchy.

a

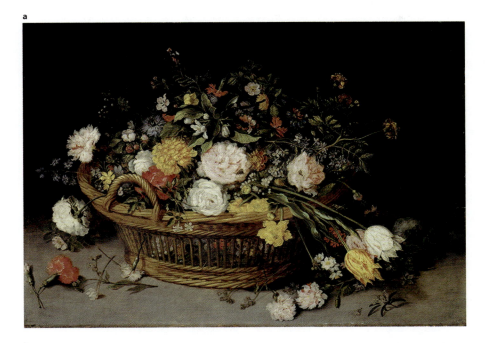

b

Figure 2.2a and **2.2b** *A Basket of Flowers*, Jan Brueghel the Younger.
In the top image, the Brueghel still life presents a *closed composition* with all its elements neatly contained within the picture's format, making the composition very stable and centralizing areas of focus. In the image below, the Brueghel still life has been cropped to make an *open composition* enlivening the organization of negative space and areas of emphasis.

Rectilinear Shapes are straight-edged in their contours. **Representational Shapes** (figs. 2.3–2.6) refer to objects in the real world, and may be realistic or barely recognizable in their appearance. Figures 2.3 and 2.4 are both figurative paintings and are examples of *representational images*. It is important to remember that *representational images* are not necessarily realistic in appearance. Figures 2.5 and 2.6 are examples of *nonrepresentational images*.

Abstraction (fig. 2.11) is the rendering of a visual element or image less realistic through the elimination of visual information and the simplification of form. An element that has become less realistic may still be considered *representational* if it

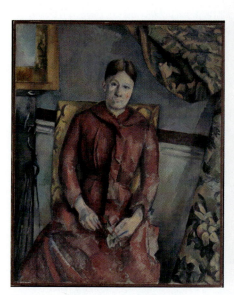

Figure 2.3 *Madame Cézanne,* Paul Cézanne

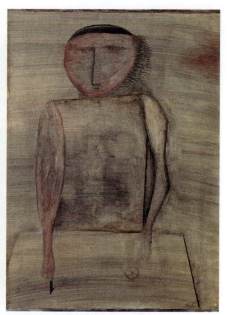

Figure 2.4 *Man,* Paul Klee

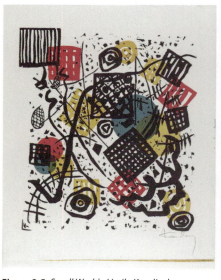

Figure 2.5 *Small Worlds,* Vasily Kandinsky

Figure 2.6 *Untitled,* Arthur Dove

remains recognizable as an object from the real world. **Stylization** is the emphasis or exaggeration of form and is often used in conjunction with *abstraction.* Stylized forms are also less realistic. Cartoon characters are a common example of *stylized* human figures (figs 2.7 and 2.8). The facial features in Fruchard's bronze bust of Honoré Daumier (Fig. 2.8) have been stylized. The head has been transformed into a triangular *shape* with the nose and jaw becoming larger than life and the eyes exceedingly small, giving the bust a menacing feeling. **Non-Representational Shapes** do not refer to objects in the real world (figs. 2.5 and 2.9).

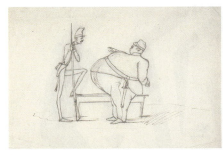

Figure 2.7 *Two Soldiers*, Anonymous. The *stylized* figures in this 19th-century cartoon illustrate the exaggeration of form. The soldier on the left exhibits the linear quality of thinness, with his counterpart on the right showing the roundness of corpulence.

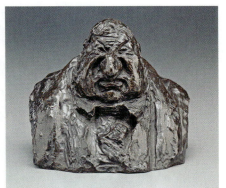

Figure 2.8 *Jean-Marie Fruchard,* model, Honoré Daumier.

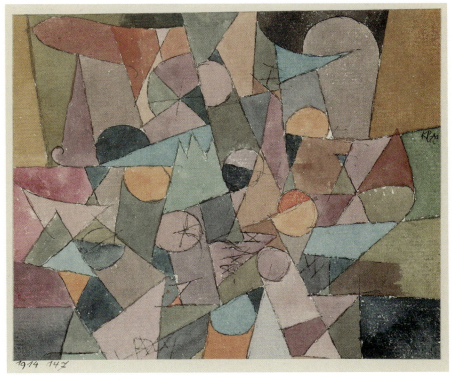

Figure 2.9 *Untitled*, Paul Klee. Klee's composition of line, *shape,* color, texture, and brushstroke is an exploration of *formal* ideas, and an example of a *non-representational* image. None of the elements in this composition replicate objects found in the real world.

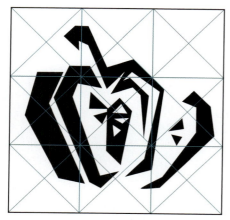

Figure 2.10 The pepper was designed using a three-by-three column grid with diagonal lines (shown in blue) intersecting at the corners of the cells. Using the grid creates a repetition of angles, which increases the similarity between the design's parts, providing a sense of unity.

Figure 2.11 *Bell Pepper*, Ainsley Bennett.

Bell Pepper by Ainsley Bennett is a logo symbol developed through the abstraction and stylization of a green bell pepper, resulting in a *representational* but not realistic rendition of the vegetable. Symbols such as those that represent commercial identities are designed for extremely short *read times,* as they are used on such things as billboards, package designs, and the sides of tractor trailers.

The forms representing the pepper have been stripped of naturalistic detail and reduced to basic two dimensional *shapes. The shapes,* while still maintaining their *representational* form, have been altered from *curvilinear* to *rectilinear* in their *contours.* The amount of *figure* to *ground* is nearly equal, enabling the *figure* to organize the *ground* into complementary *shapes.* The pepper *symbol* is composed of a series of three mutually defining *rectilinear shapes* alternately repeating themselves from left to right.

CHAPTER 3
Gestalt, Unity and Variety

Visual Analysis Outline: CHAPTER 14

VOCABULARY

Alternating Rhythm: The regular, unchanging repetition of a design element.
Closure: The completeness of sense information in the perception of objects and environment.
Continuation: 1. A real line connecting design elements.
2. A suggested line created through the alignment of unconnected forms.
Gestalt: The whole is different than the sum of its parts.

continued on page 14

In this chapter we will further investigate the relationship of the visual image to its parts, relying heavily on *Gestalt psychology of perception* to guide us.

Gestalt is the German word for form or *shape*. The central tenet of *Gestalt* psychology is that the mind understands external stimuli (sense data) as a whole, or unity, rather than as a collection of individual parts. We notice or perceive the whole before its parts. So it is with a visual image that we read the *unified* image first and then its individual parts. If an image fails to achieve a *unity* of its parts, it will be poorly perceived by the viewer, who in turn is likely to leave the image in frustration (fig. 3.1).

Gestalt is defined as *the whole is different than the sum of its parts.* The summation of an image's parts does not account for the synergistic relationship, or interaction, between the parts as they function in the image. *Gestalt,* our built-in organizing faculty, will at times ignore irregularities between an image's parts or supply missing portions of design elements in order for us to perceive a visual image.

There are a number of organizing strategies that our Gestalt uses to perceive visual unity, two of which are the *grouping of like elements* (fig. 3.2) and the *recognition of patterned repetitions of design elements.* **Repetition**, or the iteration of design unit forms, can contribute to *unity* by establishing patterns or **Rhythms**. The most *unifying*

Figure 3.1 a (top) and **3.1b (bottom)** The *shapes* in the top image appear to be unrelated and chaotic and show no visual organization. The same *shapes* in the bottom image appear visually organized and *unified* due to continuation (the alignment of their edges) and the repetition of parallel forms.

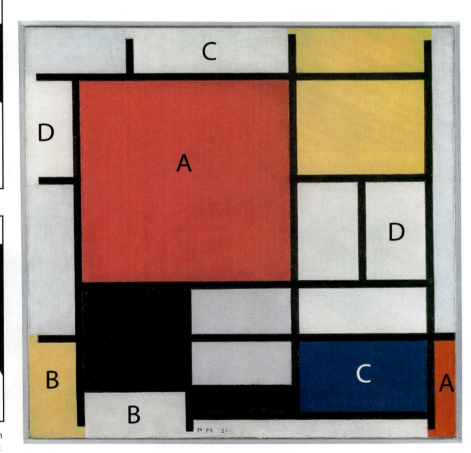

Figure 3.2 *Composition in Red, Yellow, Blue, and Black,* Piet Mondrian.
This painting by Mondrian demonstrates the *Gestalt* principle of Similarity. There is *similarity* of color (A), *similarity* of proportion (B), *similarity* of horizontal orientation (C), and *similarity* of vertical orientation (D). The likeness of the repeat elements contributes to the *unity* of the composition.

Gestalt Function: The faculty that organizes objects into wholes and promotes the understanding of sense information.

Integrative Repetition: An unrhythmic recurrence of a design element or portion of a design element lending commonality to different parts of the picture plane.

Progressive Rhythm: The regular repetition of a design element that changes with each occurrence or iteration.

Proximity: The spacial distance between design elements.

Repetition: The recurrence or iteration of a design element in a visual image. Repetition may be rhythmic or non-rythmic.

Rhythm: The repetition of a design element that occurs in a regular predictable way.

Suggested Line: A line that is implied through our Gestalt's sense of continuation. These lines are created through the alignment of forms or their edges, or by the gaze of human or animal forms within an image.

pattern is created by an **Alternating Rhythm** (fig. 3.3) consisting of repeating elements that are regular and unchanging in their recurrence. **Progressive Rhythm** (fig. 3.4) consists of a regular repetition of design elements that changes with each recurrence in the *rhythm*, adding variance and contributing to *unity*. **Integrative Repetition** (fig. 3.5) is a non-rhythmic recurrence of design elements, or portions or aspects of design elements, that lend commonality to different parts of the picture plane.

In the following paragraphs, we will consider the five principles of *Gestalt*, **Unity, Proximity, Similarity, Continuation, and Closure,** as aids to the perception of the visual whole.

Unity as defined in Chapter 2 is the agreement between individual design elements to form a whole. The agreement, which is the likeness between parts, promotes *unity*. Designs that possess an over-abundance of likeness between their parts, while forming a *unified* whole, can be extremely dull, or *over-unified*. Our Gestalt doesn't mind doing a little work in perceiving an image, but not too much. Too little or too much perceptual challenge will drive the viewer from the image through visual boredom or frustration. A *Gestalt* that is informed or schooled in design is capable of greater perception than one that is not.

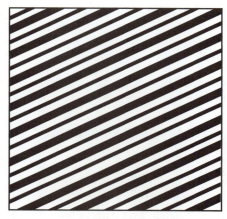

Figure 3.3 In this example of *alternating rhythm* the repeating diagonal forms are regular and unchanging.

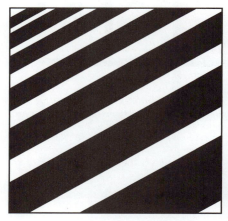

Figure 3.4 In this example of *progressive rhythm*, the *rectilinear shapes* become larger and farther apart with each repetition. The *figure* organizes the *ground* into *shapes* that become part of the *rhythm*.

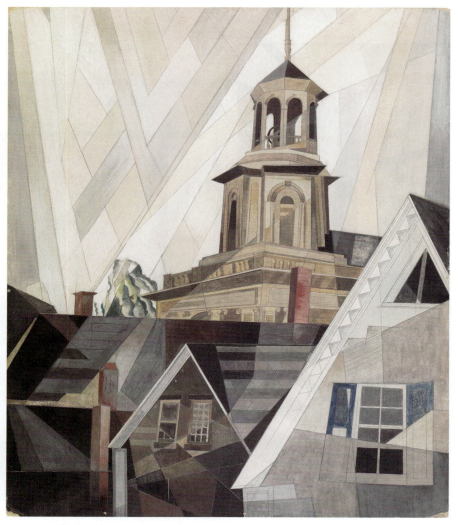

Figure 3.5 *After Sir Christopher Wren,* Charles Demuth.
Demuth integrates this cityscape through the repetition of diagonal *rectilinear* forms that are *similar* in size and color.

Variety (fig. 3.6) is difference. It is the introduction of differing design elements providing relief from sameness or *over-unity*. This relief could take the form of new elements or the modification of an existing design element such as change in *size*, *shape*, *value*, *color*, or *spacial* orientation.

Proximity (fig. 3.7) is the spacial distance between design elements. As previously mentioned, *Gestalt* creates visual organization by the grouping of design elements. Elements that are close together are more readily perceived as a group. The *continuation* of

Triangulation: A visual pathway from a focal point to accent points of lessening contrast, forming a triangular eye movement.

Variety: Difference; design elements that provide relief from sameness in visual images.

Unity/Harmony: The agreement between the visual unit forms that comprise a visual image. Unity/harmony creates a visual whole or oneness.

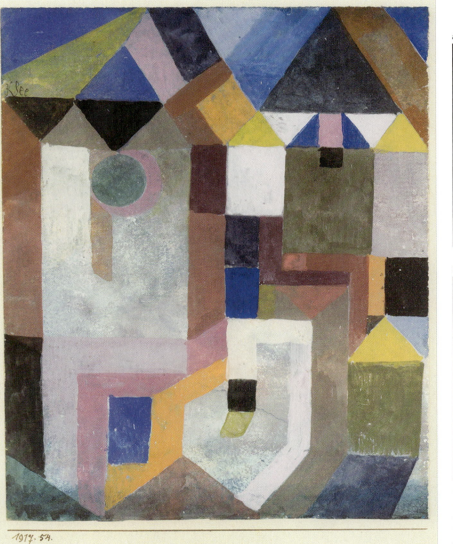

Figure 3.6 *Colorful Architecture,* Paul Klee.
Repeating *rectilinear shapes* help to unify this composition, while changes in their spacial orientation, size, and color add *variety*.

a

b

Figure 3.7a (above) and **3.7b (below).** The circles in the top figure appear to be randomly placed and lack unity. Moving the circles closer together in the bottom figure contributes to *unity* through *proximity*, and organizing the circles into a group helps our *Gestalt*. Alignment of the circle edges creates a *suggested line* through *continuation* (note the green arrows), and all of this adds to the sense of *unity* in this composition.

design elements along a common path suggesting a line extending through their edges is more readily perceived if they are relatively close in *proximity* and are in alignment.

Similarity (fig. 3.2, 3.8–3.10) means like but not the same. Design elements that share common aspects of form but are not exactly alike contribute to *unity* through their partial likeness and to *variety* in their difference.

Continuation (fig. 3.11) has a two-part definition: 1. A line connecting design elements; 2. A suggested line created through the alignment of the edges of unconnected forms. Alignment and *proximity* are key elements in the suggestion of lines.

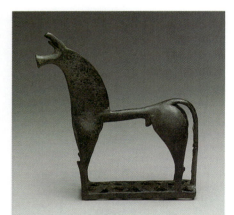

Figure 3.9 8th-Century B.C. *Bronze Horse.* The natural forms of this ancient Greek horse have been simplified to the geometry of their *shapes.* The neck, hip, ears, and tail all appear in the form of arcs (from the circle). The *repetition* of these *curvilinear shapes* lends *unity* to the *abstracted* form.

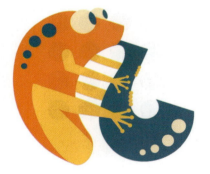

GROOVY FROG
JAZZ FOR BEGINNERS

Figure 3.10 *Groovy Frog Logo,* Eliza Whyman. This logo design was created through the *repetition* of *similar shapes.* The geometric type repeats the *curvilinear* forms in the logo *symbol.* The *shapes* of the frog and instrument have been *abstracted* by the removal of naturalistic detail, and *stylized* by the exaggeration of the roundness of their forms to create this playful logo.

Figure 3.8 *Free Curve to the Point Accompanying Sound of Geometric Curves,* Vasily Kandinsky. Kandinsky achieves *unity* in this painting by the repetition of *curvilinear* lines, demonstrating the G*estalt principle of similarity,* and adds *variety* to the composition through changes in their size and width.

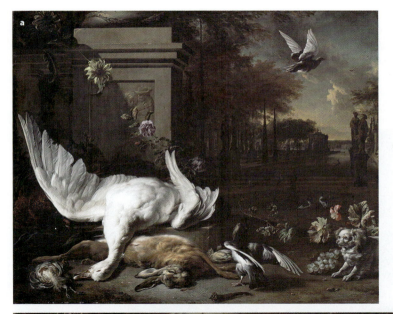

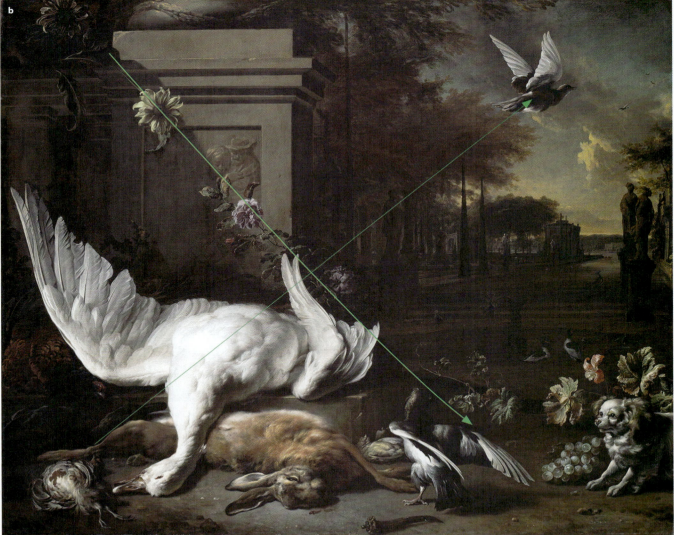

Figure 3.11a (top left), and **3.11b (above)** *Still Life with Swan and Game before a Country Estate,* Jan Weenix.
This painting by Weenix utilizes the *Gestalt principle of continuation* to create suggested lines through the alignment of forms within the composition. The repeating *suggested lines* help to unify the composition.

Closure (figs. 3.12–3.14) is the completeness of sense information in the perception of objects and environment. Our sense of *closure* allows us to view incomplete objects as complete. *Closure* as part of our *Gestalt* fills in missing portions of design elements to bring a visual image into unity.

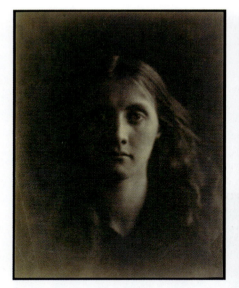

Figure 3.13 *Julia Jackson,* Julia Margaret Cameron. In this photograph, the left side of the woman's face is obscured in shadow, stimulating the viewer's sense of *closure* to complete the figure.

Figure 3.14 *Gund Logo.*
In the above logo, the designer has configured the lower edges of the letters *U* and *N* (*figure*) to organize the *ground* to imply the top contour of a bear's head. This in conjunction with the black *curvilinear* forms provides the viewer's *Gestalt* (*closure*) with enough visual cues to perceive a bear's head.

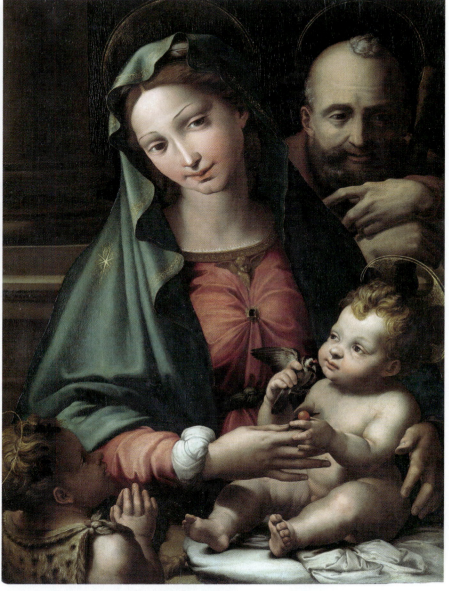

Figure 3.12 *The Holy Family with the Infant St. John the Baptist,* Perino del Vaga.
In this painting by del Varga, parts of the figures are cloaked in shadow, which stimulates our *Gestalt* to complete the portions of the forms not clearly visible.

CHAPTER 4

Color

VOCABULARY

Additive Color: Non-reflected colored light.

Color Spectrum: Light passed through a prism, yielding Red, Orange, Yellow, Green, Blue, Indigo, and Violet.

Cool Colors: Feels cold; Yellow-Green, Green, Blue-Green, Blue, Blue-Purple.

Color Temperature: Hues associated with atmospheric conditions of warmth and coolness.

Four Aspects of Color: Hue, value, saturation, and temperature.

Hue: The name of the color.

Primary Colors: Parent colors; Red, Yellow, and Blue in subtractive color and Red, Green, and Blue in additive color.

Saturation: Also known as chroma and intensity, the purity of a hue.

Secondary Colors: The hues achieved by mixing primary colors; Orange, Green, Purple.

Shading: The addition of black to a hue to make it darker in value.

Subtractive Color: Colored light reflected from pigmented surfaces.

Tertiary Colors: The hues achieved by mixing primary and secondary colors; Yellow-Orange, Red-Orange, Red-Purple, Blue-Purple, Blue-Green, Yellow-Green.

Tinting: The addition of white to a hue to make it lighter in value.

Toning: The addition of gray or the color's complement to diminish its saturation, or brightness.

Value: Light and dark; black, white, and gray.

Warm Colors: Feels warm; Yellow, Yellow-Orange, Red-Orange, Red, and Red-Purple.

In this chapter, we will review some basic aspects of color and color terms, though color theory is a broad subject and goes well beyond the scope of this book. It will be useful to know some basic vocabulary to better identify the color one sees and the role it plays in the visual image.

In the natural world, the color that we see is either reflected from pigmented surfaces, which is **Subtractive Color,** or non-reflected colored light known as **Additive Color.**

Additive color is most commonly seen as the colored light of a computer monitor or television set and is achieved by the mixing of light. The range of *additive hues* is mixed from three **Primary colored** lights, Red, Green, and Blue, which when mixed produces the **Secondary Colors,** Yellow, Cyan, and Magenta.

In *subtractive color,* sunlight passed through a prism separates into Red, Orange, Yellow, Green, Blue, Indigo, and Violet light, which comprise the light of the **Color Spectrum.** The natural world is filled with pigmented surfaces. Color pigment absorbs all the *spectrum's* light with the exception of the colored pigment in the surface on which the light is shining. The unabsorbed light is a reflection of the pigment's color, that is, a red ball absorbs the sun's Yellow, Orange Green, Blue, Indigo, and Violet light but reflects the Red light of the spectrum; therefore, we see a red ball (fig. 4.2). This phenomenon is called **Subtractive Color** due to the elimination and reflection of the *spectrum's* colored light.

All the **Hues** (color pigment) in *subtractive color* can be mixed from three **Primary Colors,** Red, Yellow, and Blue. There are twelve basic *hues* that may be arranged in a circular configuration called a **Color Wheel** (fig. 4.1). These colors are generated

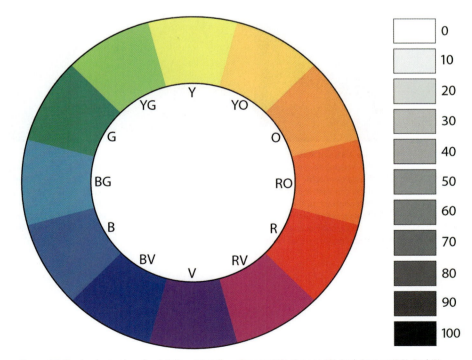

Figure 4.1 Twelve-hue color wheel: Yellow (Y), Yellow-Orange (YO), Orange (O), Red-Orange (RO), Red (R), Red-Violet (RV), Violet (V), Blue-Violet (BV), Blue (B), Blue-Green (BG), Green (G), and Yellow-Green (YG). On the right is a ten-step value scale ranging from 100 percent black to 0 percent or white. Each hue has an inherent value; yellow is lighter, and violet is darker.

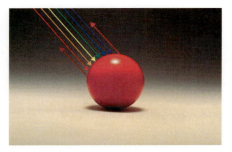

Figure 4.2 The red ball absorbs the sun's Orange, Yellow, Green, Blue, Indigo, and Violet light and reflects the Red colored light of the ball's pigment.

through the mixing of adjacent *hues* starting with the three *primary colors*, that is, Red is next to Yellow and when mixed produces Orange, Blue is next to Yellow and when mixed makes Green, and so on. The first mixture of adjacent *primary colors* yields the **Secondary Colors,** Orange, Purple, and Green. The mixing of adjacent primary and secondary colors makes the **Tertiary Colors,** Yellow-Orange, Red-Orange, Red-Purple, Blue-Purple, Blue-Green, and Yellow-Green.

Knowledge of the **Four Aspects of Color, Hue, Value, Saturation,** and **Temperature,** will aid our reading of an image with more precise color observations, that is, a repeating *similar* red *hue* becomes less *saturated* with its repetition in the composition.

Hue is the pigment for which the color is named, that is, the pigment reflecting Red light is the color Red.

Value is the lightness or darkness of a *hue.* Each color has a natural *value* equivalent (fig. 4.1). This is made clear if the color wheel is oriented so Yellow is at the top. The descending *hues* become progressively darker in their natural value. Colors may be lightened in *value* by adding white, which is known as **Tinting,** and darkened in *value* by adding black, known as **Shading.** Light colors appear to advance in space, dark colors appear to recede in space (fig. 4.3).

Figure 4.3a and **4.3b** *Black and White and Color Design,* Meredith Long.
In the designs above, Long has created the illusion of spacial depth in black and white and color. The image on the left is composed of white and gray geometric *figures* on a black *ground.* Through *value* contrasts, she creates three *spacial planes.* The white *square,* the element of highest contrast, is in the *foreground;* the triangle, the next highest contrast, in the *mid ground;* and the rectangular figure, the element of lowest contrast, in the *background.* The figures in the color design also show the illusion of depth through contrasts of *saturation (brightness)* and *temperature (warm/cool).* The *tinted* red *square* is the *warmest* and most highly *saturated* figure, establishing the *foreground;* the purple triangle is *cooler* and less *saturated,* in the *mid ground,* the rectangle is the *coolest* and least *saturated* of the figures, in the background. The *ground* is cooler and less *saturated* than any of the geometric *shapes* in the composition.

Saturation, also known as *chroma* or *intensity,* is the purity of a *hue*. Pure *hues* are brighter than *hues* with admixtures of black, white, gray or a complementary color (*hues* opposite on the color wheel, Red/Green). **Toning** is the addition of an equal *valued* gray, or a small amount of a complementary color to reduce a *hue's* brightness without changing its *value*. Highly *saturated*, bright colors appear to advance in space. Less pure, *toned* colors appear to recede in space (fig. 4.4).

Color Temperature is the association of a *hue* with the atmospheric conditions of hot and cold. **Warm Colors** are Yellow, Yellow-Orange, Orange, Red-Orange, Red, and Red-Purple, and appear to advance in space. **Cool Colors** are Yellow-Green, Green, Blue-Green, Blue, Blue-Purple, Purple, and appear to recede in space (fig. 4.5).

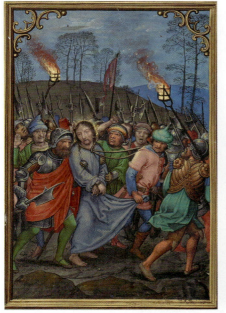

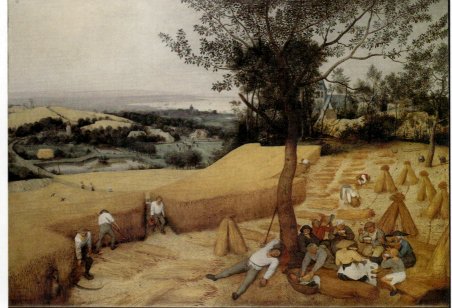

Figure 4.4 *The Arrest of Christ,* Simon Bening. In this painting, Bening creates three planes of space by using warm, *saturated* colors to create the *foreground* and *cooler,* less *saturated* colors to create the *mid ground* and *background*.

Figure 4.5 *The Harvesters,* Pieter Brueghel the Elder. Brueghel creates a sense of depth through contrasts of *color temperature* and *saturation*. The *foreground* is established by the warm yellows of the wheat. The *cool,* less *saturated* green *hues* in the *mid ground* recede in space, while the *background* is created by the extremely low contrast and *saturation* of a distant body of water.

CHAPTER 5

The Illusion of Space

VOCABULARY

Aerial Perspective: A system for creating the illusion of three-dimensional space based on the perceptual changes of size, color, and value contrasts as seen in the natural world.

Atmospheric Perspective: Another name for aerial perspective.

Background: Spacial plane that appears farthest from the viewer in a visual image.

Bright Color: Highly saturated hues.

Cool Colors: Yellow-Green, Green, Blue-Green, Blue, Purple.

Dark-Valued Color: Hues that have a dark grayscale equivalency.

Dull Color: Hues of low saturation.

Foreground: Spacial plane that appears closest to the viewer in a visual image.

Horizon Line: The line established by the viewer's gaze from a fixed vantage point, used in linear perspective.

Light-Valued Color: Hues that have a light grayscale equivalency.

In this chapter, we will examine the illusion of three-dimensional form and deep space on a two-dimensional, flat surface.

The appearance of volumetric form and depth of spacial fields on a two-dimensional picture plane are achieved through the imitation of our spacial perceptions of the natural world. *Atmospheric* or *aerial perspective* and *linear perspective* are two systematic approaches for establishing the illusion of three-dimensional space in a visual image.

Aerial Perspective, also known as **Atmospheric Perspective,** is based on a series of perceptual changes that objects appear to undergo as they recede in space. Objects appear to become smaller, lose intensity of *value,* color, detail and space between their parts (fig. 5.1). Depth of space is categorized into a series of *spacial planes* with the same perceptual reductions in contrasts at work. The *foreground space* is closest to the viewer, the *mid ground space* is the middle distance from the viewer, and the

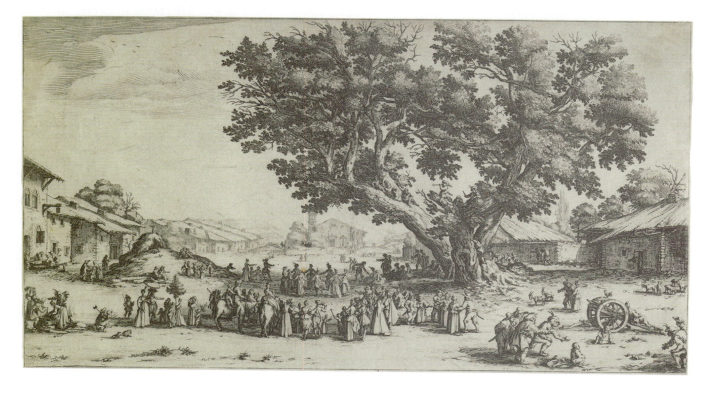

Figure 5.1 *May Day Celebrations at Xeuilley,* Jacques Callot
In this etching, Callot creates the illusion of deep three-dimensional space through the use of *aerial perspective*. The figures in the *foreground (spacial plane)* are at their largest, highest *value contrast,* and greatest detail. They become smaller, less contrasting in *value,* and less detailed with each successive appearance, thereby establishing the *mid ground* and *background* of the composition.

background space is furthermost from the viewer (fig 5.2). In the natural world, this illusion can be enhanced by atmospheric conditions. On a humid day, the increased moisture in the air heightens these perceptual changes.

The formal relationships that simulate the perceptual changes seen in *aerial perspective* may be used by artists and designers to control and manipulate the illusion of deep space and three-dimensional form (fig. 5.6). *Value* contrasts are of primary importance for black and white and color images (fig. 5.3). High *value* contrasts appear to advance in space, while low value contrasts tend to recede. An often used compositional strategy for deep space definition is to establish the *foreground* spacial plane with design elements of very high *value* contrast, the *middle ground* of a much lower contrast with the *background* spacial plane being of slight contrast (figs. 5.1 and 5.4–5.5). The same strategy may be used in color compositions with *warm, bright, light-valued* colors

Linear Perspective: A system for creating the illusion of deep space from a fixed point of view, where the receding edges of forms meet at points on a horizon line.

Line Weight: The value of a line; how light or dark it is.

Mid Ground: The spacial plane that is beyond the foreground and before the background.

Orthogonal Lines: Lines that recede to vanishing points in linear perspective.

Spacial Planes: Fields of varying depth in the illusion of three-dimensional space.

Suggested Line: A line that is implied through our Gestalt's sense of continuation. These lines are created through the alignment of forms or their edges, or by the gaze of human or animal forms within an image.

Vanishing Point: The point where orthogonal lines meet in linear perspective.

Vantage Point: The fixed point of view that establishes the horizon line in linear perspective.

Value: Light and dark; black, white, and gray.

Warm Colors: Yellow, Yellow-Orange, Orange, Red-Orange, Red, Red-Purple.

a

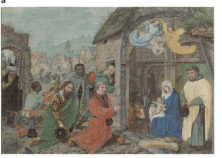

Background

Mid-Ground

Foreground

b

Figure 5.2a (above left) and **5.2b (above)** *The Adoration of the Magi*, Simon Bening. Bening uses *aerial perspective* to create three distinct *spacial planes*. *Warm, saturated* colors establish the *foreground* plane; *cooler, less saturated* colors create the *mid-ground* and *background* planes.

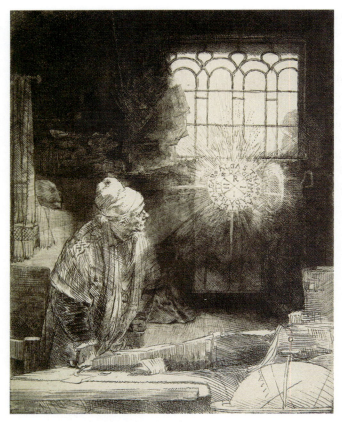

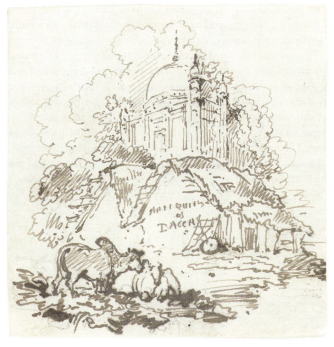

Figure 5.4 *Antiquities of Dacca*, George Chinnery.
In this pen and ink drawing, Chinnery creates the illusion of depth through *value* contrasts created by thick, dark lines in the *foreground* (high *value* contrast) and progressively thinner, *lighter-valued* lines (lower *value* contrast) from the *mid ground* into the *background*.

Figure 5.3 *Faust*, Rembrandt (Rembrandt van Rijn).
In this etching, Rembrandt uses *lighter-valued* lines in the *foregound* and thicker, darker lines as objects recede. The gradation of *value* from *foreground* to *background* creates the illusion of three-dimensional space.

a

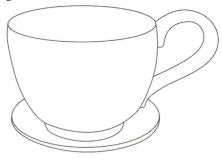

b

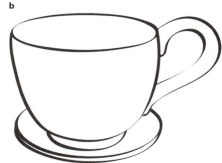

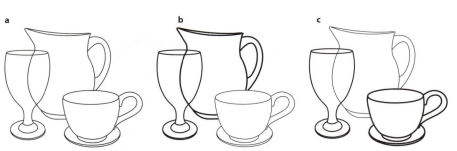

Figure 5.5a-c The three line drawings above illustrate line *value* contrast and the illusion of three-dimensional space. Figure 5.5a shows very little of the illusion because the linear figures share the same *line weight*. Figure 5.5b creates the illusion of depth through line *value* contrasts. The *values* gradate from lightest in the *foreground* to darkest in the *background* in a reverse *aerial perspective*. Figure 5.5c creates the illusion of three-dimensional space through high *value* contrast in the *foreground*, with lesser *value* contrasts establishing the *mid ground* and *background*.

Figure 5.6a and **5.6b** The contours of the top cup are of a single *line weight (no value contrast),* and do not create the illusion of three-dimensional form. The bottom cup has a variety of *line weights (value contrasts),* enhancing the appearance of volumetric form.

establishing the *foreground space; cooler, less bright, darker-valued* color in the *mid ground*; and *cool, dark-valued, dull* color in the *background* (Fig. 5.2).

 Linear perspective is a system for the delineation of the illusion of deep space based on the fixed *vantage point* of a viewer (figs. 5.7–5.11). At the start of the design process, the image maker establishes a *horizon line* (where the earth meets the sky), which represents the *vantage point* of the viewer. *The vantage points* can be low, which establishes a low *horizon line*; middle, which establishes a *horizon line* in the middle section of the picture plane; and high, which establishes a high *horizon line* (fig. 5.9). The edges of forms in the composition that are not parallel to the picture plane will recede in space, with a *suggested* or *orthogonal line* continuing from the form's edge to a point on the *horizon line* known as the *vanishing point.* Parallel edges of receding forms meet at a common *vanishing point* (figs. 5.7–5.11). An image's forms and spacial environment may require one (fig. 5.8), two (fig. 5.11), or three *vanishing points* (figs. 5.10 and 5.12). and *vanishing points* tangent to them if there are inclined planes. These three different approaches are commonly known as *one-point, two-point,* or *three-point perspective. Linear perspective* can be quite complex, and a detailed exploration of it is beyond the scope of this book. There are a number of books on the subject listed in the Bibliography for readers desiring a more in-depth study.

Figure 5.7 In this illustration of a cube in *one-point perspective,* all the *orthogonal lines* recede to a single *vanishing point.* The cube sits below the *horizon line* established by the observer's *point of view.*

a

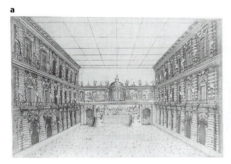

b

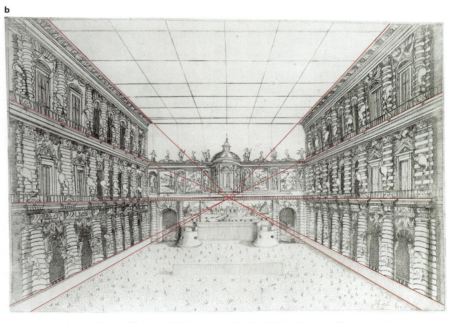

Figure 5.8a and **5.8b** *Court of Palazzo Pitti Decorated with Candelabra,* from an album with plates documenting the festivities of the 1589 wedding of Ferdinand I and Christine of Lorraine, Orazio Scarabelli. In Scarabelli's engraving, illustrating *one-point perspective,* all the *orthogonal lines* recede to one common *vanishing point* (VP).

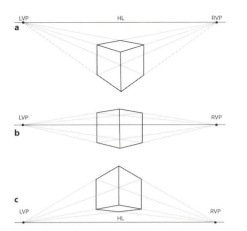

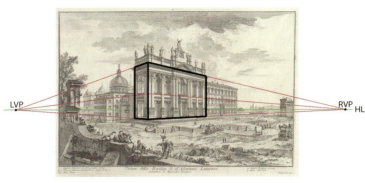

Figure 5.11 *San Giovanni in Laterano,* by Giovanni Battista Piranesi.
In this etching, Piranesi uses *two-point perspective.* The *horizon line* is in green, and the *orthogonal lines* (in red) recede to either the LVP or RVP. Parallel *orthogonal lines* recede to the same *vanishing point.*

Figure 5.9a–5.9c In illustration *a,* the cube is seen from a *high vantage point,* which establishes a *high horizon line* allowing one to see the top of the figure. In *b,* the cube is seen from a *middle vantage point,* which establishes a *medium horizon line,* with one seeing the figure straight on. In *c,* the cube is seen from a *low vantage point,* which establishes a *low horizon line,* with one seeing the bottom of the figure.

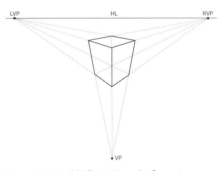

Figure 5.10 In this illustration, the figure is seen in *three-point perspective.* In addition to the two *vanishing points* on the *horizon line,* a third *vanishing point* is required for the convergence of the receding vertical *orthogonal lines.*

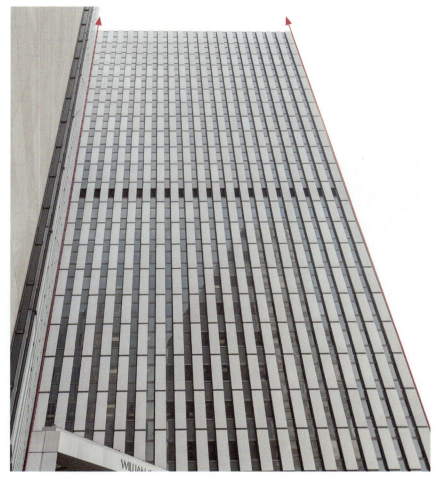

Figure 5.12 William S. Moorehead Federal Building, Pittsburgh, Pennsylvania.
In this example of *three-point perspective,* the viewer is at street level, dramatically looking up at the building. The two vertical receding *orthogonal lines* (red arrows) converge at a *vanishing point* that is located outside of the *picture plane.*

CHAPTER 6

Balance

VOCABULARY

Asymmetrical Balance: The equivalence of the design elements' visual weight but not their form, on either side of a the vertical axis of symmetry. *A pound of feathers equals a pound of lead.*
Axis of Symmetry: A vertical or horizontal line dividing the picture plane into two equal portions.
Formal Balance: Symmetrical balance.

continued on page 28

In this chapter, we will explore the distribution of visual weight in relationship to the picture plane known as **Visual Balance**.

Our sense of bodily stability, being right with gravity, is one of our primary physical concerns, one that we project in the world around us. Most people who see a picture hanging askance on a wall will experience an overwhelming desire to restore its equilibrium. The manipulation of formal elements in a visual image by the artist impacts the viewers' perception of the image. If the elements give the impression of imbalance, the image can be very disconcerting to the viewer. By blurring the edge between balance and imbalance, degrees of tension can be built into a design. To the opposite effect, an emphasis on a formal arrangement of parts to achieve balance can lend stability and a sense of *gravitas* to an image.

Balance according to *Webster's Dictionary* is "stability produced by even distribution of weight on each side of a vertical axis." This is true for the visual image though the design units or elements that make up an image most often have no physical weight. They do have **Visual Weight**, which is the element's visual attractiveness based on its contrast with its surroundings. The higher the design element's contrast, the greater its visual weight.

One compares the distribution of visual weight in an image by dividing the picture plane into two equal parts horizontally or vertically. **Horizontal Balance** is assessed by constructing the **Axis of Symmetry** through the center of the picture plane, dividing the image into two equal parts. The visual weight of the design units in each part should be equivalent in their visual attractiveness to bring the composition to a state of equilibrium. *The image cannot achieve unity if it is unbalanced.* There are three types of balance: **Symmetrical, Near-Symmetrical, and Asymmetrical.**

In **Symmetrical Balance**, the elements are exactly the same in their formal appearance and placement on each side of the *axis of symmetry*, forming a mirror image of one another (figs. 6.1 and 6.3). This sense of mirrored sameness lends a quality of

Figure 6.1 *Birth*, Keith Vanderlin. This photographic collage is an example of *symmetry,* or *formal balance.* The image is mirrored on each side of the *axis of symmetry.*

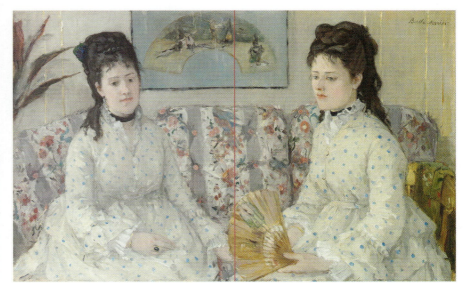

Figure 6.2 *The Sisters,* Berthe Morisot.
In this example of *near symmetry,* Morisot has placed the two young women equidistant to the *axis of symmetry.* The sister on the left appears in near-frontal view, while the sister on the right sits in three-quarter view. The other elements of the composition are *similar,* but not mirrored, in their relationship to the center axis. Our *Gestalt* easily compensates for the compositional variations.

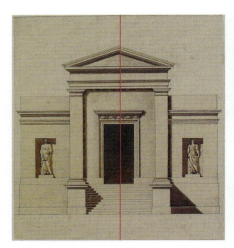

Figure 6.3 *Neoclassical* Building.
The *symmetry* in the design of this Neoclassical building imbues it with a sense of formality, solemnity, and stability.

Figure 6.4 *Still Life with Fruit and Roemer, Pieter Claesz.*
In this *asymmetrically balanced* still life, a large, moderately contrasting group of elements (feathers) on the right side of the image is balanced by the highly contrasting white cloth, plate, and bread (lead) on the left side of the image.

Hierarchy of Visual Weight: The ordering of visual weight from the top of the picture plane to the bottom, or from the bottom to top, based on the conditioned expectations of the viewer.

Horizontal Axis of Symmetry: A horizontal line running through the middle of the picture plane, dividing it vertically into two equal portions.

Horizontal Balance: The equivalence of the visual weight of design elements on either side of the vertical axis of symmetry.

Informal Balance: Asymmetrical balance; *a pound of feathers equals a pound of lead.*

Near-Symmetrical Balance: A variant form of symmetrical balance, where the basic distribution of visual weight is the same on each side of the vertical axis. The elements are not, strictly speaking, a mirrored image of one another.

Pictorial Hierarchy of Visual Weight: The distribution of visual weight with the most attractive design elements at the bottom of the composition, ascending to the least attractive design elements at the top of the composition.

Symmetrical Balance: Design elements are exactly the same in their formal appearance and placement on each side of the axis of symmetry, forming a mirror image of one another.

Typographic Hierarchy of Visual Weight: The distribution of visual weight with the most attractive design elements at the top, descending to the least attractive design elements at the bottom.

formality, stability, and above all *unity* to a composition. It is also known as **Formal Balance.**

 Near-Symmetrical Balance is a varied form of *symmetrical balance* with the basic distribution of *visual weight* being the same on each side of the vertical axis, with some difference (fig. 6.2). The elements are not, strictly speaking, a mirrored image of one another. Elements or groups of elements and their proximity to the central axis will be the determining factors in accessing *near-symmetrical balance. Near symmetry* contributes to the *unity* of an image.

 Asymmetry means *not symmetrical, but not out of balance.* **Asymmetrical Balance** (figs. 6.4 and 6.5) is achieved by elements on each side of the *axis of symmetry* that are

a

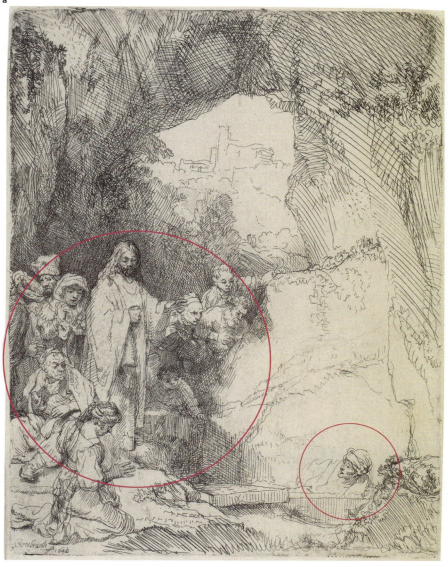

b

Figure 6.5a and 6.5b *The Raising of Lazarus,* Rembrandt (Rembrandt van Rijn).
Rembrandt creates a sense of drama and tension in this etching through his use of *asymmetrical balance.*
Christ and the surrounding group of figures are contained in the left half of the composition, forming a
large visual mass *(pound of feathers).* Lazarus *(pound of lead)* is the only human figure on the right side
of the image, placed in its lower-right corner. His isolation and relatively high value contrast balance the
larger visual mass on the left side of the picture plane.

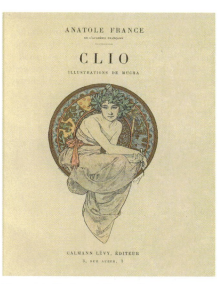

Figure 6.6 *Clio,* Anatole France, Illustrations
by Alphonse Marie Mucha.
This title page is an example of *typographic hier-
archy.* Most of the *visual weight* is located in the
top half of the picture plane, meeting the viewer's
expectation of reading top to bottom.

equivalent in their visual attractiveness but not their form. Most often a larger element, or
group of elements, of moderate contrast on one side of the *axis of symmetry* is balanced by
a smaller element of higher contrast on the other side. *A pound of feathers equals a pound
of lead* neatly encapsulates the concept of *asymmetrical balance. Asymmetrical balance*
is also known as **Informal Balance** and contributes to *unity* in that it is a type of balance,
but most especially through its variance contributes to *variety.*

Vertical Balance: A relative equivalence
between the visual attractiveness of design
elements at the top and bottom of the
picture plane.
Vertical Axis of Symmetry: A vertical
line running through the center of the
picture plane, dividing it horizontally into
two equal portions.
Visual Weight: The visual attractiveness
of a design element based on its degree
of contrast with its surroundings.

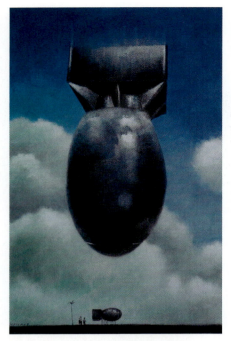

Vertical Balance is a comparison of visual attractiveness of the design elements in the top and bottom halves of the picture plane (figs. 6.6, 6.7). The picture plane is divided into equal parts by a horizontal axis. In this comparison, the idea of weight created by the pull of gravity is of particular importance. Viewer expectation of visual weight distribution is tempered by the types of images under consideration. In pictorial images, those of the world around us, we are conditioned by an expectation that the heaviest design elements will reside in the bottom half of the picture plane. This phenomenon is known as the **Pictorial Hierarchy of Visual Weight** (fig. 6.9). In images that are considered to be graphic design, images and text, the viewer expects the heaviest *visual weight* to be in the top half of the picture of the image, or *live area.* This is known as the **Typographic Hierarchy of Visual Weight** (fig. 6.10). If the weight of the visual elements is counter to the viewer's conditioned expectations, then *visual tension* is created (fig. 6.7). This may add excitement and increase the visual interest of an image or, if overdone, create visual annoyance, breaking the *unity* of the design.

Figure 6.7 *Big Bomb Little Bomb,* Brad Holland. Holland creates dramatic tension by placing the massive, highly attractive bomb in the top half of the picture, which runs counter to the viewer's expectations for the placement of visually heavy elements. ©Brad Holland

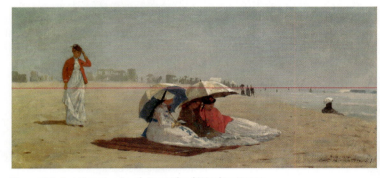

Figure 6.8 *East Hampton Beach, Long Island,* Winslow Homer. Homer, by placing the *horizon line* in the middle of the *picture plane,* vertically divides this beach scene into two horizontal portions of equal size. The strong horizontal elements make for an extremely stable composition, the lower half of which is weighted with visual elements of good contrast of bright color and value.

Figure 6.9 Pictorial Hierarchy. Most of the visual weight is located in the bottom half of the composition.

Figure 6.10 Typographic Hierarchy. Most of the visual weight is located in the top half of the composition.

Balance

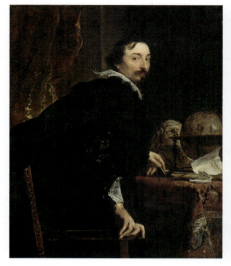

Figure 6.11
Portrait of Lucas van Uffel by Anthony van Dyck.

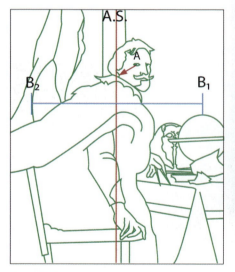

Figure 6.12
In side view, van Uffel is is looking over his right shoulder at the viewer, directing the viewer's *line of sight* back to the *axis of symmetry* (A.S.). The bust, globe, and paper (B₁) are lighted to form an *accent point*. (B₂) van Uffel's dark clothing is highlighted to form another *accent point*.

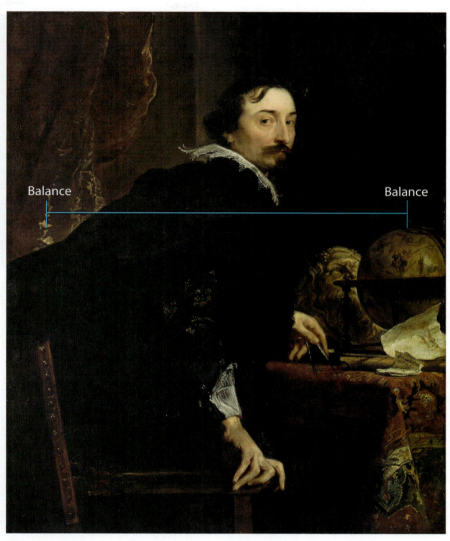

Figure 6.13 Axis of Symmetry (A.S.).

This portrait by van Dyck provides an interesting example of *formal balance* in tension, making what might be a static arrangement of parts into a visually dynamic composition.

The visual elements are arranged in *near-symmetrical balance.* We see van Uffel in side view looking over his right shoulder at the viewer. His torso is placed on the *axis of symmetry*, with his head tangent to the axis, his eyes just a bit to the right of it (fig. 6.13). His gaze is toward the viewer, which takes us back to the center of the image. The bulk of the *visual weight* in this painting lies in the center and center-right portion of the picture plane. In the right half of the image, a bust, globe, and piece of paper are lighted to form an accent point. In the left half of the picture plane, van Uffel's dark clothing is in high contrast with the lighted area of drapery behind it, forming another accent point (fig. 6.12). The strong accent points in the right and left halves of the picture plane are of equal distance from the *axis of symmetry,* bringing the image to a *near-symmetrical* balance.

CHAPTER 7

Emphasis and Eye Flow

In this chapter, we will examine the visual attractiveness of design elements of high contrast and their function within the *visual hierarchy* to create areas of focus and eye flow through an image.

Highly contrasting elements being the most visually attractive become points of emphasis or **Accent Points** (fig. 7.1) in a visual image as they are noticed more than other elements of lower contrast. A **Focal Point** is the element of highest contrast in the *visual hierarchy,* or the primary *accent point.* It is important that points of emphasis are of different degrees of contrast from one another as separate elements fighting for the same position in the *visual hierarchy* will cause a chaotic break in image *unity.* Care must be taken to integrate *focal* and *accent points* within the design so they do not overpower the rest of the composition, causing a break in *unity. Focal* and *accent points* provide areas of rest that function a bit like the punctuation of a written composition. The higher a point of emphasis' contrast, the longer the visual pause.

Points of emphasis may work together to create visual direction cues that guide the viewer's gaze through a design. Noticing the elements of high contrast, we tend to look from *accent point* to *accent point,* creating eye movement, a *visual pathway,* or *line of*

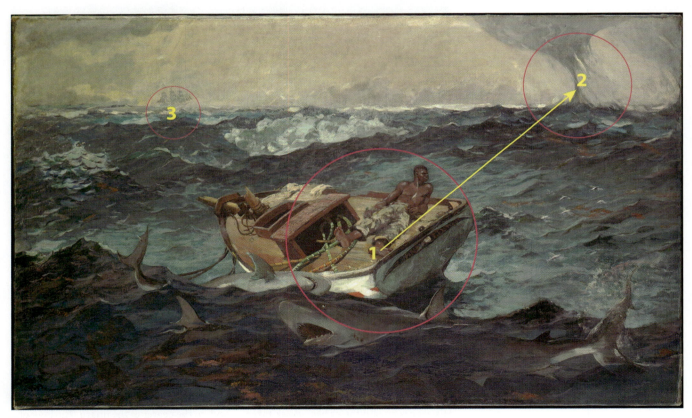

Figure 7.1 *The Gulf Stream,* Winslow Homer.
In this painting, Homer creates *triangulation* with well-defined *focal* and *accent points.* The figure and boat in the *foreground* form the *focal point* as they are large in *scale* and high in *value* contrast. The figure extended by the rope-like object creates a *real line* pointing to the water spout, which is the second *accent point,* due to its unusual *shape* and relatively large size. The sailing ship on the horizon differs in *shape* and *value* from its surroundings, forming the third *accent point* in the *triangulation.*

sight through the design. The *visual pathway*, or *line of sight*, is not followed in isolation from the rest of the image, as it is a bit like driving a car and following the visual cues offered by street signs. The driver sees the signs and the surrounding environment simultaneously. The directional paths formed by points of emphasis therefore tend to be simple rather then complicated and maze-like.

Lines of Sight (fig. 7.2) are visual cues that direct a viewer's gaze through an image. They may be created through our *Gestalt's* act of grouping *similar* elements that are not close to one another in the picture plane, or by *real* or *suggested lines*. A **Real Line** is a line or edge of a form that one can see. A **Suggested Line** is a line that is implied through our *Gestalt's* sense of *continuation*. These lines are created through the alignment of forms or their edges, or by the gaze of human and animal forms within an image. We tend to look where other people are looking and to a little lesser extent where animals look.

Scale: Size.

Suggested Line: A line that is implied through our Gestalt's sense of continuation. These lines are created through the alignment of forms or their edges, or by the gaze of human or animal forms within an image.

Triangulation: A visual pathway from a focal point to accent points of lessening contrast, forming a triangular eye movement.

Value: Light and dark; black, white, and gray.

Visual Hierarchy: An ordering of visual unit forms, from greater to lesser, based on the visual attractiveness of the unit forms. An element's or unit form's degree of contrast determines its place in the visual hierarchy.

a

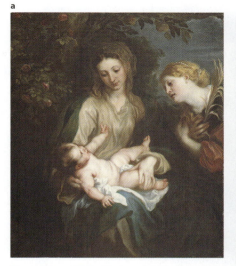

b

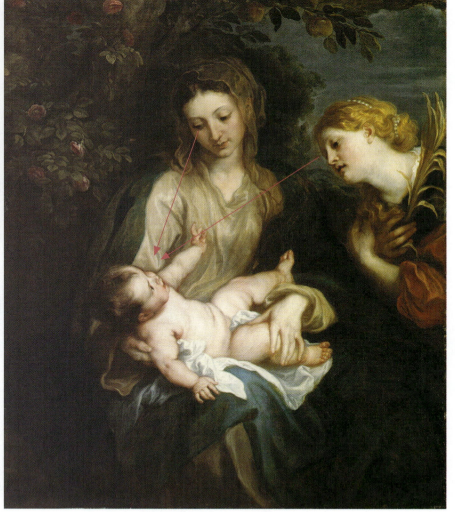

Figure 7.2a and 7.2b *Virgin and Child with St. Catherine of Alexandria,* Anthony van Dyck.
In this painting, van Dyck uses *suggested lines* created by the gaze of the Virgin, St. Catherine, and the Christ Child to establish a strong *line of sight* between the three figures. Contrasts of *shape, value,* and *scale* establish the figure of Christ as the *focal point.* St. Catherine is the second *accent point* due to value contrast and the *suggested lines* between herself and the Christ Child. The Virgin Mary forms the third *accent point* because of contrasts of *value* and *scale,* completing the *triangulation* of *focal* and *accent points.*

Triangulation (fig. 7.3) occurs when *focal* and *accent points* are placed in such a way as to create a triangular *line of sight* across an image from *focal point* to *accent points* of lessening contrast. This compositional strategy assures a full visual sweep through each part of the picture plane. The more similar the points of emphasis, the stronger the visual flow as our *Gestalt* is more adept at grouping *similar* elements (fig. 7.4).

a

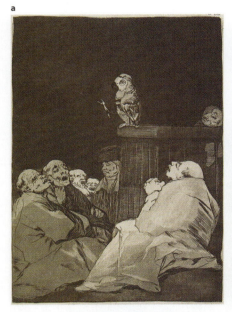

Figure 7.3a and 7.3b *What a Golden Beak!* Francisco Goya.

In the etching above from his *Los Caprichos* series, Goya has made the owl the *focal point* of the compositon by its placement on the *axis of symmetry,* its relative isolation from the group of figures below it, and its gaze at the viewer (us). The *foreground* and *background* figures of high *value* contrasts are the second and third *accent points* in the *triangulation* of these elements. The *line of sight* between the *focal* and *accent points* is reinforced by the *suggested lines* created through the gaze of the *foreground* and *background* figures.

b

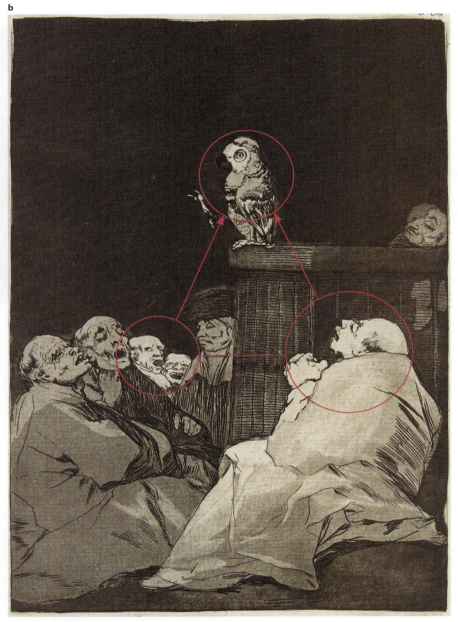

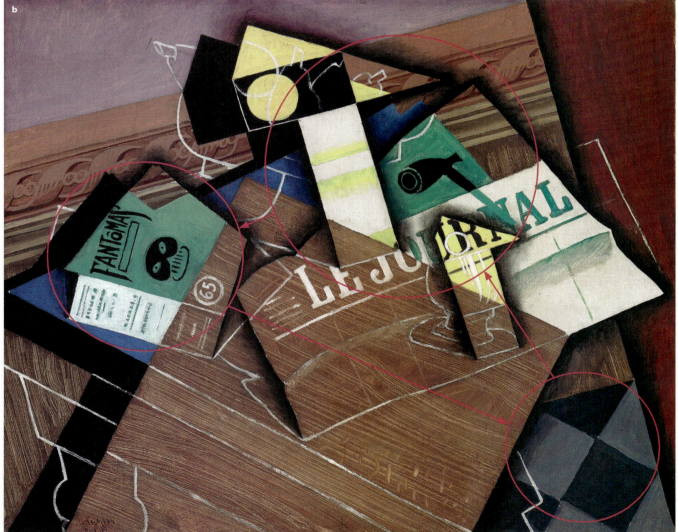

Figure 7.4a and 7.4b *Fantômas*, Jan Gris.
In this painting, Gris has created a high-profile *triangulation* through his use of strong color and *value* contrasts. The yellow black, blue, and green *focal* and *accent points* group quickly because of their *similarity* and high contrasts, creating rapid eye movement between the *triangulating* points of emphasis.

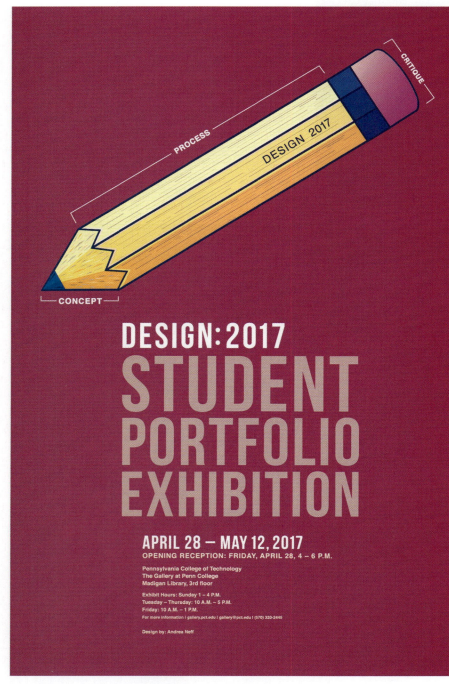

Figure 7.5 *Design 2017,* exhibition poster by Andrea Neff.

Design 2017 (Fig. 7.5), an exhibition poster by Andrea Neff, is a good example of an image designed to deliver its form and content quickly and efficiently. Given the context in which this image would be seen, the initial viewing time for a poster of this sort would be in the range of three to five seconds. Its clearly defined, highly contrasting *focal* and *accent points* facilitate a quick, crisp reading of the image.

The *focal point* is the pencil with its contrast of *scale* (largest element), *position* (top placement), *color/value* (warm, light, highly saturated hue), and *dynamic orientation* (strong diagonal). The *second accent point* is "Design: 2017" due to its highly contrasting white *value;* the subtitle in larger, lower-contrasting type is associated with "Design: 2017" by its close *proximity.* The *third accent point* is the exhibition date due its smaller size and highly contrasting white *value.* Further down in its position on the *visual hierarchy* is more detailed information placed below the exhibition dates that will require a second and closer read of the poster.

CHAPTER 8

Proportion

Visual Analysis Outline: CHAPTER 17

VOCABULARY

Dynamic Rectangles: Rectangles that are generated from a square and its diagonal and a square and its half diagonal; possessing the qualities of dynamic symmetry.

Dynamic Symmetry: The just balance of variety in symmetry (as proposed by Hambridge).

Diagonal: Diagonal lines drawn from opposing corners of a square, used to project root rectangles.

Golden Section Rectangle: A rectangle produced from the projection of a square's half diagonal with a proportional ratio of 1:1.618.

continued on page 38

In this chapter, we will discuss **Proportion** as it relates to the configuration of the picture plane and the harmonic placement of design elements within it.

Proportion is a comparison between a part of a design and the whole, or between the individual parts themselves. This comparison describes relative relationships of scale and space. The most basic *proportional* considerations start with the configuration of the picture plane. The initial comparison is between a **Rectangle's** height and width. We can express this comparison using numbers in what is called a **Ratio,** the numerical expression of a *proportion.*

Rectangles possessing equal sides are **Squares** (fig. 8.1) and those with unequal sides are **Long Rectangles** (fig. 8.2). The numerical expression of the comparison between the height and width of a *square* is 1:1 as their sides are always equal in measure. A *square* has a *ratio* of 1:1. All *long rectangles* contain *squares* within their area. The short side of a *long rectangle* is its *square* side (a side of the *square* contained within the *long rectangle*). The long side of a *long rectangle's* numerical expression is 1 (the other side of the contained *square*) plus the remaining portion of the rectangle that extends beyond the contained *square* (fig. 8.3). To calculate the numerical *ratio* of any *long rectangle,* measure the short and long side of the rectangle and divide the measurement of the short side (divisor) into the measurement of the long side (dividend). The resulting number (quotient) is the numerical expression of the long side of the rectangle (fig. 8.4).

The *proportion* of the *picture plane* is the beginning of a design statement. Our visual perception of the world is geared to the formation of visually perceived wholes or *unities.* The *square* is the essence of *unity* with four equal sides. It makes a stable *unified* ground for design with no long dimension, neither portrait nor landscape, vertical nor horizontal, in its orientation. *Long rectangles,* in contrast, have spacial orientation, vertical/horizontal, landscape/portrait.

Jay Hambridge (1867–1924), an artist and scholar, studied geometry in the art and architecture of ancient cultures. He discovered a set of harmonic proportions he termed **Dynamic Symmetry,** which he defined as *the just balance of variety in symmetry.* This may be understood as a harmonic mix of stability and movement, or a pleasing combination of *unity* with *variety.*

Figure 8.1 A square is a figure with four equal sides that meet in 90° angles.

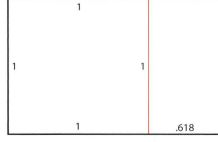

Figure 8.2 A long rectangle is a figure with four sides that are not equal that meet in 90° angles.

Figure 8.3 Every long rectangle contains a *square.* The numerical expression of the *proportion* or *ratio* of the short side of a rectangle is 1. The numerical expression of the long side is 1 plus whatever part of the rectangle extends beyond the *square.*

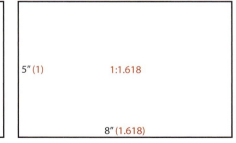

Figure 8.4 To calculate the *proportional ratio* for the rectangle above, measure the short side, 5", and the long side, 8". Divide the short measurement, 5", into the long side measurement, 8", which equals 1.618, the numerical expression of the long side. The short (square) side of the rectangle is always expressed as the number 1. The *ratio* of the rectangle is 1:1.618.

Dynamic Rectangles possess pleasing combinations of parts and are generated from a *square* and its *diagonal* and a *square* and its *half diagonal*. A **Half Diagonal** (fig. 8.5) is a line drawn from the midpoint of a square's side to either of its opposite corners.

The **Diagonal of a Square** (fig. 8.6) projected onto an extension of the square's baseline will result in a *long rectangle* with a baseline *proportional* expression that is the $\sqrt{2}$, a rectangle with a *ratio* of 1:1.4142. If the process is repeated by projecting a *diagonal* from the $\sqrt{2}$, a $\sqrt{3}$, a rectangle with a *ratio* of 1:1.762, results, and so on to the projection of a $\sqrt{5}$, a rectangle with a *ratio* of 1:2.236 (fig. 8.7).

The *square* and the projection of its *half diagonal* produce a rectangle with a ratio of 1:1.618, known as a **Golden Section Rectangle**. This *proportion* is found in the human body, in the phyllotaxies of plants such as the sunflower, in the spiral of the nautilus shell, and throughout nature and is also known as the *divine proportion*. Golden section geometry is well used in graphic design and has been a bulwark in the design of book pages down through the centuries (fig. 8.8). Refer to the Appendix for more *golden section* information and resources.

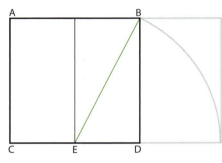

Figure 8.5 A *square* and its *half diagonal*. Point E is the midpoint of CD, EB is the diagonal drawn to an opposite corner. A *half diagonal* is used to construct a *golden mean* rectangle (1:1.618).

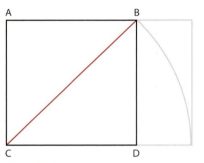

Figure 8.6 A *square* and its *diagonal*. Line CB is the *diagonal* of *square* ABCD. A *full diagonal* is used to construct $\sqrt{2}$, a rectangle with a ratio of 1:1.4142.

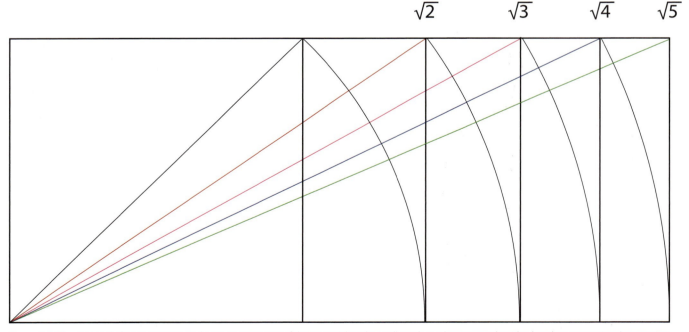

Figure 8.7 The *diagonal* of a *square* projected onto an extension of the *square's* baseline will result in a *long rectangle* with a baseline *proportional* expression that is the $\sqrt{2}$, a rectangle with a *ratio* of 1:1.4142. If the process is repeated by projecting a *diagonal* from the $\sqrt{2}$, a $\sqrt{3}$, a rectangle with a *ratio* of 1:1.762, results, and so on to the projection of a $\sqrt{5}$, a rectangle with a *ratio* of 1:2.236.

Figure 8.8 The construction of a golden section margin.
Using a T-square and 45° triangle, draw a diagonal line from point A to point N and point D to point K. These diagonal lines are shown in red. Second, draw a diagonal line from point B (top of gutter) to point K and point B to point N. These diagonal lines are shown in green. Third, draw a vertical line from point C that passes through point G and ends at point M. Fourth, draw a diagonal line from point C to point E. This line is shown in blue. Using a T-square, draw a horizontal line from point F to point H. This line is shown in gray. Using a T-square and triangle, draw a line from point H to point J. Project a vertical line down from point F and a horizontal line left from point J. The intersection of these two lines will give you point I and completes the rectangle. Project a line from point F (top) and point I (bottom) to the left spread and complete the left rectangle shown in gray.

CHAPTER 9

Structure

VOCABULARY

Columnar Grid: A typographic grid in which the primary guidelines are organized into columns, ranging from one or more.

Custom Grid: Structural networks built from a graphic element in the design.

Echo Lines: Diagonal lines within the harmonic armature to which design elements approximate themselves.

Eyes of a Rectangle: The 90° intersections of diagonal lines within the harmonic armature. These are places of harmonic rest.

In this chapter, we will explore internal frameworks or **Structures** that aid in the organization of negative space and the creation of harmonic relationships between design elements. *Structures* form the skeletons on which the body of the image rests and, like the human form, they are seen only indirectly through the *flesh* of the design.

Design *structures* exist prior to the placement of the design elements in the image. The choice of structural guides is often the initial step in the formation of an image, though many designs are conceived and executed without them. Internal design *structures* may be **Formal** or **Informal.**

Formal Structures, used primarily in graphic design, are known as **Typographic Grids,** or **Grids,** and consist of networks of guidelines that demand close adherence (figs. 9.1–9.3). A **Columnar Grid** used in page layout requires that the images and text be placed in even increments to conform to the *grid's* structural guides. Occasionally, a designer may break conformity to the *grid* to add variety. *Formal structural grids* may be of many configurations. The more **Cells** in the *grid*, the more spots there are to place elements in conformity with the *grid's* structural guides, allowing for more variety and flexibility in the placement of design elements. *Grids* may be customized

Figure 9.1 *Visual Literacy Workbook for Fine Artists and Graphic Designers,* Chapter 2 opening spread.
The page layout, above, utilizes two *typographic grids: A columnar grid* governs the placement of images and text columns, and a *leading* or *baseline grid* guides the placement and spacing of the main text. Both image and type conform themselves to one or multiples of the vertical column guides. Elements resting on the edge of the column guides share a common edge or *suggested lines,* creating, a *unifying* relationship between the elements. The *baseline grid* facilitates horizontal alignment of the lines of body text across the columns and pages.

Formal Structure: A structural network that requires strict adherence to its guidelines.
Grid Cell: The smallest compartment in which to place design elements in a structural grid.
Harmonic Armature: A structural network that provides places of harmonic rest and guides for the diagonal placement of design elements.

continued on page 42

a

b

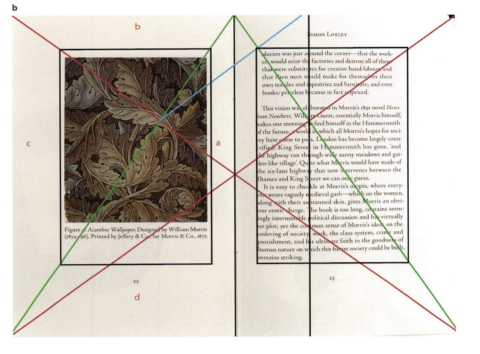

Figures 9.2a and 9.2b William Morris Chapbook, designed by Mark Wilson.
This chapbook was made using a *golden section margin structure* (see fig. 8.8). Wilson used the *structure* to create harmonic margins in his page designs. The *golden mean ratio, a:b :: c:d (1:1.618)*, provides a pleasing sense of variety.

a

b

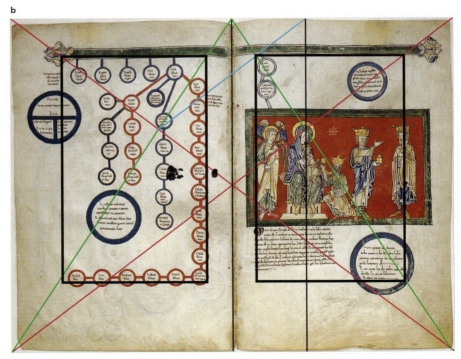

Figures 9.3a and 9.3b Leaves from a Beatus manuscript: bifolium with part of the Genealogy of Christ and *The Adoration of the Magi*.
This Spanish manuscript dating back to 1180 shows the use of a *golden section margin* (see fig. 8.8). The designer broke the margin on the left page with the blue circle and the right page with the large rectangle. Breaking the margin provides variety in the margins while maintaining a *structure* to create *unity*.

Informal Structure: A structural network where design elements have a casual relationship to its guidelines.

Long Rectangle: A rectangle with unequal sides.

Proportion: A comparison of a part of the design to the whole or to another part.

Rabatment: The projection of the short sides of a long rectangle onto a long side of the long rectangle. Each projection will form a square within it.

Rabatment Container: The squares created within a long rectangle by the projection of its short sides onto a long side. Unity (square) within the long rectangle provides a harmonic resting place for design elements.

Rabatment Lines: Lines created by the projection of the short sides of a long rectangle onto a long side, forming the interior side of the rabatment containers. They provide harmonic resting places for accent points.

to accommodate the needs of the designer by constructing the guidelines from the contours of graphic elements within the design (figs. 9.4 and 9.5).

Informal Structures consist of structural guides that provide suggestions for the placement of visual elements. Compositions may benefit from near or partial conformity to the *grid* coordinates, unlike the less forgiving requirements of the *typographic grids* discussed above.

Figure 9.5 When designing with a custom grid, one starts with the dynamic placement of a dominant element (the letter *d*). Guidelines are then projected from the edges of the dominant form. As other elements are added, new guidelines are projected. This helps to create a *unifying* relationship between the dominant element and forms in alignment with the custom guidelines.

Figure 9.4 *Optima Poster*, Brittany Maise. Brittany Maise utilizes a *custom typographic grid* built from the graphic configuration of the word "Optima." The *grid* coordinates, which take the form of small red type, run tangent to the vertical and horizontal edges of the letter forms, creating repeating parallel forms and variations in *grid cell* dimensions.

Figure 9.6 *Young Ladies of the Village,* Gustave Courbet.
Courbet houses the figures of this compositon in a *rabatment container* constructed by the projecton of the right side of the *picture plane* (*square* end) onto the base. An *accent point* formed by the figure of a young girl rests on the image's left *rabatment line.*

The **Rabatment** of a *long rectangle* is achieved by projecting the rectangle's short sides *(square sides)* onto a long side of the rectangle, forming a *square* within the rectangle for each projected short side (figs. 9.6–9.9). The interior *squares (unity)* are the rectangle's **Rabatment Containers** and may provide a harmonic resting place for design elements within a composition. The vertical lines from the projection of the *long rectangle's* short sides are called **Rabatment Lines** and provide a harmonic spot for the placement of *accent points*. The desirability of placing *accent points* on *rabatment lines* decreases when the *proportion* of the picture nears that of a *square* as the *rabatment lines* come precariously close to the edges of the *picture plane.* There is no *rebatment* of a *square.*

Square: A rectangle with four equal sides.

Structure: A network of guidelines that promotes harmony and organization in design.

Typographic Grid: Formal structural networks used in graphic design. The columnar grid is the most common example.

Figure 9.7 To construct a *rabatment,* the short side of a *long rectangle* is projected onto the long side. This creates a *square (rabatment container)* within the *long rectangle.* The *rabatment line* (shown in red) can be used in the placement of *accent points;* the *container* provides a non-centered, haromonic spot for the placement of dominant design elements.

Figure 9.8 The illustration above shows a vertical double *rabatment.* In the construction of a double *rabatment,* the short sides (top and bottom) of a long rectangle are projected onto the long sides. This forms two *squares* (top and bottom) within the *long rectangle.*

Figure 9.9 *The Collector of Prints,* Edgar Degas. Degas houses the figure in a *rabatment container* constructed by the projection of the bottom of the *picture plane* (*square* end) onto its long side. The second *rabatment,* constructed by the projection of the top of the *picture plane's* (*square* end) onto its long side, makes a *line where the accent point* rests that is formed by the hand and print.

The **Harmonic Armature** is a compositional guide that offers aid in the harmonic placement of *accent points* (places of harmonic rest) and the orientation of diagonal design elements (fig. 9.10). The *armature* is drawn within a rectangle and consists of two diagonal lines projected from each corner of the *picture plane.* One diagonal is projected from each corner, to its opposite corner, forming two crossing diagonals intersecting in the center of the rectangle. A second line is projected from each corner so it intersects the diagonal line opposite to it at 90° (fig. 9.11). The 90° intersections are the **Eyes** of the rectangle, are four in number, and provide harmonic spots for the placement of *accent points.* The relative position of the *eyes* varies within each rectangle depending on its *proportion.* The closer a picture plane's *proportion* is to *unity* (a *square*), the closer the *eyes* are positioned to the center of the rectangle. A single *harmonic armature* will not work in a *square* because the four *eyes* rest in its center. This situation is remedied by dividing the *square* in half, yielding two $\sqrt{4}$ rectangles. A separate *armature* is drawn in each half of the *square* (fig. 9.13).

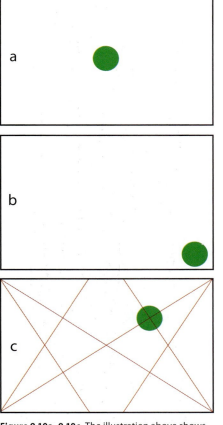

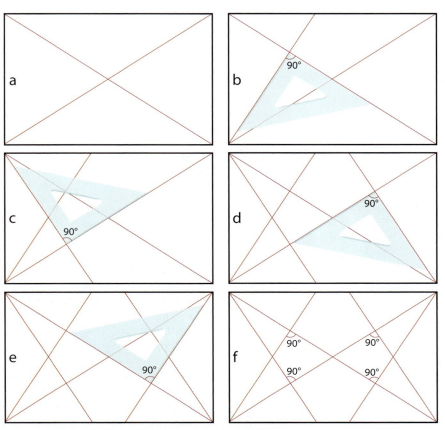

Figure 9.10a–9.10c The illustration above shows three picture planes and three different placements of circular design units within them. The centered placement (a) promotes over-*unity* because we tend to automatically look to the center of images; there are also equal amounts of negative space on the top and bottom and left and right sides of the unit form. In example (b), the tight placement of the circle in the lower-right corner causes an annoying visual tension, adding extreme *variety*. The placement of the unit form on the second harmonic *eye (eye of the rectangle)* in example (c) demonstrates a pleasing mix of *unity* (stability) with *variety* (movement).

Figure 9.11a–9.11f This series of illustrations demonstrates how to draw an *armature* in a *long rectangle*. The progression starts in the top left and moves right to left and top to bottom.

The *armature's* diagonal lines, called **Echo Lines,** provide diagonal positioning for *real* or *suggested* lines and forms (figs. 9.10–9.13). The word echo suggests a repetition of a sound with a diminution of strength as the sounds repeat. *Echo lines* are guides to which design elements approximate themselves, with parallel repeating elements becoming less obvious to the viewer with each occurrence. There are six diagonal lines *(echo lines)* within each *armature.* Three lines lean to the left, and three lines lean to the right. The center-left and right-leaning lines are formed by the rectangles crossing diagonals. The first and third left-leaning lines are parallel to one another, and the first and third right-leaning lines are parallel to each other. The repetition of diagonal elements is an important aspect of the visual forces that comprise dynamic composition.

a

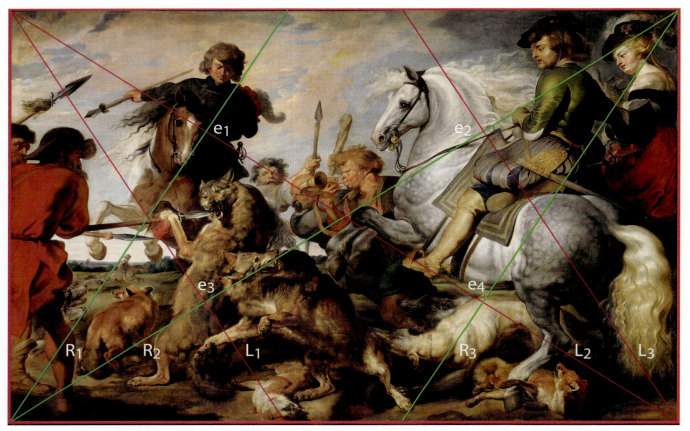

b

Figures 9.12a and 9.12b *Wolf and Fox Hunt,* Peter Paul Rubens.
Rubens makes use of the *harmonic armature's eyes* and *echo lines* in the complex composition above. The four eyes, one in each quadrant of the picture plane, provide harmonic resting spots for points of emphasis, such as the dark mounted figure resting on e_1 and the *light-valued* horse and rider on e_2. The *armature's* diagonal lines are echoed throughout the composition. Line L_1 is *echoed* by a *suggested line* extending from the dark horse and rider through the wolves; line L_3 is echoed by the rearing horse; the gaze of its rider and the gaze of his female companion *echo* line R_2 and many more. The repeating *similar* diagonals create a rhythm throughout the image and act to balance the dynamic of the composition.

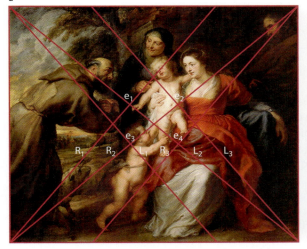

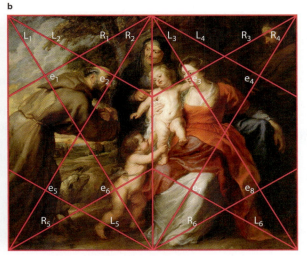

Figure 9.13a *The Holy Family with Saints Francis and Ann and the Infant St. John the Baptist,* Peter Paul Rubens.

This painting by Rubens is fairly close to a *square* with a ratio of 1:1.142. When an *harmonic armature* (in red) is placed over the composition, it becomes evident that the four *eyes* (e_1, e_2, e_3, e_4) are centrally located. This greatly limits the effectiveness of using a single *armature* structure in the planning and execution of an effective design. However, this single *armature* is still relevant to the harmonic relationships that Rubens utilized in creating this composition. There are repeating lines in the image that are parallel to the *echo lines* in the armature. R_1 is parallel to the back of St. Francis, the infant's right arm and angle of his eyes, the Madonna's left leg, the sheep's head, and the man's body (upper-right corner). *Echoing* R_2, is a *suggested line* created by the gaze of the cherub with the man in the upper-right corner. The four *eyes* of the armature do not play a significant role in the composition due to the near *square proportion of the picture plane.*

Figure 9.13b *The Holy Family with Saints Francis and Ann and the Infant St. John the Baptist,* Peter Paul Rubens.

Here is the same Rubens painting with two *harmonic armatures* placed over the composition. The painting is vertically divided in the center; a *harmonic armature* was in each half of the painting. With two *armatures,* there are eight *eyes* (e_1, e_2, e_3, e_4, e_5, e_6, e_7, e_8) and twelve diagonal *echo lines* to use in the composition. The *eyes* have now become important to this composition; St. Francis's face lies on the intersection of e_2 and the Madonna's face lands on e_3. There are also many more relationships developed with the *echoing* of the diagonal lines of the two *armatures.*

CHAPTER 10

Compositional Dynamics

VOCABULARY

Accent Point: A design element of high contrast in a visual image.

Compositional Dynamics: The distribution of diagonal, vertical, and horizontal design elements in a visual image.

Counter-Diagonals: Diagonal elements, either real or suggested lines, that are positioned crosswise to a dominant diagonal dynamic, offsetting its visual force.

In this chapter, we will examine gravity as a visually analogous force in pictorial composition.

Webster's Dictionary defines **dynamic** as "relating to physical force or energy." A design element's **Dynamic Orientation** is determined by the position of its *major axis* within the space of the picture plane. The long dimension of a form is its **Major Axis;** the short dimension of a form is its **Minor Axis.** There are **Dynamically Neutral Forms** such as the *square* and circle that possess *major* and *minor axes* of the same length (Fig. 10.1).

Elements within a design are stable (horizontal), stable with the potential for motion (vertical), or unstable (diagonal) forms in motion. The more stable a design element, the greater its contribution to *unity.* The more unstable a design element,

a

b

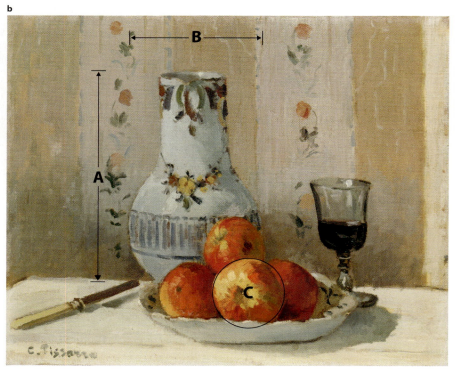

Figure 10.1a (above left) and 10.1b (above) *Still Life with Apples and Pitcher,* Camille Pissarro. The *major axis* (A) of the vase in this painting is vertical; its *minor axis* (B) is horizontal, giving it a vertical *dynamic orientation.* The apple (C) *is dynamically neutral* as its axes are of equal length.

the greater its contribution to *variety*. Most pictorial compositions are a combination of diagonal, vertical, and horizontal forms (fig 10.2).

The *dynamic force* exhibited by design elements depends on their spacial orientation or *dynamic orientation*. Diagonal elements, those in motion, display the greatest amount of visual force. The more obvious they are to the viewer, the stronger their

Dominant Dynamic: The most significant diagonal, vertical, or horizontal design elements in a pictorial composition.

Dynamic Hierarchy: The ordering of design elements by the amount of visual energy they display, with diagonals at the top of the hierarchy, verticals in the middle, and horizontals at the bottom.

continued on page 50

a

b

Figure 10.2a (top) and 10.2b (above) *The Thinker,* Auguste Rodin.
The *dominant dynamic* (a) in Rodin's *Thinker* extends from the base (lower right) through the top of the figure (upper left), and is repeated in the figure's lower legs. The force of the *dominant dynamic* is balanced by the *counter-diagonal* (b) that runs through the figure's shoulders and repeated in the thighs and forearm.

Dynamic Orientation: The spacial orientation (diagonal, vertical, horizontal) of a design element in a visual image.

Dynamically Neutral Forms: Design possessing dimensional axes of equal length.

Focal Point: The design element of highest contrast , or primary point of emphasis in a visual image.

Lines of Sight: A visual pathway or direction through an image.

Major Axis: The long dimension of a form.

Minor Axis: The short dimension of a form.

Triangulation: A visual pathway from a focal point to accent points of lessening contrast, forming a triangular eye movement.

visual energy (fig. 10.3). Vertical forms are primarily stable, but their potential for motion gives them a built-in energy that horizontal forms, those at rest, do not possess. **Dynamic Hierarchy** is the ordering of design elements by the amount of visual energy they display, with diagonals at the top of the hierarchy, verticals in the middle, and horizontals at the bottom.

Images created with strong diagonal forms as their **Dominant Dynamic** will also have **Counter-Diagonals** of lesser strength positioned crosswise to the *dominant diagonals,* acting to temper the force of the primary dynamic. If the offsetting diagonals are too similar to the dominant diagonal, the composition will become visually static, spoiling the *unity* of the image. Images that have verticals and horizontals as their *dominant dynamic* and are primarily stable can be enlivened by subordinate diagonal elements,

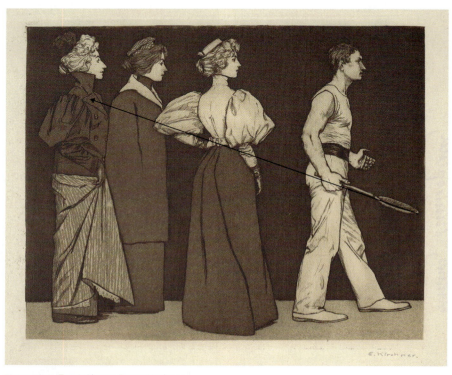

Figure 10.3 *Tennis Players,* Eugen Kirchner.
In the etching above, the four vertical figures progress in their placement from left to right, establishing a strong horizontal movement. The male figure in white is a place of visual rest due to high value contrast. His tennis racket is the start of a diagonal *suggested line* running through the adjacent figure's diagonally placed forearm and the collars of the last two figures on the left, bringing our *line of sight* back to our starting point.

such as diagonal *lines of sight* created by the *triangulation of focal* and *accent points* (figs. 10.4 and 10.5). The interplay of *dynamic orientations* provides a subliminal subtext for image content, provoking a range of feelings from excitement to serenity. Whatever the compositional mix of *dynamic orientations*, they should harmonize to form a unified whole.

a

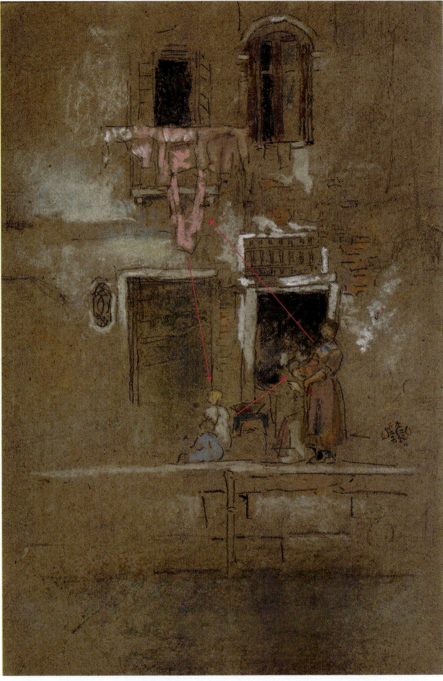

b

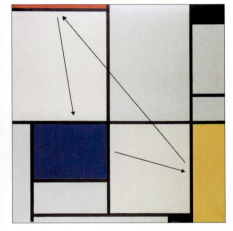

Figure 10.5 *Tableau I*, Piet Mondrian.
The vertical and horizontal *dynamic orientation* in *Tableau I* creates a very stable and *unified* pictorial environment. Mondrian adds variety to the composition through changes in element size, proportion, and color. *Triangulated focal* and *accent points* serve to complement the stability created by the repeating vertical and horizontal elements.

Figure 10.4a (above) and 10.4b (top right) *Note in Pink and Brown*, James McNeill Whistler.
Whistler's hazy architecture facade consists of repeating vertical and horizontal forms, making for a very stable composition. The darkened windows along with spots of color in the figures and drapery create *triangulated focal* and *accent points* that enliven the image by creating a diagonal *line of sight*.

Compositional Dynamics

St. Sebastian by Georges de La Tour (Fig. 10.6) provides the viewer with a dynamic interplay of visual forces.

St. Sebastian reclines, on a slight diagonal, in the lower-left quadrant of the picture plane. He is attended by St. Irene, holding a taper, and three other vertically positioned figures. The vertical taper, with its tall flame, is the sole source of light in the image. In addition to the vertical figures, there is a vertical column that extends from St. Sebastian's head in the lower-left quadrant of the picture plane through and beyond the top of the picture plane in the upper-left quadrant, making for the sixth significant vertical form in the image.

A strong diagonal *suggested line*, which nearly bisects the composition diagonally, is created through the alignment of St. Sebastian's head and those of his attendants. The aligning heads progressively change in height, further emphasizing the *suggested diagonal line.* Consulting the *harmonic armature,* we find that it echoes lines R_1 and R_3. The dominant diagonal is also echoed by two less prominent parallel *suggested lines* (fig. 10.7). The first extends from St. Sebastian's left forearm, passing through St. Irene's left hand

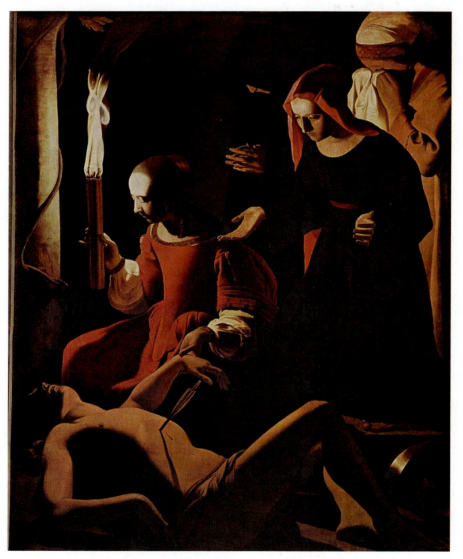

Figure 10.6 *St. Sebastian,* Georges de La Tour.

Compositional Dynamics *continued*

and the hand of the attendant behind her. The second echoing line is established by St. Sebastian's upper right leg.

The force of the dominant diagonal and its parallel diagonals is offset by the repeating verticals created by the attendants, taper, pillar, and a set of *counterpositioned diagonals* of diminishing strength. The *counter-diagonals* are created by St. Sebastian's torso, extending through his head, the alignment of St. Irene's left and right hands, the alignment of the second attendant's left hand and that of the hooded figure beside her, the second attendant's shoulders and forward-leaning head, and those of the crying figure behind her.

The relationships of the visual forces in this composition illustrate the differences in dynamic strength between the elements in the *dynamic hierarchy.* The seemingly more numerous, prominent vertical elements in the image are outweighed by the greater dynamic force of the composition's diagonal forms (fig. 10.8).

Figure 10.8 Compositional dynamics diagram of *St. Sebastian,* Georges de La Tour.
The diagram above illustrates the interplay of *dynamic* forces in La Tour's painting of *St. Sebastian. Dominant diagonal* (dynamic) *contours* are stabilized by a series of *counter-diagonals* and repeating verticals. *Suggested lines* 1 and 1a form the main thrust of the diagonal contour that extends from the lower-left corner to the upper-right corner of the picture plane, and is echoed by lines 1b and 1c, integrating the diagonals into the composition, with the *counter-daigonals,* C, Ca, and Cb acting as a balast to the *dominant diagonals.* The vertical lines 2–2e create a gently *progressing rhythm,* further stabilizing the diagonal *dynamic* and carrying the *line of sight* from the left side of the picture plane to the right edge of the image.

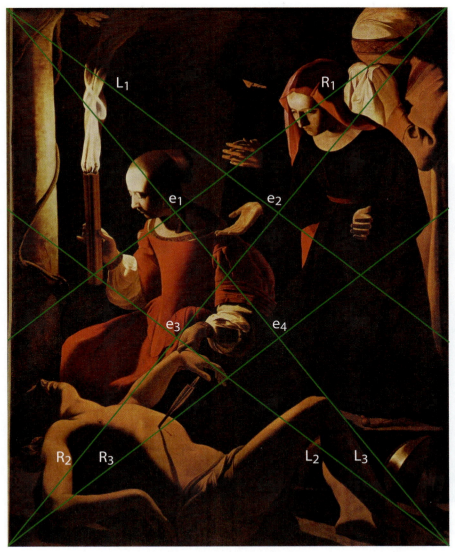

Figure 10.7 Harmonic Armature Imposed on de La Tour's *St. Sebastian.*
The dominant diagonals illustrated in the diagram in fig. 10.8 strongly echo the lines R₁ and R₃, in the harmonic armature, indicating a visually pleasing orientation to the picture plane.

CHAPTER 11

Visual Content

Visual Analysis Outline: CHAPTERS 20–23

VOCABULARY

Bracketed Observation: The process discerning a visual element, the element's function and condition.

Background: Spacial plane that appears farthest from the viewer in a visual image.

Closure: The completeness of sense information in the perception of objects and environment.

Conceptual Depth: The layering of ideas in the vessel of visual form.

Contextual Association: The relating of a work's contextual information to its visual information.

Contextual Information: Visual or nonvisual information associated with a work that is not part of its form.

Element Condition: The outward appearance of a visual element. The third step in a bracketed observation.

In this chapter, we will further investigate the image as a vehicle for communication. The study of pictures and their meaning can be an area of great complexity, the subject matter of *Aesthetics* (philosophy of beauty), *Semiotics* (study of signs and symbols), *Hermeneutics* (methodological interpretation), all of which are well beyond the scope of this book. In our study of *visual content*, we will take a simple, systematic approach to the subject—starting with two basic levels of image perception, the *primary* and *secondary* levels; two types of image data, *visual information and contextual information;* and three categories of content, *formal, symbolic,* and *narrative.*

The **Primary Level of Perception** (what is it?; figs 11.1 and 11.2) is one's initial look at the image. Do we, the viewer, see a *unified* whole? Our *Gestalt* perceives the world as consisting of whole entities; a collection of fragmented pieces will generally not warrant one's viewing time or attention. Provided that an image is *unified,* the next consideration is the harmonic arrangement of its parts. Is there a sufficient mix of *variety* in the design to hold the viewer's attention? In either situation, that of an un-unified or

11.1

11.2

Figures 11.1 and 11.2 *George Washington,* Gilbert Stuart (on left); *One Who Understands,* Paul Klee (on right).
In Stuart's painting, the artist's formal exploration has been put at the service of rendering a likeness of the body and spirit of the sitter, and contributing to the nation's historical record with a portrait of its first president. Paul Klee's visual speculation of a highly *abstracted* human head uses visual form for a different end. The artist is expressing the *visual content* of this painting through the interplay of *color, line,* and *shape;* its meaning is felt by the viewer through looking and not easily reduced to prose.

over-unified image, one will not go beyond the first level of encounter—all of this happening in a few seconds, and without conscious analysis.

The **Secondary Level of Perception** (what does it mean?) is a sustained visual examination of the image to discern its *visual content*, either *formal, symbolic, narrative* singularly or in combination (fig. 11.3). In this level of perception, the viewer's *Gestalt* will be busy with the process of understanding image content. A well-informed *Gestalt*, both visually and conceptually, will have more memorable references to associate with the visual forms under consideration, and will be able to read images where the visual and conceptual cues are subtle. Our *Gestalt* is concerned with understanding the

Figure 11.3 *Rich Man, from the Dance of Death,* after Holbein; Etcher: Wenceslaus Hollar, Hollar's *symbolically* rich intaglio print depicts a rich man wearing a fur-collared coat (wealth), ignoring a beggar (poverty), concerned only with his business affairs. Riding on his shoulder is a winged demon (avarice), while death, in the form of a human skeleton, holds up an hourglass (time) in an effort to reform the rich man.

Element Function: The purpose (being) of a visual element. The first step in a bracketed observation.

Foreground: Spacial plane that appears closest to the viewer in a visual image.

Form: An abstract quality or property expressed in matter.

Formal Content: Information that relies on the visual nature of the unit forms and their interaction.

Gestalt: The whole is different than the sum of its parts.

Gestalt Function: The faculty that organizes objects into wholes and promotes understanding of sense information.

Mid Ground: The spacial plane that is beyond the foreground and before the background.

Narrative Content: Image that tells a story. This may include commercial imagery.

Primary Level of Perception: One's initial look at an image.

Secondary Level of Perception: A sustained visual examination of an image to discern its visual content, either formal, symbolic, narrative singularly or in combination.

Spacial Planes: Fields of varying depth in the illusion of three-dimensional space.

Symbolic Content: Visual unit forms represent something beyond their appearance, that is, a dove represents peace.

Visual Content: The message communicated by a visual image. It may be formal, symbolic, narrative, or a combination of the three.

Visual Information: The image one sees and its constituent forms.

Variety: Difference; design elements that provide relief from sameness in visual images.

Unity/Harmony: The agreement between the visual unit forms that comprise a visual image. Unity/harmony creates a visual whole or oneness.

Figure 11.4 *Hands Graphic.*
Two hands coming together to make a heart is easily recognized as a *symbol* for love and marriage. The message is quickly delivered to the viewer, relying on highly contrasting *figure/ground* relationships to organize the *shapes,* not requiring more than a couple of seconds to deliver its message.

conceptual *unity* of an image as well as its visual *unity,* answering the questions *what is it?* and *what does it mean?* The *mystery genre,* in literature, illustrates the importance of conceptual *closure* (degrees of completeness). The best examples contain the right number and kind of clues, withholding just enough information to encourage the reader's *Gestalt* in solving the problem, to make the story a compelling read.

In a single two-dimensional *picture plane,* the viewer is able to simultaneously see all the design elements from a single vantage point. The three-dimensional work requires multiple points of view (360°) through the rotation of the work, or a walk around it. Even though all the two-dimensional work's elements are on immediate view, not all images release their *seen form* to the viewer's perception at the same rate. **Visual Depth** is the levels of formal information contained in the arrangement of a composition's visual parts. Images of great *visual depth* reward extended viewing time; The longer one looks, the more there is to see (figs. 11.4 and 11.5).

Discerning an image's *visual content* may require exploring different levels of conceptual information hidden in its visual form, its **Conceptual Depth.** Images will vary

Figure 11.5 *Floating World,* Gretchen Heinze Moyer.
The *Floating World* is an image that exemplifies *visual depth*. At first glance, the viewer is engaged by six fish randomly swimming in water. The fish are translucent and the dominant elements on the page. With further inspection, the viewer begins to notice the four human figures across the bottom that appear to be swimming or floating. The figures are smaller than the fish and are painted in a similar hue (yellowish brown) and similar value that move them to mid ground. The figure on the far left is smaller than the other figures and is in a fetal position and appears to be in a womblike structure. There is a much smaller red figure that is cropped off the bottom of the picture plane. It is a closer in value to the background to move it further back in the composition. The figures are subordinate to the fish and require the viewer to spend more time to notice them. Looking further, there is a red checkerboard pattern that appears in the top half and a green triangular object with red highlights in the lower-right quadrant. This pastel painting has visual depth that requires the viewer to spend a considerable amount of time viewing and thinking about the elements being observed. The message that is being communicated requires extended viewing in order to unlock its *symbolic* and *narrative* content.

widely in their layering of *narrative* and *symbolic* content. Works by artists exploring subtle narrative and symbolic messages will benefit from repeated and extended viewing. Much of the work in Graphic Design is calculated to convey its information to the viewer very rapidly. Billboards, posters, T-shirts, digital and magazine ads, and the like are allotted very short viewing time and do not benefit from contemplation.

Reading an image's *visual content* requires the examination of **Visual Information,** forms that make an *image* and their arrangement, and **Contextual Information,** information associated with a work that is not part of its visual form and may be visual or non visual. An image's title; historical, cultural, religious, political, sociological environment; architectural situation; whether it appears in buildings or books are all examples of *contextual information.* **Contextual Association** is the relationship of contextual information to the *visual information* comprising an image (fig. 11.6). The *visual information* should play the primary role in the association of two types of information as it provides the vessel for content that may not be readily discernible to

Figure 11.6 *The Penitent Magdalen,* Georges de La Tour.

La Tour's painting illustrates the correlation of *visual* and *contextual information.* At the *primary level of perception,* this well-composed, formally intriguing image warrants an extended examination. He presents the viewer with a woman sitting in a chair, holding a skull, as she peers into a flaming candle that sits in front of a mirror. Through a *bracketed observation,* one may glean some *narrative* and *symbolic* content. The young woman sitting alone in a darkened room is involved in the contemplation of some serious issues, as indicated by the skull sitting in her lap. *The contextual information* provides the viewer with an informed environment in which to see the work. One learns the identity of the woman (Mary Magdalen) and her *narrative* action (penitent reflection) from the painting's title. The further exploration of the events of her life reveals her dissolute past and virtuous future. Its association with the image provides for a deeper understanding of the *narrative* and *symbolic* elements.

the viewer; this is much like the process of unlocking the visual forms *(shapes)* that comprise a representational object. Through our study of *Gestalt,* we have observed the synergistic effects produced by the parts to make a whole (image), with the whole image not being reducible to the sum of its parts. The correlation of *visual* and *contextual information* provides an opportunity for a synergy of visual meaning.

Visual information contained in a *representational* image may be **bracketed** in the process of observation by naming the visual *element,* identifying the *element function* (of the object), to include any and all visual aspects of the image, such as landscape, architecture, time of day, lighting, weather, and so on and then describing the *element condition,* that is, a candle *(element)* is for producing light, dispelling darkness *(element function),* this particular candle has been rendered, through burning, to a wax stub, and will soon provide no light *(element condition)* (fig. 11.6).

In *The Approaching Thunderstrom,* by Martin Johnson Heade (fig. 11.7), one would start by identifying the most prominent *element,* a landscape with a view of an inlet and distant mountains. Then one would describe the *element's function,* that is that the foreground inlet is a home to aquatic life and a place of recreation, fishing, boating, and the like. The *element's condition* is quite dramatic with a stark contrast of *value* between the *foreground/mid ground* and the *background.*

The importance of *contextual association* to the *visual content* of a work depends on the particular picture under consideration. Some image titles, especially for highly abstract works, are responsible for providing the *narrative* and *symbolic* dimensions of

Figure 11.7 *Approaching Thunderstorm,* Martin Johnson Heade.
The *bracketed observation* begins with the identification of the visual *elements* in the work, starting with the most prominent, (in this case, the environment) and proceeding to the image's smaller elements.

a composition (fig. 11.8). Artists may at times deliberately leave their work *untitled* in order to free it from *narrative* or *symbolic* associations (fig. 11.9).

Formal Content, the visual parts of an image and their arrangement, is the gateway to *visual content.* All *visual images* are *formal* and rely on the *abstract* properties of the design elements and their interaction for its expression, whether they are *representational* or *non-representational* or exist to serve *symbolic* and/or *narrative* expression. Images that are the fruit of purely visual speculation are analogous to instrumental music, relying solely on the aesthetic response of the viewer to make an impression. Their pictorial concepts are not readily translated into prose.

Symbolic Content transcends the forms of their expression. *Symbols* represent something beyond their appearance. The conceptual abstraction of visual forms through *bracketed observation* and their *contextual association* are methods for discerning *symbolic* elements of an artwork. *Symbols* may augment *formal* and *narrative* content, giving it additional meaning and depth. *Symbolic* works may also function as signs of commercial enterprises, being readable in an instant, imparting in the memory of the viewer a particular business brand, sports team, and so on.

Narrative Content consists of a visual work's storytelling elements (fig. 11.10). A story is a sequence of related events that, in its most common form, proceed in a linear order. Literature, cinema, theater, and music are art forms structured for the linear sequencing of their formal elements. *Visual images,* with the exception of comic strips, comic books, and visual novels, are static images where all the elements are seen, but maybe not perceived, at once. The exception consists of multiple *narrative*

a b

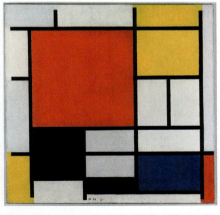

Figure 11.9 *Composition in Red, Yellow, Blue, and Black* by Piet Mondrian.
Mondrian's painting is a visual exploration of color and *proportion* in *rectilinear shapes,* an example of *formal content.* He consciously avoids any *symbolic* or *narrative* associations through a formal title.

Figure 11.8a and 11.8b *Geometric Composition No. 1* (a, on left); *The Birth of Athenae from the Head of Zeus,* (b, on right).
Image *(a)* is a *non-representational* composition of geometric forms that explores the interaction and repetition of *rectilinear* and *curvilinear shapes.* Images *(a)* and *(b)* are identical in their visual information though their *contextual information* is quite different. Image *(a)* is a work that expresses a formal message, having no particular *narrative* or *symbolic content.* Image *(b)* is transformed by its title *(contextual information)* into a highly abstracted *narrative/ symbolic* work. The large, primarily *rectilinear* (male) form represents the Greek god Zeus; his *curvilinear* head spawns smaller circles (female forms) representing the goddess Athenae. The title has provided the viewer with the proper context to bring *narrative closure* to the image.

sequences being placed within a single picture plane, a popular narrative device in European painting in the 14th through 17th centuries (fig. 11.11). The various sequences are housed in different *spacial planes;* the present action is in the *foreground,* past actions in the *mid ground* and *background.*

Figure 11.10 *The Fall of Richmond, Virginia, on the Night of April 2nd, 1865,* Currier and Ives. This 19th-century chromolithograph is a *historical narrative,* depicting Confederate soldiers setting fire to the warehouses and bridges as they evacuated Richmond, toward the end of the American Civil War. This dramatic image highlights the spectacular nature of the event.

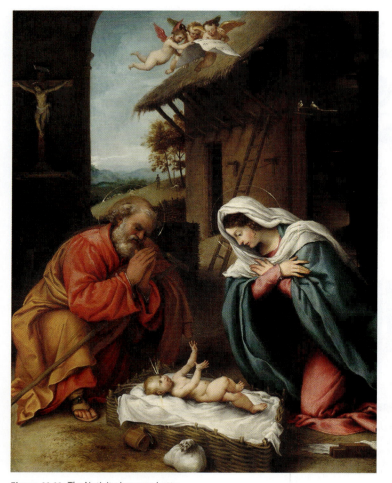

Figure 11.11 *The Nativity,* Lorenzo Lotto. This painting depicts both the birth of Christ, present action, *(foreground),* and the crucifixion of Christ, future action (upper-left quadrant, *mid ground*), Lotto separates the time-related sequences by placing them in different spacial planes.

Imaging a story's single sequence is the most common form of *narrative content*. If the viewer is unfamiliar with the *narrative,* whether literary, religious, historical, or of the artist's invention (figs. 11.12 and 11.13), he or she will be tasked with excavating the image's *visual content.* Viewers well familiar with the story an image portrays may have to negotiate with the artist's particular visual interpretation of the subject matter (figs. 11.14 and 11.15). Commercial narratives take many different forms, though attractive people participating in enjoyable pastimes in the company of a particular product is one of the more common storylines.

Figure 11.12 *Aesthetics of Fundraising,* Ed Wong-Ligda.
This painting by Wong-Ligda is chock-full of narrative action and is telling its story through a series of overlapping events, not necessarily happening simultaneously. The story is not one that would be commonly known or easily researched by the viewer, as it is of the artist's invention. This is not to say that the painting is inaccessible to the viewer. The process of a *bracketed observation* and *contextual association* could reveal much of the image's visual content as an image's *visual content* is not limited to the artist's *narrative* intentions.

Figure 11.13 *The Steps to the Steps,* Brad Holland.
Holland's invented *narrative* poignantly visualizes a paradox. The image presents the viewer with a sense of mystery and transcendence without obscuring the illustration's *visual content.*
© Brad Holland

11.14 11.15

Figures 11.14 and 11.15 *David with the Head of Goliath,* Pietro Novelli (on left), *David with the Head of Goliath,* Guido Cagnacci (on right).

The two paintings above share the title *David with the Head of Goliath.* Both works feature a young man next to the severed head of, judging from its size, a large and powerful man. Each of the images is a religious/historical *narrative* relating aspects of the future king of Israel, King David's, killing of the giant Philistine warrior Goliath in single combat. The images, for all their *similarities,* are quite different in their *narrative content,* as each artist has emphasized a different facet of the story. Novelli, in in the painting on the left, has chosen to portray David's rise to prominence from a young shepherd to military hero, and his reliance on God's providence, he being the most unlikely candidate to achieve such a feat. Cagnacci, in the image on the right, has painted David in fine military attire, looking forward to his eventual rise to be king of a united Israel, and the progenitor of a royal lineage.

The images above illustrate the importance of the relationship between the *visual* and *contextual information.* The artist is the interpreter and, particularly since the 18th century, the author of the *visual content,* not all of which is seated firmly in the artist's consciousness. In the rendering of an image, a nuanced *visual content* can be infused into an image through the inflection of the painter's hand. The stroke of the brush, pen, or chisel in the making of a work is like the tone of one's voice to the spoken word. In reading a visual image for *narrative* and/or *symbolic content, visual information* should never be lost from view. The *contextual information* is important and should serve to enhance the image in the same way salt and spice enhance the flavors of food.

Visual Content *continued*

Figure 11.16 *You See We Are Blind,* Odd Nerdrum.

Odd Nerdrum presents the viewer with an enigmatic *narrative* in his painting of three blind women sitting on a mountaintop. The image is in *near-symmetrical* balance, with the central figure placed on and tangent to the *axis of symmetry.* The *symmetrically* placed women are seated on a stone and are slightly oblique to the format of the *picture plane,* lending visual tension to their formal arrangement. The horizon line in the *background* conforms to the curvature of the earth, indicating that the figures are seated at a very high altitude. The sky and clouds are washed in warm reddish hues; it is either sunrise or sunset. The women are dressed in what appears to be medieval-like clothing that is shear and only partially covers the center and left figures. Each of the sitters has a very thin stick to aid her in her darkened navigation. The thinness of the sticks enables the women to relay more information about the density of the objects they strike. The woman on the left is pointing in the direction of the light source and speaking to her companion seated next to her.

These elements have *symbolic* and *narrative* associations. Mountaintops traditionally are places of mystical encounter. The reddish sky and clouds are portents of the next day's weather (red sky in the morning, etc.), good and bad. Divining rods, also known as witching rods, bear a strong resemblance to the women's crossed guide sticks. The figure seated on the left is pointing to something visual, the light in the clouds. Implicit in the image's title is a challenge to the viewer. We see our physical surroundings; these women in their blindness see beyond it.

The Visual Literacy Analysis Outline

Still Life with Flowers & Fruit,
Henri Fantin-Latour

CONTENTS

Part I of the text contains basic vocabulary, form, and content theory in conjunction with visual examples. This is designed to inform and act as a catalyst for classroom discussion and further exploration of the material.

The **Visual Analysis Outline** is the vehicle for the application of the information in Part I to a visual image. The chapters in Part II give detailed instructions for completion of each section in the outline.

A list of artists and artworks is provided in the Appendix, but they are just suggestions. If one is composing his or her own list, it will be important to follow a few guidelines. The initial images should be *rich in realistic objects.* The purpose of the first section of the Visual Analysis Outline is the development of **Abstracting Vision,** the ability to see recognizable objects as a collection of shapes, or visual forms apart from what the objects are, that is, a drinking glass, a bunch grapes, and so on. Abstract artworks will provide no challenge as the forms have already been reduced to their essential shapes. One should choose examples that lend themselves to the sections of the *Analysis Outline* under consideration.

There is a suggested schedule for working with the *Analysis Outline* in the Appendix. Pacing will depend on the number of class hours per week. A class that meets twice a week for a total of five hours would complete one analysis per week in the beginning of a school term and one every week and a half as the students progress deeper into the *Outline.*

The first analysis consists of Section 1 of the *Outline*: *Shape Type and Distribution.* A new artwork is selected for the second analysis, which would include Section 1, and Section 2, *Gestalt.* With each week, a new image is chosen and another section from the *Outline* is added to the *Analysis.* Upon completion of the *Analysis,* students should present their work to the class, opening their findings up to discussion. The emphasis should be on the students' informed process of reaching their conclusions.

The *Analysis* is a process of observation and critical reflection of a visual image informed by the theory learned in Part I of the text. Students are expected to use a gridded composition book known as the *rough book,* in which they will hand-write their class notes, in-class analysis, and the preliminary versions of their assigned analysis. Printed images of the artwork under consideration are to be rubber-cemented into the rough books (consult the Artists' Resources section in the Appendix), along with the appropriate acetate flaps (see the *Analysis Outline).* The flaps are to be cut the same size as the rubber cemented image and attached over the picture clear tape hinge (fig. 12.1). Multiple acetate flaps (max. 4) are to be hinged from different sides of the image, allowing one to view it through any one of the flaps. The flaps aid students in discerning formal relationships within the artworks they are examining.

The final version of the *Analysis* is written in ink on 1/8-inch grid paper, to include a printed image of the artwork under consideration with acetate flaps (see the Appendix for layout instructions). It is only necessary to rubber cement the image to the first page of the analysis. All of the following pages can be viewed beside the first page. The finished *Analysis* along with photo duplicates of the preliminary rough book work are submitted in plastic sleeves for evaluation. Upon return, they are kept in a three-ring binder that should also contain all the semester's course handouts (fig. 12.2). The binders are collected and reviewed by the instructor at the close of the semester and will serve as a resource for students as they continue their studies.

The handwritten page contains:

Ashley Tate — *Very Good*
Pennsylvania College of Technology
PENNSTATE

Subject: The Penitent Magdalene
By: G. La Tur
Date: 4/3
Sheet 1 of 10 sheets

This painting is (1) representational with the majority of shapes being curvilinear.

ULQ
curvilinear
- woman's hair
- highlight on hair
- contour of face (2)
- neck & chest contour
- shoulders (2)
- shadow on arm (sleeve)
- folds in dress (12)
- sleeve of dress
- red part of dress
- woman's arm
- shadow on arm
- shadow behind woman
- shadow on chest
rectilinear
- border around edge of picture plane
- shadow behind face on wall

LLQ
curvilinear
- sleeve of woman
- shadows on sleeve
- contour of dress
- shadow on wall
- bottom edge of shadow

rectilinear
- none

URQ
curvilinear
- fingers (6)
- hand
- skull
- eye socket
- shadow on skull
- highlight on skull
- decorative texture on mirror (8)
- flame (2)
- dark center of flame (2)
- candle (2)
- candle holder
- shadow on candle holder

Figure 12.1 *Visual Analysis Page*.
The single *analysis* page is shown with one flap open. The page is handwritten in pen and permanent markers are used for the acetate flaps.

Figure 12.2 Visual Analysis pages in a three-ring binder.
The three-ring binder (above) is open, showing two completed *analyses*. The analyses are put into plastic sleeves, and the binder will become a resource for future design classes.

Visual Analysis Outline

ULQ Upper-Left Quadrant	**URQ** Upper-Right Quadrant
LLQ Lower-Left Quadrant	**LRQ** Lower-Right Quadrant

Analyze the design by sections in the order they appear on this sheet. Detailed procedural instructions for completion of the analysis appear in Chapters 13–22 and are listed in the *Outline* section heads below.

Acetate Flaps:

Flap 1: Shape Type and Distribution
- Shapes Traced in Green
- Central Axis in Blue (horizontal balance)

Flap 2: Geometry
- Rebatment in Red

Flap 3: Geometry
- Harmonic Armature in Blue

Flap 4: Compositional Dynamics
- Dominant Dynamic Green
- Subdominant Dynamic Red
- Subordinant Dynamic Blue
- Write the number 1 on the flap next to the lines that are dominant, number 2 on lines that are subdominant, and 3 next to the subordinate lines.

1. Shape Type and Distribution: CHAPTERS 2, 13

Acetate Flap 1
- **Representational** or **Non-Representational,** the whole design
- Dominant Design Shape (**Curvilinear** or **Rectilinear**), the whole design

Inventory Shapes by Quadrant
- Use the heading **Rectilinear** or **Curvilinear**.

2. Gestalt: CHAPTERS 3, 14

Identify the dominant elements in the categories listed below; be specific in your observations.
- **Proximity:** Dominant Groups and Subgroups
- **Continuation:** Real and Suggested Lines
- **Closure:** Lost and Found Edges
- **Similarity:** Dominant Color/Value, Scale, Shape

3. Balance: CHAPTERS 6, 15
- **Symmetry**
- **Near-Symmetry**
- **Asymmetry** (Pound of Feathers = Pound of Lead)

4. Focal and Accent Points: CHAPTERS 7, 16
- Name Dominant Contrasts for Each Area of Emphasis
- Focal and Accent Points, Integration
- Triangulation

5. Geometry: CHAPTERS 8, 9, 17, FLAPS 2, 3

Proportion Ratio of Picture Plane
Golden Section
Root Rectangles
Rebatment Lines/ Focal and Accent Points, Containers
Harmonic Armature: Eyes of the Rectangle, Echo Lines

6. Compositional Dynamics: CHAPTERS 10, 18, FLAP 4

The distribution of horizontals, verticals and diagonals and their importance to the composition. Reference your observations in the Gestalt section, specifically continuation, making mention of real and suggested lines to aid you in your analysis; also refer to the echo lines of the harmonic armature. If you have identified triangulation, that dynamic should be mentioned again as part of this section. Make reference to the dynamic hierarchy when determining the order of importance (diagonals are strongest, etc.). Look for parallel dynamics in each category.

1. Dominant dynamic: dynamic of highest contrast
2. Subdominant dynamic: dynamic of next highest contrast
3. Subordinate dynamic: dynamic of lowest contrast

7. Unity & Variety: CHAPTERS 2–18

This section is a summation and synthesis of Part I.
Unity: Using your observations from the previous sections, explain how the design elements work together to form a unified whole. Include specific examples, in particular, from the following categories:

- **Balance**
- **Repetition: Integration, Rhythm (if relevant)**
- **Compositional Dynamics**
- **Gestalt/Similarity**

Variety: Making reference to your observations in the previous sections, explain the visual element's contribution to variety. Refer to the list above. Similarity contributes to both unity and variety. In this section, call attention to the difference in repeating similar elements.

Balance of Unity and Variety: Write a paragraph explaining your thoughts as to whether the image is strong in unity, strong in variety, or somewhere between the two.

8. Bracketed Observation: CHAPTERS 11, 20

Make a list of what you see, including objects, human figures, animals, the environment, and so on. Identify the *element* (what it is), its *function* (what it is for), and describe its *condition* (what it looks like).

- **A.** A candle *(element)* gives light by a burning flame *(element function)*; the candle has burned to a stub and is caked with wax drippings *(element condition)*.
- **B.** The central human figure is a male *(element)* shepherding sheep *(function)*. He is an adolescent of slight build dressed in coarse woolen shepherd's clothing, which is an observed characteristic of the figure *(element condition)*.

9. Contextual Information: CHAPTERS 11, 21

Research the title of the work and any other information that might be relevant; that is, a particular historical, religious event, literary narrative. In the rough book, cite your research sources, write a brief synopsis of your findings, and list the three most important pieces of information.

10. Contextual Association: CHAPTERS 11, 22

Review each item in the *bracketed observation* pages of the rough book in light of the *contextual information*. Record your thoughts regarding the *symbolic* and *narrative* content of visual elements under review, placing them in the appropriate column.

11. Visual Content Summary: CHAPTERS 11–22

This section is a summation and synthesis of your observations and research. Write a paragraph for each of the content categories *(narrative, symbolic, formal)* in descending order of importance: the *dominant category,* (most representative), *subdominant category* (second most representative), *subordinate category* (least representative). Identify the category or categories that best describe this image. Be sure to explain the reasons for your classifications for each category, making sure to refer to your observations.

Narrative Content:

a. What is the storyline of the image?
b. Identify the story's key visual elements.
c. How does the image express the storyline (by highlighting one of the story's characters, sequences, etc.)?
d. How has the artist interpreted the story, that is, visually emphasizing a particular aspect or point of view?

Symbolic Content:

Consider the three most important elements:

a. Identify the *symbolic* elements.
b. Explain the *symbolism* of the elements.
c. How do the *symbolic* elements relate to the *narrative* content?

Formal Content:

a. Consider the three most important elements from Section 7 of the Analysis Outline (the Unity, Variety, and Balance paragraphs)
b. Do the image's *formal* components contribute to its *symbolic* or *narrative content?*
c. Explain the relationship between the *formal, symbolic,* and *narrative content.*

CHAPTER 13

Shape Type and Distribution, Section 1

Chapter Reference: CHAPTERS 1 and 2

Objectives: Inventory and classify shape types, identify predominant shape type in the image, classify as representational or non-representational.

VOCABULARY

Abstracting Vision: The ability to see the formal qualities of visual elements. Visual elements recognizable as an assemblage of shapes, color, texture, and so on.

Axis of Symmetry: A vertical or horizontal line dividing the picture plane into two equal portions.

Curvilinear Shapes: Shapes made up of rounded flowing edges.

Forest: An analogical term meaning a broad or general view of a visual image.

Non-Representational Shape: A shape that does not replicate or refer to an object in the real world.

Picture Plane: The area to be designed. The picture plane can be paper, canvas or other materials.

Rectilinear Shapes: Shapes made up of straight edges.

Representational Shape: A shape that replicates or refers to an object in the real world.

Shape: A clearly defined area that one can see. It may be defined by a line or a change in value or color.

Trees: An analogical term meaning a close detailed inspection of of a visual image.

The Shape Type and Distribution section is of key importance in developing one's powers of observation, or *abstracting vision.* Pick an image to analyze that is rich in a variety of realistic forms (refer to the Artists' Resources section in the Appendix). The *analysis* of a visual image will require two complementary types of observation: the *overview* or big picture, and a detailed, *close examination* of its visual parts. It may be helpful to refer to these two methods of observation using the analogous terms **Forest** for the overview or broad view and **Trees** for the close examination. Both these types of looking will be required in this section.

Starting with the broad view or **Forest,** determine whether the most prominent shapes are *curvilinear* or *rectilinear,* or whether neither predominates. One will then determine the image's *representational* or *non-representational* qualities. A detailed listing of forms by their shape classification as *rectilinear* or *curvilinear,* or a cataloging of the **Trees,** follows.

In order to maintain a close focus, the *shape* classification inventory must be systematic in its execution. The *picture plane* is divided into four equal parts or quadrants. Classification should proceed from the upper-left to lower-right part of each quadrant. It is very important to observe and classify every shape seen, including the smaller parts of large shapes. Every portion of the picture plane that has a defined edge qualifies as a *shape,* so be sure to classify light and shadows where applicable.

The process of *analysis* starts in the *rough book* (fig. 13.1) and should be revised and *polished* before the final version is copied in black ink on 1/8-inch grid paper. The first assignment consists of *analysis:* Section 1, *Shape Type and Distribution.* A new section on the *Analysis Outline* is added to each successive assignment (see the schedule in the Appendix for sequencing).

a

Shape Type and Distribution
Dominant shape is objective and curvalinear.

ULQ
Curvalinear shapes
- top portion of handle on pot ✓
- hook of spoon (handle) ✓
- bone at top of meat ✓
- meat ✓
- marbling on meat ✓

URQ
Curvalinear shapes
- rim of pottery ✓
- neck of pottery ✓
- handle of pottery ✓
- rim on bottle ✓

LRQ
Curvalinear shapes
- bowl on upper left side ✓
- body base of pottery ✓
- bottle laying on its side ✓
- rim of bottle laying on its side ✓
- ribbon tied to bottle laying on its side ✓
- neck of bottle on right ✓
- base bottle on right ✓
- seven round objects ✓
- spoon ✓
- bowl behind the spoon ✓
Rectilinear shapes
- edges of table

LLQ
Curvalinear shapes
- rim of bowl on right side
- bowl on right side → • pot on its side
- rim of pot on its side ✓
- inside of pot on its side ✓
- handle of pot on its side ✓
- shadow of pot on its side ✓
- bone beside pot
- meat on end of bone
- small pottery on left side ✓
- knob on pottery
- lid on pottery ✓ • details on pottery ✓

Unity

Proximity
All items are close together
which creates on group. You
can also group some of
the items together making
subgroups The subgroups
in this photo are:
- bone and pottery
- pot, meat, spoon, +
 bowl
- bowl in back, pottery and
 two bottles
- 8 round objects

Similarity
- small pottery, bone, and
 table are similar in color
- pot, meat, bowl, and round
 objects similar in color
- pottery, two bottles, bowl
 similar in color
Rectilinear shapes
- edges of table
- neck of spoon

- pot, 2 bowls, 2 pottery,
 2 bottles have similar
 shape

Continuation
- edge of table
- spoon and round obj.

b

Focal and Accent Points:

Contrast: (3rd)

- value between bowl and background
- value between moth and background
- value between bowl and bottom of glass
- contrast texture between raspberries and leaves
- color and value between raspberries
- value between glass and, table and background

Triangulation: (4th)
- I see triangulation starting at the raspberry peice
farthest left, up to the white moth, then to
the bottom of the glass/leaf, and then back
to the small raspberry piece on the far left.

Focal Point: (1st)

The focal point of Beert's "The Younger Still Life with
Wild Raspberries, Oil on Panel" is the large bowl
of raspberries, leaves and moth. I made this
conclusion because I noticed it was the largest in
size, placed directly in the middle, lightest in value
(bowl) and last because two of the
leaves fall on the rabatement line.

Accent Points: (2nd)

- The moth is an accent point because of its value
- The glass is an accent point because of its size
- The three leaves and sticks on the left are
an accent point because of proximity

Overall Statement:

After analysing contrast, triangulation and the
focal and accent points, I was able to conclude
that the focal point is integrated into the
rest of the picture through the similarity in
raspberry peices, dark and light values and curvilinear
shapes.

Repetition:
- red raspberries (47)
- green leaves (7)
- Curvilinear shape in raspberries, leaves, glass, bowl
 shadows, raspberry peices, moth, veins, sticks
- yellow in table and leaves and sticks
- brown sticks
- Viens in leaves
- lines in glass
- curvilinear shapes in glass

Overall Statement for repetition:

After careful analysis of the repetition of shape, texture,
placement, values, color and size I was able to
determine that the main repetition used for
integration is the curvilinear shapes seen in the
raspberries, bowl, moth, glass, leaves, sticks and
veins and shadows.

Unity and Variety:

Now that I have analyzed many aspects of the
painting "The Younger Still Life with Wild Raspberries,
Oil on Panel" by Osias Beert I know that
the main unifier is the repetition of curvilinear
shapes such as the raspberries, leaves, moth, shadows
and viens on the leaves. Another important unifier
in this painting is the light value in the bowl,
moth, raspberries and glass.

Variety: One of the main source of variety
in this painting is the glass composed of many
rectilinear line. It is one of the only
shapes composed of rectilinear lines besides
the table edge.

Repetition:

Rhythm:
There is an alternating rhythm and + can be seen in the
in this painting and + can be seen through
repetition of shapes and color in the white bowl.
the raspberries in the bowl.

Figure 13.1a and 13.1b Student Rough Book.
The three *rough book pages* (above) show a *visual analysis* in process. A printed copy of the image to be examined is rubber-cemented into a grided composition book; acetate flaps are then affixed over the image with hinges of clear tape. Each of the four flaps should be hinged from a different edge. Additions and revisions are made to the analysis before the final version is carefully written in black ink on 1/8-inch grid paper.

a

b

c

Figure 13.2a–c Analysis Acetate Flap.
The top image shows the flap covering the picture, and the picture plane divided into four quadrants using blue marker. The middle image shows the process of tracing the contours of all the shapes in the composition. The bottom image shows the finished tracing without the picture.

The Process

1. The analysis process starts in the rough book and proceeds to the final version, which is written on 1/8-inch grid paper.

2. Pick an image from the Artists' Resources section in the Appendix, and print two copies of the image to be analyzed. The picture should fit into the top third of the rough book page. Rubber-cement the image, one per spread, onto the page (see the Appendix. Note: It is only necessary to rubber cement the image to the first page of the final analysis. All of the following pages can be viewed beside the first page.)

3. Cut a piece of acetate the same size as the image. Hinge the acetate flap over the image with a piece of clear tape.

4. Determine whether the image is *representational* or *non-representational*.

5. Dominant shape classification: Observing the entire image or view of the **Forest,** decide whether the dominant shape is curvilinear or rectilinear, if one is predominant.

6. In a blue fine-tipped marker, draw a vertical and then a horizontal line on the acetate flap dividing the picture plane into four equal parts. Use a straight edge to ensure the accuracy of the vertical and horizontal axes (fig. 13.2).

7. Label the four parts of the picture plane as upper-right quadrant (URQ), lower-left quadrant (LLQ), and so on.

8. In a green extra-fine-tipped permanent marker, trace every edge of every shape in the quadrants, to include the interior as well as exterior edges (fig. 13.2).

9. Catalog the shapes by quadrant, classifying them as *rectilinear* or *curvilinear.* When there are a number of repeating identical *shapes,* as in a bunch of grapes, count the number of *shapes* and place the number in parentheses next to the named shape. Placing a sheet of blank white paper underneath the acetate flap will help to see the shapes.

10. Review your work and make any necessary corrections, additions, or deletions.

11. On a clean sheet of 1/8-inch grid paper, glue the second image and hinge a new acetate flap using clear tape. Using black ink, carefully copy your polished *rough book* work onto the grid paper (see completed Visual Analysis).

Completed *Shape Type and Distribution, Section 1* of the *Analysis Outline*

Still Life with a Skull and a Writing Quill, by Pieter Claesz

This painting is representational.

Most of the shapes are curvilinear.

ULQ

Curvilinear
- Bowl of candle stick holder (oval)
- Shadow in bowl (arc)
- Handle of candlestick holder (arc)
- Inside shape of handle (arc)
- Top half of stem of candle stick holder
- Part of the forehead of skull
- Eye socket of skull
- Top half of nasal cavity

Rectilinear
None

LLQ

Curvilinear
- Quill case
- Leather straps for quill case
- Shadow of quill case
- 3/4 of writing quill (arc)
- Shadow in bowl of candle stick holder
- Bottom of stem of candlestick holder
- Small round part of ink container
- Larger oval base of ink container
- Top portion of ink container
- Shadow of ink container
- Teeth of skull (3)
- Bottom half of candle stick holder
- Lip of skull
- Cheek bone of skull

Rectilinear
- Pages of paper (2)
- Book cover
- Shadow of writing quill

URQ

Curvilinear
- Top arc of skull
- Shadow of back of skull (arc)
- Eye socket in skull
- Temple shadow on skull
- Bottom foot of goblet
- Small section of goblet stem

Rectilinear
None

LRQ

Curvilinear
- Stem of goblet
- Detail ovals on goblet (5)
- Bowl of goblet (oval cut in half)
- End of writing quill
- Shadow on book of writing quill
- Small section of goblet foot
- Bottom of eye socket
- Left cheek of skull
- Teeth
- Very small piece of skull (right side)

Rectilinear
- Back cover of book
- Cover of book
- Table edge
- Table edge (top)
- Paper pages (3)
- Highlight on goblet (8)

CHAPTER 14

Gestalt, Section 2

Chapter Reference: CHAPTER 3

Objectives: Identify prominent examples of the four aspects of Gestalt: proximity, similarity, continuation, closure.

VOCABULARY

Alternating Rhythm: The regular, un-changing repetition of a design element.

Closure: The completeness of sense information in the perception of objects and environment.

Continuation: 1. A real line connecting design elements. 2. A suggested line created through the alignment of uncon-nected forms.

Gestalt: The whole is different than the sum of its parts.

Gestalt Function: The faculty that orga-nizes objects into wholes and promotes understanding of sense information.

Integrative Repetition: An unrhythmic recurrence of a design element or portion or aspect of a design element lending commonality to different parts of the picture plane.

Progressive Rhythm: The regular repetition of a design element that changes with each occurrence or iteration.

Proximity: The spacial distance between design elements.

Real Line: A line or edge of a form as it actually exists in a visual image.

Repetition: The recurrence or iteration of a design element in a visual image. Repetition may be rhythmic or non-rythmic.

Rhythm: The repetition of a design element that occurs in a regular, predictable way.

Similarity: Means *like*, but not the same. Design elements that share common aspects of form that are not exactly alike contribute to unity in their likeness and to variety through their difference.

Suggested Line: A line that is implied through our Gestalt's sense of continua-tion. These lines are created through the alignment of forms or their edges, or by the gaze of human or animal forms within an image. We tend to look where people are looking and to a somewhat lesser extent where animals are looking.

Texture: A visually complex, detailed surface imparting a tactile feel to the viewer.

continued on page 76

In this section of the analysis, we are going to examine the composition to find examples of the four aspects of *Gestalt: proximity, continuation, closure,* and *similarity.* Starting with the broad view or *forest view* we will determine the most prominent examples of each.

Proximity is the spacial distance between design elements. Our *Gestalt* organizes design elements into groups as a way of establishing visual order in its perception of an image. The closer the design elements are to one another, the more easily they are perceived as a group. Groups of design elements can be divided into sub groups when elements within the group are in close *proximity* or of *similar* form. Determine first if there are any groups of design elements in close *proximity,* then whether there are any subgroups of unit forms. It is important to remember that design elements may overlap without being close together in space. One must take into consideration the illusion of three-dimensional, or *deep space.*

Continuation is a *real line* connecting design elements, or a *suggested line* created through the alignment of unconnected forms. *Real* and *suggested lines* may be repeated throughout a composition to create rhythms that carry a viewer's gaze through an image, or suggest a visual pathway through a composition. In this section, we are going to identify the most important or dominant *real* and *suggested lines.*

Closure is the completeness of what we see. Our *Gestalt* is in the habit of making up for incomplete visual information by filling in what is missing. How much visual infor-mation your *Gestalt* is able to supply depends on how well informed it is. The study of design will inform our *Gestalt,* increasing its ability to supply missing information to a visual image. Our *Gestalt* is unable to supply visual information that is unfamiliar to it. In this section, we are looking for parts of the image that disappear from view and require our sense of *closure* to supply missing information. For example, the edges or parts of form that disappear in shadow or haze, rather than parts of forms that go tem-porarily missing through the overlapping of objects.

Similarity means *like* but not the same. Design elements that share common aspects of form but are not exactly alike contribute to *unity* through their partial likeness and to *variety* in their difference. In this section, we are going to take a *forest* point of view, to identify the most important or *dominant,* the next most important or *subdominant,* and the least important or *subordinate* instances of repeated similar forms. Choose from the following five categories of design elements: *shape, color/value, angle (formed by real or suggested lines), scale (include groups), texture.* In considering *shape* and *angle,* refer back to the *Shape Type and Distribution* section of the *analysis* and to the *Continuation* part of this section to aid in your decisions.

Triangulation: A visual pathway from a focal point to accent points of lessening contrast, forming a triangular eye movement.

Variety: Difference; design elements that provide relief from sameness in visual images.

Unity/Harmony: The agreement between the visual unit forms that comprise a visual image. Unity/Harmony creates a visual whole or oneness.

The Process

1. *Proximity:* Look at the entire image, taking an overview *(forest)* of what you see. Determine if there are any large groupings of design units by their *proximity.* Name the major components in the group and their location by quadrants in the picture plane. For example, the skull, wine goblet, book, papers, and feather in the URQ and LLR qaudrants (fig. 14.1).

2. Look within the group or groups to see if there are any elements that distinguish themselves by their *proximity* as subgroups. Name the elements that comprise the subgroups and cite their location by quadrant.

3. *Continuation:* Take another overview of the design to see if there are any *real lines* that run through the picture plane connecting design elements in the composition (they must extend through the height or width of the picture plane). Look for a line or lines that run through the entire width or height of the design (fig. 14.2).

4. Identify the most noticeable *suggested line,* if one exists. Take a clear plastic straight edge and lay it across the edges (or along the forms' major axes) of the aligning forms. Name the forms that align and identify their position in the picture plane by their quadrant. Check for parallel *suggested lines* by moving the straight edge across other aligning elements (fig. 14.3). List only prominent examples.

5. If you have identified diagonal suggested lines, in Step 4, using the same methods, check the composition for diagonal lines that run *counter* to the *suggested lines* that you have identified. Name the forms that align and identify their position in the picture plane by their quadrant. List only prominent examples.

6. *Closure:* Look at the entire image. Identify forms that lose their visual completeness. Edges may disappear into shadows or forms may lose visual clarity in light. Partial loss of form through overlapping objects is not a good example of *closure* (fig. 14.4).

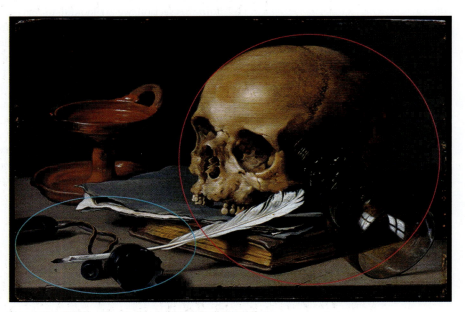

Figure 14.1 *Still Life with a Skull and a Writing Quill,* Pieter Claesz.
There is one large group and two subgroups in the above illustration. All the still life elements are in close *proximity* and form the dominant group. The subdominant group is circled in red (skull, wine goblet, and books), the subordinate in blue (ink bottle, ink bottle top, quill case, and quill).

7. *Similarity:* In this step, identify the three most prominent examples of *similar* (like) repeating elements: *dominant* (most important), *subdominant* (second in importance), *subordinate* (third in importance). The examples will come from the categories of *shape, color/value, angles (parallel), scale (may include groups),* and *texture.* If you find repeating examples of *similar shapes* or *angles,* consult *Shape Type and Distribution,* and the *Continuation* sections of the analysis as an aid in the identification of the repeating forms. Choose only the three *most prominent* types of repetition. *There may be less than three categories of repeating elements.* Remember to base all your decisions on what you see.

8. *Dominant Similar Element:* identify the most striking example of a repeating element by category *(shape, color, etc.)* (fig. 14.5). Name the element and its location by quadrant, then the most important repeating examples of the element and its location in the picture plane. Say how the element changes in its repetition, for example, *the repeating curvilinear forms are circular and oval in their shape and vary in size.*

9. *Subdominant, Subordinate:* Continue the process using the same methods as in Step 8.

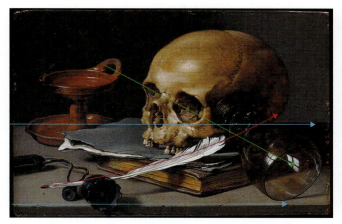

Figure 14.2 This illustration shows four examples of *continuation.* The first two are *real lines* shown in blue. The third is the *suggested line* created by the aligning, repetition of oval shapes shown in green. The fourth is the *suggested line* created by the feather quill shown in red.

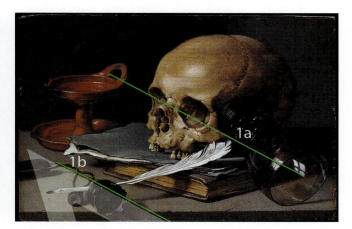

Figure 14.3 This illustration shows an example of a *suggested line* (1a) through the repetition of aligning *similar shapes (ovals).* The oval shapes are repeating from the oil lamp handle through the eye sockets of the skull to the bowl of the wine goblet. Other parallel angles can be found by moving a clear plastic angle across the composition (1b).

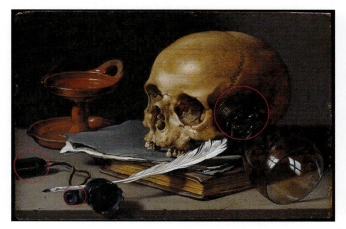

Figure 14.4 This illustration shows three examples of *closure* circled in red where the edges of the forms disappear in shadow. This painting by Claesz utilizes a minimal amount of *closure.*

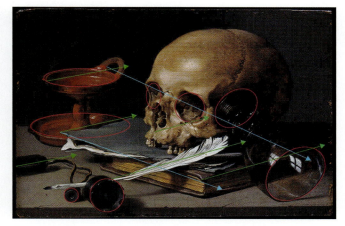

Figure 14.5 This illustration shows the two most prominent examples of repeating *similar* elements, *shape* and *angle.* The oval *shapes* (in red) are the dominant repeating element. Their *similar shape* contributes to *unity,* while their change of size adds to *variety.* The repeating diagonal *real* and *suggested lines* (blue and green) are the subdominant repeating *similar* elements. The parallel repetitions contribute to *unity* through their likeness, while their contrasting direction lends itself to *variety.*

Completed *Gestalt, Section* 2 of the *Analysis Outline*

Still Life with a Skull and a Writing Quill, by Pieter Claesz

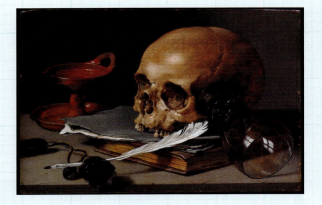

Gestalt

Proximity

The dominant (largest group) in the painting is formed by the objects on the table as they are all in close proximity. The skull, goblet, book, and papers form the subdominant group (a subgroup) in the URQ and LRQ. The subordinate group (another subgroup) is formed by the feather quill pen and ink container in the LLQ, as they are overlapping in the foreground of the composition. The reddish-colored lamp is a prominent object within the dominant group, standing in back of the subdominant and subordinate groups.

Continuation

A real line is created by the front of the table. It extends from the LLQ to the LRQ in the foreground. The rear edge of the table continues behind most of the elements, from the LLQ to the LRQ, forming another real line. A strong diagonal suggested line is created by the alignment of the oval shape of the reddish lamp, ovals of the skull's eye sockets, and the oval form of the wine goblet. The alignment of these elements is enhanced by the similarity of their shapes. A parallel diagonal suggested line extends from the bottom of the book in the LLQ through the base of the reddish oil lamp (LLQ). A counter diagonal suggested line is created by the alignment of the feather quill pen and the back bottom of the skull in the LLQ and LRQ. It is paralleled by a suggested line running from

the quill case, in the LLQ, through the edge of the greenish papers (LLQ) extending through the nasal cavity to the fissure in the back of the skull (URQ).

Closure

There are a few examples of closure in this composition created by the disappearing edges of the bowl, stem, and base of the wine goblet located in the LRQ, as well as in the base of the skull in the LRQ. Closure is also seen in the edge of the book that is barely visible through the glass wine goblet in the LRQ. The contours of the quill case and ink container top located in the LLQ are lost in the black of the shadows.

Similarity

The dominant examples of similarity in this composition are the repeating ovals. The ovals appear in the bowl and base of the glass wine goblet (LRQ, foreground), the eye sockets of the skull (centrally located and in the middle ground of the composition), the black ink container (foreground, LLQ), and in the top and base of the red-glazed earthenware oil lamp. The oil lamp is the ULQ of the composition and is similar in size and shape to the wine goblet.

The subdominant example of similarity is the repeating suggested line diagonals. There is a strong diagonal that is created through the use of ovals that runs from the handle of the oil lamp in the ULQ (background) to the skull's eye sockets (in the center of the composition) and ends with the bowl of the wine goblet, located in the LRQ in the foreground. This diagonal is repeated in the edge of the book that is located beneath the skull in the LRQ, and the quill case top and leather strap that are located in the LLQ. Strong counter diagonal suggested lines are created by the quill pen and shadow that runs from the LLQ to the LRQ. This diagonal is repeated in the book that is located beneath the skull in the LRQ, the back of the pages that sits below to the left of the skull in the LLQ, the quill case that is located in the LLQ, the lip and handle of the oil lamp that is in the ULQ.

The subordinate similarity is the repeating ocher hue seen in the skull, and the pages of the book in the ULQ, LRQ, as well as in the table top in the LLQ and LRQ.

Balance, Section 3

Chapter Reference: CHAPTER 6

Objectives: Determine the type of horizontal balance, symmetry, near-symmetry, asymmetry.

VOCABULARY

Asymmetrical Balance: The equivalence of the visual weight of design elements, but not their form, on either side of a vertical axis. *A pound of feathers equals a pound of lead.*

Axis of Symmetry (A.S.): A vertical or horizontal line dividing the picture plane into equal portions.

Formal Balance: (another name for symmetrical balance) Design elements are exactly the same in their formal appearance and placement on each side of the vertical axis, forming a mirror image of one another.

Horizontal Axis of Symmetry: A horizontal line running through the middle of the picture plane, dividing it vertically into two equal portions.

Horizontal Balance: The equivalence of the visual weight of design elements on either side of a vertical axis.

Informal Balance: (another name for asymmetrical balance) The equivalence of the visual weight of design elements, but not their form, on either side of a vertical axis. *A pound of feathers equals a pound of lead.*

Near-Symmetrical Balance: A variant form of symmetrical balance, where the basic distribution of visual weight is the same on each side of the vertical axis. The elements are not, strictly speaking, a mirrored image of one another.

Pictorial Hierarchy of Visual Weight: The distribution of visual weight, with the most attractive design elements in the bottom of the composition ascending to the least attractive design elements in the top of the composition.

Symmetrical Balance: Design elements are exactly the same in their formal appearance and placement on each side of the vertical axis, forming a mirror image of one another.

Typographic Hierarchy of Visual Weight: The distribution of visual weight, with the most attractive design elements at the top descending to the least attractive design elements at the bottom.

continued on page 80

In this section of the analysis, we are going to determine the type of horizontal balance—*symmetry, near symmetry, asymmetry*—employed in the image that is the subject of our examination.

The *vertical axis of symmetry (A.S.)* divides the image (horizontally) into two equal parts. All our decisions concerning balance will be based on the relationship of the design elements to the *A.S.* and their varying degrees of contrast. It is important to remember that the *A.S.* functions like the fulcrum of a balance scale. The closer an element is to the *A.S.*, the less visual weight it lends to either side of the composition. The greater the distance from the *A.S.*, the more *visual weight* it lends to that side of the composition (fig. 15.3).

Determining the *visual weight*, relative to the left and right halves of the composition, can be measured by the position and contrast of the individual elements, groups, and subgroups of design unit forms. It will be helpful to refer back to the *proximity* portion of the *Gestalt* Section of the *Analysis* to reference the groups and subgroups that we have already identified.

Symmetrical balance can be recognized by the exact placement in distance and kind of the image elements on either side of the *A.S.* (fig. 15.1).

Near symmetry is recognizable by the placement of individual design elements, groups, or subgroups of elements that are similar in mass and *visual weight,* in similar positions on either side of the *A.S.*

Asymmetrical balance is distinguished by larger design unit forms or groups of unit forms of moderate contrast *(pound of feathers)* in one half of the picture plane offset by a smaller, more highly contrasting elements or group of elements *(pound of lead)* in the other half of the composition. The larger mass of elements may be placed fairly close to the *A.S.*, with the smaller, more highly contrasting elements being placed farther from it (figs. 15.2 and 15.3). *Suggested* and *real lines* may aid in balancing the composition by directing the viewer's gaze to the side of the composition with the least visual mass.

Vertical Balance: A relative equivalency between the visual attractiveness of design elements in the top and bottom of the picture plane.

Vertical Axis of Symmetry: A vertical line running through the center of the picture plane, dividing it horizontally into two equal portions.

Visual Weight: The visual attractiveness of a design element based on its degree of contrast with its surroundings.

The Process: Re-read Chapter 6, Balance

1. Establish the *vertical axis of symmetry (A.S.).* Look to the acetate quadrant flap dividing the picture into equal parts. We will only be interested in accessing the right and left sides of the composition (fig. 15.4).

2. Inspect the left and right sides of the picture plane to determine the placement and contrasts of design elements or groups of design elements, noting their distance from the *A.S. Note:* Check the proximity portion of the *Analysis,* Section 2, Gestalt, for identified groupings of design elements as an aid in accessing the distribution of visual masses.

3. Compare the mass and contrasts of the elements on both sides of the *A.S.,* taking note of their positions in relation to the *A.S.* (fig. 15.5).

4. If you decide that the composition is *symmetrically balanced,* explain how the elements are exactly alike in their appearance and placement on either side of the *A.S.*

5. If the composition appears to be *nearly symmetrical* in balance, explain your conclusion by identifying the similarly positioned groups in their relationship to the *A.S.*

6. If the composition is *asymmetrically balanced,* identify the mass and visual contrasts of the elements you consider to be the pound of feathers and the elements that you identify as the pound of lead (fig. 15.6). Be sure to include their relative positions from the *A.S.*

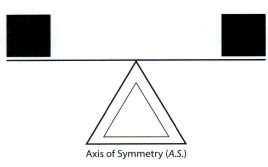

Figure 15.1 This is an example of *symmetrical balance.* There is an equal amount of weight on each side of the fulcrum or *axis of symmetry (A.S.).*

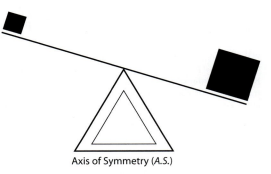

Figure 15.2 An unequal amount of weight that is equally spaced from the fulcrum creates imbalance.

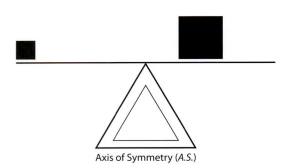

Figure 15.3 An element of larger visual mass is moved close to the *A.S.,* and the element of smaller visual mass is shifted farther from it, increasing its visual contrast *(asymmetrical balance).*

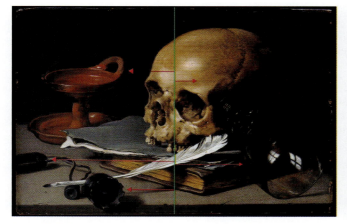

Figure 15.4 The green line shows the *axis of symmetry (A.S.)*.

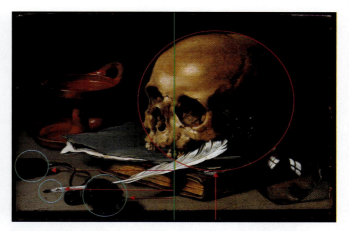

Figure 15.6 The skull in the red circle, along with the glass, book, and papers, is the *pound of feathers* in the composition and the ink container group (indicated by the blue circles) is *the pound of lead*. The red arrows indicate the distance from the *A.S.* and bottom of the picture plane. *Note:* The *asymmetrical balance* contributes variety and visual tension to the image through the balancing of unequal visual masses.

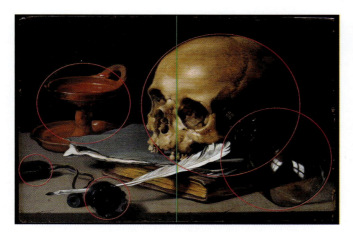

Figure 15.5 The red circles are indicating the relative mass of each of the elements in the composition. The book and papers would be grouped with the skull and goblet.

Completed *Balance,* Section 3 of the *Analysis Outline*

Still Life with a Skull and a Writing Quill, by Pieter Claesz

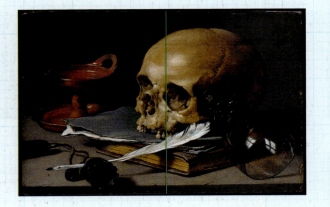

Balance

Asymmetry/Near-Symmetry/Symmetry

This painting is asymmetrically balanced. The largest visual mass is the skull, book, papers, and wine goblet (subdominant group of the proximity portion of Gestalt, Section 2) located in the URQ and LRQ (pound of feathers). The skull is the largest and most highly contrasting member of the group, there being high value contrast within its eye and nose cavities. This most visually attractive portion of the skull rests on the *A.S.,* placing its visual weight in a more neutral part of the picture plane with regard to visual balance.

The ink container, container top, quill case, and quill tip (subordinant group of the proximity portion of Gestalt, Section 2) are located in the LLQ of the picture plane, forming a group of objects high in value contrast and located significantly to the left of the A.S. (pound of lead). The lower portion of the ink bottle overhangs the table edge, creating visual tension and adding to its visual attractiveness. The contrasting red hue of the clay oil lamp in the ULQ and its similarity of shape to the wine goblet help to complete the image's asymmetrical balance. At first glance, the red color may appear to be an isolated element, but the repeating hints of red in the back of the skull and the reflection of the goblet serve to integrate it into the compositon.

A suggested line created by the gaze of the skull directs the viewer's line of sight to the left side of the picture plane, further aiding image balance. It is tempered by a counter directional line made by the writing quill.

CHAPTER 16

Focal and Accent Points, Section 4

Chapter Reference: CHAPTER 7

Objectives: Identify points of emphasis, focal and accent points, triangulation.

VOCABULARY

Accent Point: A design element of high contrast in a visual image.

Focal Point: The design element of highest contrast, or primary point of emphasis in a visual image.

Contrast: The amount of difference between a visual unit form and its immediate surroundings.

Line of Sight: A visual pathway or direction through an image.

Real Line: A line or edge of a form as it actually exists in a visual image.

Suggested Line: A line that is implied through our Gestalt's sense of continuation. These lines are created through the alignment of forms or their edges, or by the gaze of human or animal forms within an image.

Visual Hierarchy: An ordering of visual unit forms from greater to lesser based on the visual attractiveness of the unit forms. An element's or unit form's degree of contrast determines its place in the visual hierarchy.

In this section of the analysis, we are going to identify *points of emphasis* or *accent points* and examine their role in guiding the viewer's reading of the visual image. It will be important to recognize the three most important contrasting elements in the *visual hierarchy:* the *focal point* (element of highest contrast) and next two *accent points* of highest contrast.

Points of emphasis are design elements that are of noticeably higher contrast than the elements that surround them. They serve as points of rest or visual punctuation within the image, and as signposts to guide the viewer in the visual navigation of the design. A design may have any number of *accent points,* no two of which can occupy the same position in the *visual hierarchy.* It is very important to identify the different types of contrasts (scale, value, color/brightness, shape, etc.) that establish an element's position in the *visual hierarchy.* Most likely, there will be more than one type of contrast for each *point of emphasis,* that is, the large red apple in the LLQ is the focal point because of its light value, bright red color, and its isolation from surrounding design elements. Distinguishing the strength in contrast of two points of emphasis may not be immediately obvious, so listing the types of contrasts will help in making a decision.

Once the *focal* and two most prominent *accent points* have been identified, we will determine if they create a triangular *line of sight,* or *triangulation,* starting from the *focal point,* and proceeding to the two *accent points* in a descending order of contrast. In order for *triangulation* to occur in the visual navigation of the composition, it should establish a *line of sight* through the four quadrants of the picture plane. *Triangulation* limited to isolated portions of the image is not of compositional significance and should not be identified. Not every image will contain examples of *triangulation.*

The Process: Re-read Chapter 7, Emphasis and Eye Flow

1. Identify the visual element of highest contrast, the *focal point* (dominant), and list all the contrasts that make it so. Indicate its location in the picture plane by quadrant (fig. 16.1).

2. Identify the *accent point* of next highest contrast (subdominant) and list all the types of contrasts that make it so. Indicate its location in the picture plane by quadrant (fig. 16.2).

3. Identify the *accent point* of third highest contrasts (subordinate) and name all the types of contrast that make it so. Indicate its location in the picture plane by quadrant (fig. 16.3).

4. If there is *triangulation* between the three points of emphasis, identify the *line of sight* they create through the picture plane. List the quadrants through which the *line of sight* travels (fig. 16.4).

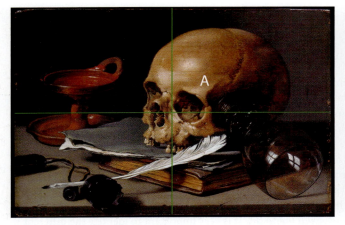

Figure 16.1 The focal point, (A), due to contrasts of scale, value texture, and color, occupies portions of the URQ, LRQ, ULQ and LLQ.

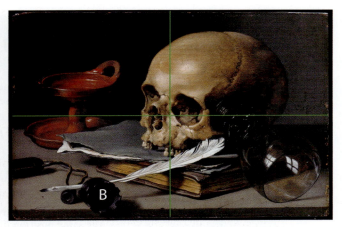

Figure 16.2 The ink container, located in the LLQ, is the subdominant *accent point* (B), due to contrasts of *value*, *position*, *scale*, and *shape*.

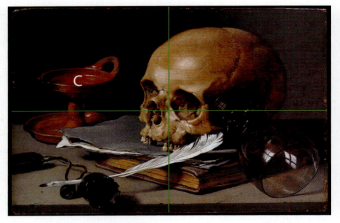

Figure 16.3 The subordinate *accent point* (C), due to contrasts of *color, position,* and *shape,* is located in the ULQ and LLQ.

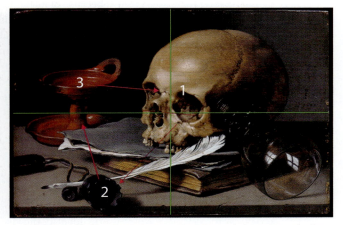

Figure 16.4 The *focal* and *accent points* (dominant, subdominant and subordinate) create a clear *triangulation,* that moves the viewer's gaze through the composition from 1 to 2 to 3, covering all four quadrants in the composition.

Completed *Focal and Accent Point,* Section 4 of the *Analysis Outline*

Still Life with a Skull and a Writing Quill, by Pieter Claesz

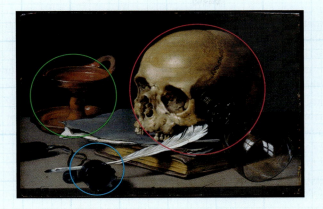

Focal and Accent Points

Dominant/Subdominant/Subordinate

In this painting by Pieter Claesz, there are three distinct accent points. The skull in the URQ and LRQ is the focal point (highlighted in red) due to contrasts of scale, value, and color. The color of the skull is a saturated ocher that is light in value and contrasts with the dark value behind it. The texture of the teeth, nose, and eye cavities, along with value contrasts within the skull, heightens its visual attraction.

The subdominant accent point is the ink container in the LLQ (highlighted in blue) due to contrasts of position, value, shape, and scale. The container sits overhanging the front edge of the table and is very close to the bottom edge of the picture plane, causing a good deal of visual tension. It is black (with a very dark value) and contrasts with the lighter (approximately 40% gray) table top. The shape of the ink container is round with a textured rim that adds to its contrast, in

addition to its being one of the smallest elements in the composition.

The subordinate accent point is the red lamp in the ULQ and LLQ (highlighted in green) due to contrasts of color, position, and shape. The lamp is placed away from other elements in the composition, seemingly isolating its red color, which attracts the viewer's attention. Even though the color may feel isolated, it is subtly integrated into the composition, appearing on the surfaces of the glass goblet, skull, and book pages. The silhouette of the lamp is fairly complex and contrasts with the other objects in the painting.

There is a clear triangulation of dominant (focal point), subdominant, and subordinate accent points in this composition. The viewer's line of sight starts with the skull (focal point) and moves left (foreground) to the ink container (subdominant accent point), and then to the lamp (subordinate accent point), moving the viewer's gaze through the four quadrants of the picture plane.

Geometry, Section 5

Objectives: Determine picture plane proportion (dynamic rectangle?), relevance of harmonic armature and rabatment.

VOCABULARY

Dynamic Symmetry: The just balance of variety in symmetry (as proposed by Hambridge).

Eyes of a Rectangle: The 90° intersections of diagonal lines within the harmonic armature. These are places of harmonic rest.

Formal Structure: A structural network that requires strict adherence to its guidelines.

Full Diagonal: Diagonal lines drawn from opposing corners of a square, used to project root rectangles.

Golden Section Rectangle: A rectangle produced from the projection of a square's half diagonal with a proportional ratio of 1:1.618.

Half Diagonal: The diagonal line drawn from the midpoint of a square's side to an opposite corner.

Harmonic Eyes:. Eyes of the rectangle.

Informal Structure: A structural network where design elements have a casual relationship to its guidelines.

Long Rectangle: A rectangle with unequal sides.

Proportion: A comparison of a part of the design to the whole or to another part.

Ratio: The numerical expression of a proportion.

Real Line: A line or edge of a form as it actually exists in a visual image.

Rectangle: A figure with four sides that meet at 90°.

Root Rectangle: Rectangle with a side that is the numerical expression of the square root of a number.

In this section of the *Analysis Outline*, we are going to examine the foundational design configuration of our image.

Proportion and *structure* are primary design considerations whether they are the result of careful deliberation and forethought or the result of one's intuition in the making of the image. The *proportion* of the picture plane is analogous to laying a building's foundation as it gives the architecture its basic form and support. The picture plane's *proportion* is the foundation of our image. The first step in this process will be to calculate the numerical expression, or ratio, of that *proportion* (fig. 17.1) (for simplicity's sake we have eliminated reciprocals).

Continuing the architectural analogy, the interior's supporting structural framework (skeleton) establishes a building's form. The interior design structures whether *typographic grids* or more informal geometric configurations perform a similar function for the visual image. *Formal structures* order design elements through a regular geometry most often seen in graphic design and some abstract pictorial works. *Informal structures* tend to remain more hidden from the viewer, as an element's conformity to the structural guides is more casual than in a *formal structure*.

The *rabatment* of the picture plane creates two *square* containers within the rectangle (figs. 17.2, 17.4). These *rabatment containers* facilitate a dynamic placement *(as in dynamic symmetry)* of design elements within the composition. The interior edges of the *rabatment* containers form *rabatment lines* and are places of harmonic rest.

The next step in our process will be to construct an acetate flap, place it over the image, and rabate the picture plane on the flap. Do the elements in the composition conform to the *containers*? Are there points of emphasis resting on the rabatment lines?

The *harmonic armature* creates places of harmonic rest in the 90° crossing lines that form the *eyes of the rectangle* and harmonic orientation of the diagonal elements within the picture plane. In this last step, we will draw a *harmonic armature* on a new acetate flap and overlay it onto the image, checking to see if the *eyes* of the rectangle have been used in the placement of *accent points* and if there are elements in the composition that align with diagonal lines *(echo lines)* of the *armature*.

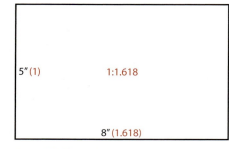

5" (1) 1:1.618

8" (1.618)

Figure 17.1 To calculate the proportional ratio for the rectangle above, measure the short side, 5", and the long side, 8". Divide the short measurement, 5", into the long side measurement, 8", which equals 1.618, the numerical expression of the long side. The short (square) side of the rectangle is always expressed as 1. The ratio of the rectangle is 1:1.618.

Figure 17.2 Constructing a rabatment creates a square inside a long rectangle. The *square* acts as a *container* for design elements, and its interior edge forms a *rabatment line,* creating a harmonic spot for the placement of *accent points.*

The Process: Proportion of the Picture Plane: Re-read Chapters 6 and 7

1. Measure, in millimeters, the height of the picture plane.

2. Measure, in millimeters, the width of the picture plane.

3. Divide the small measurement (divisor) into the large measurement (dividend). The resulting quotient will be the numerical expression of the long side of the rectangle. The short side *(square side)* is always 1 (fig. 17.3).

4. Compare your calculated *ratio* with the ratios of *dynamic rectangles (root and golden section rectangles)*, and identify, if applicable, which *dynamic rectangle* it is.

The Process: Rabatment of the Picture Plane

1. Cut out an acetate flap to the same measurements as the picture plane.

2. Draw the rabatment lines, on the flap, by projecting each of the short sides of the picture plane onto the long side of the picture plane (fig. 17.4).

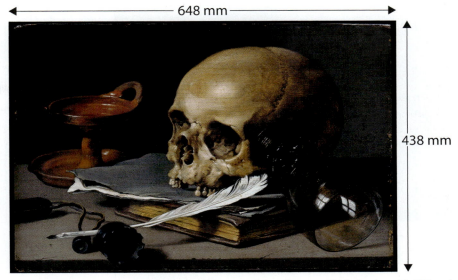

Figure 17.3 Measure the long and short side of the rectangle in millimeters. Divide the short side (438 mm) into the long side (648 mm). This yields 1.47, the numerical expression of the rectangle's long side.

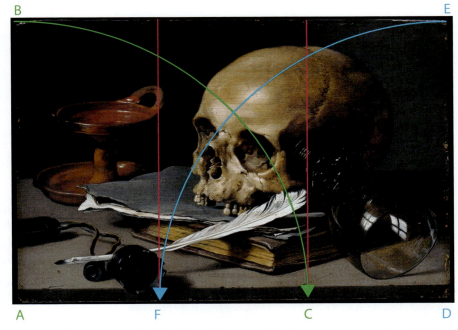

Figure 17.4: The double rabatment creates two *squares* inside a long rectangle. Using a compass set the compass on point A and extend the compass to point B. Draw an arc to point C. This makes the first *rabatment line* (in red). Do the same from point D to point E and draw an arc to point F, Making the second *rabatment line*.

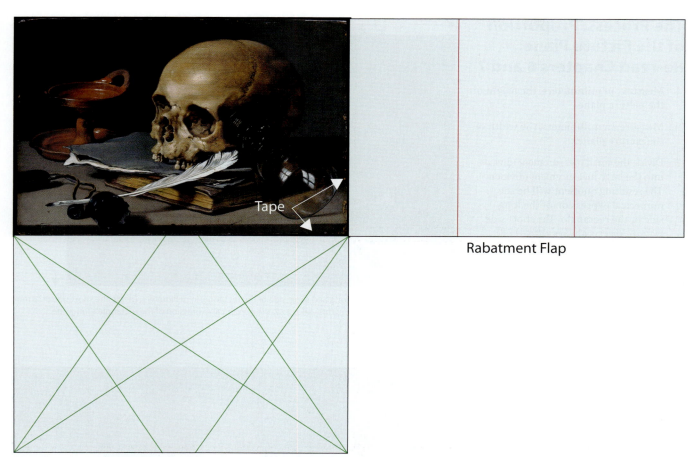

Tape

Rabatment Flap

Armature Flap

Figure 17.5 The *rabatment* flap is taped on the right side of the image and the *armature* flap is taped on the bottom. Each flap is hinged with tape and covers the image. This illustration shows the flaps open.

Right Container

Left Container

Figure 17.6 A *rabatment line* can be used to position accent points (in red) or as *containers*. The two overlapping *rabatment containers* (above) are used to organize elements in a composition.

3. Place the flap over the the image, and attach it with clear tape, making sure not to put the tape over a pre-existing hinge (fig. 17.5).

4. Identify *accent points*, if applicable, that rest on the *rabatment lines.*

5. Determine if the *rabatment containers* are important to the compositon.The *rabatment* containers that house significant portions of the design elements in the compositon play an important organizing role in the design. (fig. 17.6).

The Process: Harmonic Armature

1. Cut out an acetate flap to the same measurements as the picture plane.

2. Draw the *harmonic armature* on the flap. If the proportion of the picture plane is closer to 1:1 than 1:1.2, divide the picture into two equal parts by dividing the long side of the rectangle in half. Draw an *armature* in each half of the divided picture plane (fig. 17.7).

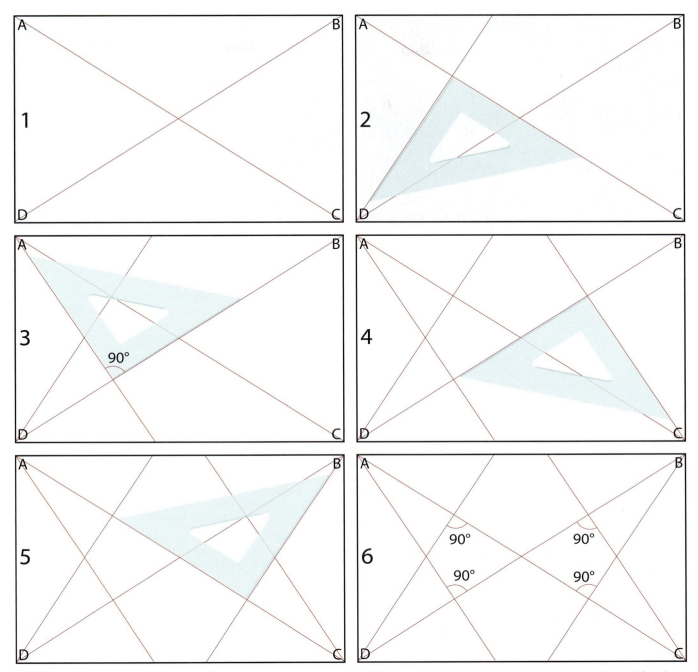

Figure 17.7a–17.7f This series of illustrations demonstrates how to draw a *harmonic armature* in a long rectangle. The progression starts in the top left and moves right to left and top to bottom.

3. Place the flap over the the image, and attach it with clear tape, making sure not to put the tape over a preexisting hinge (fig. 17.6).

4. *Eyes:* There will be four *Eyes* (90° crossings) on the *armature*, one in each quadrant of the picture plane. Label the *Eyes* 1 (ULQ), 2 (URQ), 3 (LLQ), 4 (LRQ) (fig. 17.9). When using two armatures, number the eyes starting from the left proceeding to the right, or the top proceeding to the bottom, continuing the numerical sequence, eye_5, eye_6, eye_7, eye_8.

The Process: Harmonic Armature

5. Identify the *focal* or *accent points* that correspond to the *Eyes* of the picture plane, making sure to pair the *accent point* with the number of the *Eye* it is paired with.

6. *Echoes:* There are six diagonal lines in the *armature*. Three lines point to the right and three lines point to the left. Label the *right* pointing lines R_1, R_2, R_3, and the *left* pointing lines L_1, L_2, L_3. When using two *armatures*, number the diagonal lines starting from

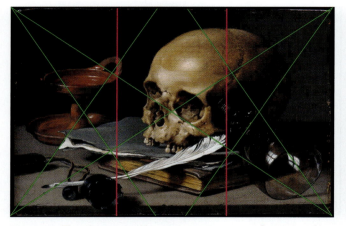

Figure 17.8 The *rabatment* and *harmonic armature* acetate flaps covers the painting and can be viewed separately or together.

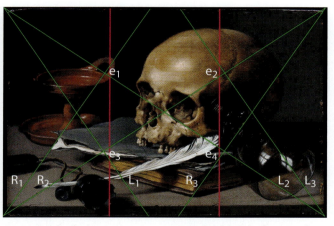

Figure 17.9 On the *harmonic armature* acetate flap, label the *four eyes of the rectangle* and *six echo lines* that will facilitate the identification of *accent points* and dynamic compositional elements.

the left proceeding to the right, or the top proceeding to the bottom, continuing the numerical sequence, R_4, R_5, R_6, L_4, L_5, L_6 (fig. 17.9).

7. Check the compostion for *real* and *suggested lines* that align, or are close to being in alignment with R_1, R_2, R_3. L_1, L_2, L_3. Identify them and other *real* or *suggested lines* that are parallel to them. Record your suggested line observations in the following form.

List the aligning elements comprising the suggested line from the line's beginning to its end. Record the lines in the form of a list rather than as a paragraph.

Echo Line (R1)-Quadrant, Line Starts-Aligning Elements-Quadrant, Line Ends

Example: R1-LLQ-quill case–top edge of paper-ULQ

The armature consists of two diagonal lines projecting from the four corners of a long rectangle.

1. The first two diagonals are drawn to connect the opposing corners of the rectangles. The second diagonal is drawn from each corner so it intersects the diagonal line opposite it (the corner) at a 90° angle.

2. Draw a diagonal line from point A to point C and from point D to point B.

3. Slide a 90° triangle along line AC until it intersects corner D. Draw a line to corner D and extend the line from D to intersect line AB.

4. Slide a 90° triangle along line BD until it intersects corner A. Draw a line to corner A and extend the line from A to intersect line CD.

5. Slide a 90° triangle along line BD until it intersects corner C. Draw a line to corner C and extend the line from C to intersect line AB.

6. Slide a 90° triangle along line AC until it intersects corner B. Draw a line to corner B and extend the line from B to intersect line CD.

Completed *Geometry, Section 5* of the *Analysis Outline*

Still Life with a Skull and a Writing Quill, by Pieter Claesz

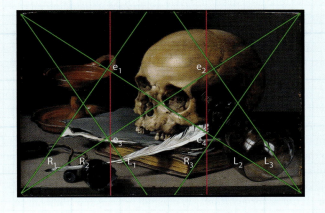

Geometry

Rabatment/Harmonic Armature Proportion

This painting measures 111.5 millimeters by 75.5 millimeters. The ratio of the painting is 1:1.47. This ratio is very close to a $\sqrt{2}$, rectangle.

Rabatment

The left rabatment line (shown in red) intersects two of the three accent points, the red lamp (ULQ) and the ink container (LLQ), which aide in the harmonic placement of each object. The right rabatment line (shown in red) runs through the center of the skull, which is the focal point of the composition, and also creates a spot for its harmonic placement. The ink bottle and lamp are housed in the left rabatment container. The goblet, skull, book, and papers, representing the largest visual mass, are in the right rabatment container.

Armature

Eyes of the Rectangle

The red oil lamp is placed on (e_1); the skull, book, and papers (focal point) rest on eyes (e_2) and (e_3). There are no prominent elements placed on (e_4).

Echo Lines

R_1, R_3:

No suggested lines.

R_2:

- LLQ-pen container–top edge papers-ULQ
- LLQ-quill case–nasal and left eye cavity skull-URQ
- LLQ-ink container–feather quill–lower back edge skull-URQ
- LLQ-ink container bottom–bottom edge books–goblet-LRQ

L_1, L_3:

- LLQ-ink container–leather straps–quill case–bottom edge lamp-ULQ
- LRQ-long axis goblet-LRQ

L_2:

- LRQ-goblet rim -bottom left eye cavity and top nasal cavity skull -top right edge oil lamp-ULQ

Compositional Dynamics, Section 6

Chapter Reference: CHAPTERS 1–10

Objectives: Identify the dominant, subdominant, subordinate dynamics (diagonal, vertical, horizontal), and their importance to the composition.

VOCABULARY

Accent Point: A design element of high contrast in a visual image.

Counter-Diagonals: Diagonal elements, either real or suggested lines, that are positioned crosswise to a dominant diagonal dynamic, offsetting its visual force.

Compositional Dynamics: The distribution of diagonal, vertical, and horizontal design elements in a visual image.

Dominant Dynamic: The most significant diagonal, vertical, or horizontal design elements in a pictorial composition.

Dynamic Contours: Real or suggested lines and forms used in accessing the compositional dynamics of a visual image.

Dynamic Hierarchy: The ordering of design elements by the amount of visual energy they display, with diagonals at the top of the hierarchy, verticals in the middle, and horizontals at the bottom.

Dynamic Orientation: The spacial orientation (diagonal, vertical, horizontal) of a design element in a visual image.

Dynamically Neutral Forms: Design possessing dimensional axes of equal length.

Focal Point: The design element of highest contrast, or primary point of emphasis in a visual image.

Forest: An analogical term meaning a broad or general view of a visual image.

Lines of Sight: A visual pathway or direction through an image.

Major Axis: The long dimension of a form.

Minor Axis: The short dimension of a form.

Real Line: A line or edge of a form as it actually exists in a visual image.

Suggested Line: A line that is implied through our Gestalt's sense of continuation. These lines are created through the alignment of forms or their edges, or by the gaze of human or animal forms within an image.

Triangulation: A visual pathway from a focal point to accent points of lessening contrast, forming a triangular eye movement.

The interaction of dynamic forms within a composition plays an important role in establishing its emotional tone. The *dynamic orientation* of its forms can evoke a wide range of feelings, from serenity to wild excitement and action. In this section of the *Outline,* we are going to determine how these forces are at work within our image by identifying the *dominant* (most prominent), the *subdominant* (middle prominence), and *subordinate* (least prominent) *dynamic orientation* of the elements in the design. We will be working to establish the basic **Dynamic Contours** within the image, so it is important to identify only the work's most prominent examples. Over-identification of dynamic elements will only obscure our observations in a sea of confusing details.

Turn to your research in the *Gestalt/Continuation* and the *Geometry/Harmonic Armature* sections of the *Outline.* Consult your listings of *real and suggested lines* and their relationship to the *echo lines* of the *harmonic armature.* Identify the dominant spacial orientation (diagonal, vertical, horizontal) and any significant repetitions of them (parallel) in the composition. It is important to remember that within the *dynamic hierarchy,* not all *spacial orientations* are of equal force. A few highly prominent diagonals will outweigh many more vertical and horizontal *dynamic contours.*

After recording your observations in your *rough book* for the dominant, subdominant, and subordinate dynamics, review and ruminate a bit over your work. Cut an acetate flap and place it over the image and attach it with a clear tape hinge. Using your clear plastic straight edge and a fine-tipped marker, draw and label the contours of the dynamic forces at work in your composition. Write your conclusions in the *rough book.*

The Process: Compositional Dynamics: Re-read Chapter 10

1. Cut out an acetate flap and place it over the image. Attach the flap with clear tape, making sure not to tape over a preexisting hinge.

2. Taking a *forest view* of the composition, determine the *dominant dynamic*. Make sure to take into consideration the *dynamic hierarchy* in making your decision. The diagonal dynamic is at the top of the hierarchy, the vertical dynamic is in the middle, and the horizontal dynamic occupies the lowest or most passive position in the hierarchy. Identify the example that is the most prominent.

3. Refer to the *Gestalt/Continuation* and the *Harmonic Armature/Echo Lines* sections of the *Analysis Outline* to help in your dynamic assessment of the image. You have already identified *suggested lines* of different dynamic orientations in both these sections. If diagonal dynamics are important, make particular use of the *echo lines* of the armature.

4. Draw a line, using a clear plastic straight edge and a green fine-tipped marker, on the acetate flap running through the major axis of the *dominant dynamic*; label it (1) (fig. 18.1).

5. Lay the plastic straight edge over significant parallel dominant dynamic contours, draw a line through their major axis, and label them (1_a), (1_b), and so on (fig. 18.2).

6. Identify the subdominant and subordinate dynamic contours and repeat the process. Label the subdominant contours (2), (2_a), (2_b) in red, and the subordinate contours (3), (3_a), (3_b) in blue. If the dominant dynamic is diagonal, there will most likely be counter-balancing diagonals to account for. Label the counter-diagonals (C), (C_a), (C_b) in green (fig. 18.3).

7. Write your observations and explain your reasoning. Make sure to reference the labeled *dynamic contours* that you have identified.

Note: There may not always be examples of all three dynamics.

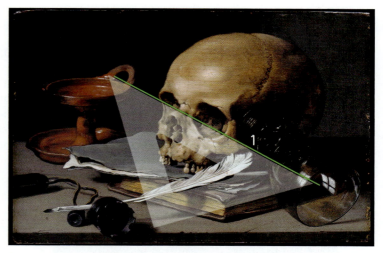

Figure 18.1 The *dominant dynamic contour* of this composition extends from the handle of the red lamp through the repeating ovals and glass goblet.

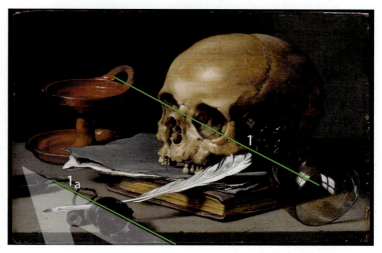

Figure 18.2 Slide the straight edge through the composition to find lines parallel to the *dominant dynamic contour*.

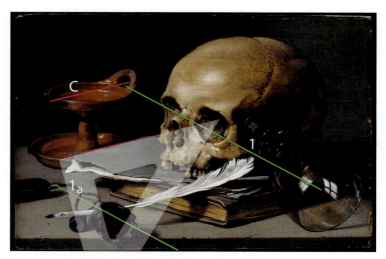

Figure 18.3 Find the *counter-diagonals* and the subdominant *dynamic contours*.

Completed *Compositional Dynamics*, Section 6 of the *Analysis Outline*

Still Life with a Skull and a Writing Quill, by Pieter Claesz

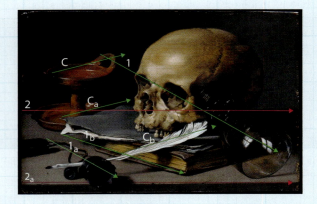

Compositional Dynamics

The dominant dynamic contour in this painting is indicated in green (1), and is a suggested line created by the repetition of ovals extending through the handle of the red lamp, both eye sockets of the skull, and ending at the mouth of the glass goblet. This diagonal is repeated in the angle of the leather straps and reservoir of the black ink container (1$_a$), the book, and pages (1$_b$). The strong diagonal dynamic is a visual force that creates a more exciting composition. The counter dynamic contour is indicated in green (C, C$_a$, C$_b$), and is repeated in the red lamp, the back edge of the book and quill case, the front edge and book pages, and the feather

quill pen. This dynamic balances the strong dominant dynamic (shown in green), and prevents the composition from being overwhelmed by the visual force created by the dominant dynamic.

The subdominant dynamic contour (shown in red) is the real line that runs horizontally and is overlapped by the lamp, book, skull, and goblet (2). This horizontal is repeated in the foreground (2$_a$). This horizontal is also the real line that runs across the bottom near the edge of the picture plane. These two horizontal dynamics help to stabilize the stronger dominant dynamic.

CHAPTER 19

Unity and Variety, Section 7

Chapter Reference: CHAPTERS 1–11

Objectives: Summarize and synthesize formal elements' contribution to unity and variety.

VOCABULARY

Alternating Rhythm: The regular, unchanging repetition of a design element.

Closure: The completeness of sense information in the perception of objects and environment.

Compositional Dynamics: The distribution of diagonal, vertical, and horizontal design elements in a visual image.

Continuation: 1. An actual line connecting design elements. 2. A suggested line created through the alignment of unconnected forms.

Dynamic Contours: Real or suggested lines and forms used in accessing the compositional dynamics of a visual image.

Forest: An analogical term meaning a broad or general view of a visual image.

Gestalt: The whole is different than the sum of its parts.

Gestalt Function: The faculty that organizes objects into wholes and promotes understanding of sense information.

Integrative Repetition: An unrhythmic recurrence of a design element or portion or aspect of a design element lending commonality to different parts of the picture plane.

Progressive Rhythm: The regular repetition of a design element that changes with each occurrence or iteration.

Proximity: The spacial distance between design elements.

Real Line: A line or edge of a form as it actually exists in a visual image.

Repetition: The recurrence or iteration of a design element in a visual image. Repetition may be rhythmic or non-rhythmic.

Rhythm: The repetition of a design element that occurs in a regular predictable way.

Suggested Line: A line that is implied through our Gestalt's sense of continuation. These lines are created through the alignment of forms or their edges, or by the gaze of human or animal forms within an image.

Variety: Difference; design elements that provide relief from sameness in visual images.

Unity/Harmony: The agreement between the visual unit forms that comprise a visual image. Unity/harmony creates a visual whole or oneness.

We perceive the world around us, as mentioned in *Gestalt*, Chapter 3, as a *unity* of parts or wholes, as opposed to a conglomeration of unrelated fragments. In the previous sections of the *Analysis Outline,* we carefully examined the various parts of our image with a mind to determining how they work with one another, within the composition, to form a *unified* whole. This section of the *Outline* is a summation and synthesis of our observations. The first set of classification paragraphs will address *unity,* the second *variety,* and the third the balance of *unity* and *variety* within the image.

Review the formal observations gathered in the *Analysis Outline: compositional dynamics, balance, repetition (rhythmic and integrative),* and *Gestalt/similarity* are particularly important elements in the summation of the *unity* and *variety* classification paragraphs. Giving specific examples, explain how they contribute to *unity, variety,* or both. A repeating *similar* design element will contribute to *unity* to the degree that it is like the other elements in the repetition and will contribute to *variety* through its difference, for example, the color red may appear as part of several different elements in various areas of a picture plane. The red *hue* contributes to the *unity* of the image. In each instance of the repetition, the red becomes less bright and slightly darker in *value,* adding to the variety of the composition by its change in *saturation* and *value. Asymmetry* in the balance of an image will contribute to *variety,* through the difference in mass and contrasts of the elements on either side of the *axis of symmetry*; and to *unity,* in that the elements have achieved an equilibrium in their *visual weight.* Not all the elements under consideration will contribute to both *unity* and *variety.* A *formally* balanced composition may be imbued with a sense of stability, serenity, and perhaps gravitas. The *symmetrical* placement of forms on either side of the *axis of symmetry* contributes to *unity* alone.

The assessment of the degree of *variety* and *unity* within the composition will require a *forest,* or long view of the image in conjunction with the conclusions reached in the *unity* and *variety* paragraphs. In the formulation of your opinions for this paragraph, you should consider the following questions: Does the image tend more toward *unity* while having *variety* enough to hold our visual interest? Is the composition raucous, with an abundance of *variety* while still achieving unity? Or does the image fall somewhere in between?

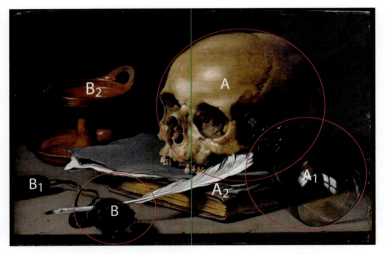

Figure 19.1 Consult and confirm the *Balance section's* findings. The skull, along with the glass, book, and papers, is the *pound of feathers* (A); the ink container is *the pound of lead* (B). *Note:* The *asymmetrical balance* contributes variety and visual tension to the image through the balancing of unequal visual masses.

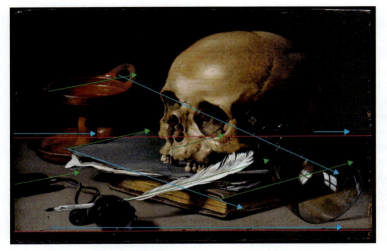

Figure 19.2 Consult and confirm the *Continuation/Gestalt and Compositional Dynamic sections'* findings for repetition of the dominant dynamic diagonal and horizontal contours (shown in red and blue).

The Process: Unity and Variety: Review Chapters 1–10

1. Look at the image, and then review the information that you have gathered in the *Gestalt, Balance, and Compositional Dynamics* sections of the *Analysis Outline.*

2. Revisit the image and review your conclusions *for the relevant sections of the Analysis Outline.* Compile the relevant data for each of the classification paragraphs (unity, variety, balance of unity and variety) in your rough book, from your observations. It will be important to look for specific, significant examples for each category (Gestalt, balance, compositional dynamics, repetition). Include any additional information after the subordinate paragraph.

Elements Contributing to Unity (some elements contribute to unity and variety):

- similar repeating elements, emphasis on their sameness
- symmetrical and near-symmetrical balance (fig. 19.1)
- horizontal, vertical, and dynamic contours (fig. 19.2)
- integrative repetition of elements (fig. 19.3)
- alternating rhythms

Elements Contributing to Variety (some elements contribute to unity and variety):

- similar repeating elements, emphasis on their difference
- asymmetrical balance (fig. 19.1)
- diagonal dynamic contours (fig. 19.2)
- integrative repetition of changing elements (fig. 19.3)
- progressive rhythms

3. *Unity Classification Paragraphs:* Using your observations and gathered data, write an outline in your rough book. Pick the three most important examples to write about (dominant, subdominant, subordinate). It will be important to take a forest view of the image when making these decisions.

 Some of your information may be useful in both the unity and variety paragraphs though you will be placing emphasis on different aspects of the information, that is, the repetition of an ocher hue in several elements, in different parts of the picture plane, contributes to unity. The hue changes in saturation and value with each repetition. This aspect of the design adds to variety and would be mentioned in the variety paragraphs.

4. *Variety Classification Paragraphs:* Using your observations and gathered data, write a paragraph outline in your rough book.

 As mentioned above, you may be placing emphasis on different aspects of repeating similar elements, that is, the repetition of an ocher hue in several forms, in different parts of the picture plane, changes in saturation and value with each iteration. Name the form and mention how they change in their contribution to variety. Pick the three most important examples to write about (dominant, subdominant, subordinate). It will be important to take a forest view of the image when making these decisions.

5. *Balance of Unity and Variety Paragraph:* Take a forest view of the image, keeping in mind your conclusion in the unity and variety paragraphs, and record your thoughts in the rough book.

 Write a paragraph explaining your conclusion as to whether the image is strong in *unity*, strong in *variety*, or somewhere between those extremes.

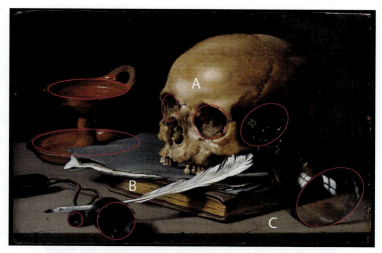

Figure 19.3 Consult and confirm the *Similarity/Gestalt section* for findings of *integrative repetition.* There are repeating circles and ovals (in red) and a yellowish brown *hue* (A, B, C).

Completed Unity and Variety, Section 7 of the Analysis Outline

Still Life with a Skull and a Writing Quill, by Pieter Claesz

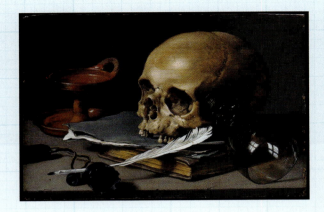

Unity and Variety

Unity

The dominant unifying elements in this composition are repeating ovals/circles: the bowl and base of the wine goblet, (LRQ), the skull (URQ,ULQ, LRQ, LLQ), skull eye sockets and nasal cavities (centrally located), two circles in the ink container (LLQ), and the top and base of the red oil lamp (ULQ, LLQ). These shapes are found in each quadrant of the composition. The subdominant unifying elements are two horizontal dynamic contours (real lines). The first horizontal contour (LLQ, LRQ) is formed by the back of the table extending through the oil lamp, books, and skull. The second horizontal contour is formed by the front edge of the table and is parallel to the bottom edge of the picture plane.

The subordinate unifying elements in the composition are the repeating ocher hues (ULQ, URQ, LLQ, LRQ) that appear in the skull (high saturation and light value), book pages (similar in value and saturation as the skull), and tabletop (similar color saturation but lower value than the skull) as well as in the highlights of the oil lamp, feather quill pen, and glass wine goblet, and they are repeated in each quadrant of the composition.

The repeating shapes, dynamic contours, and colors act to integrate the elements of the composition, lending commonality to the quadrants of the picture plane.

Variety

The dominant elements that contribute to variety in this work are the repeating diagonal dynamic contours. The first diagonal contour is created through the alignment of repeating ovals, making a suggested line that extends from the handle of the red oil lamp through the two eye sockets of the skull to the mouth of the glass goblet. The diagonal is repeated in the books (medium-length real line), ink container, and leather straps (medium-length real line). Repeating counter-diagonals are created by the quill pen, oil lamp handle, and top and bottom edges of the book and papers, are medium in length, and appear in the ULQ, LLQ, and LRQ. Asymmetrical balance is the subdominant factor in creating variety in this composition. The varying changes in scale (large skull, medium lamp and goblet, and smaller ink container) are placed so there is an unequal distribution of visual mass on either side of the picture plane, creating visual tension. The composition is brought into balance by the higher-contrasting, smaller elements on the image's left side (pound of lead) being of equivalent visual weight to the larger elements, of lower contrast (pound of feathers) on its right side.

The subordinate elements contributing to variety are the variations in the repeating shapes (curvilinear) and hues (ocher variations) mentioned in the unity paragraph.

Unity and Variety

Pieter Claesz has created a good balance of unity and variety in this composition. He has used a clear repetition of similarly shaped objects, repeating colors and angles (horizontal and diagonal) to create unity; and is balancing this repetition with the change in scale (large, medium, and small), the counter-diagonals to the dominant dynamic diagonals, and the change in value of the repeating color. These differences add variety to the composition and create a more exciting design to hold the viewers' attention.

CHAPTER 20

Bracketed Observation, Section 8

Chapter Reference: CHAPTER 11

Objectives: Discern the composition's visual element, element function, and element condition.

Note: The Bracketed Inventory is not necessary for non-representational images as the formal information in the previous Analysis Outline sections will suffice.

VOCABULARY

Bracketed Observation: The process discerning a visual element, the element's function and condition.

Conceptual Depth: The layering of ideas in the vessel of visual form.

Element Condition: The outward appearance of a visual element. The third step in bracketed observation.

Contextual Association: The relating of a work's contextual information to its visual information.

Contextual Information: Visual or nonvisual information associated with a work that is not part of its form.

Form: An abstract quality or property expressed in matter.

Formal Content: Information that relies on the visual nature of the unit forms and their interaction.

Element Function: The purpose (being) of a visual element. The second step in bracketed observation.

Narrative Content: Image that tells a story. This may include commercial imagery.

Primary Level of Perception: One's initial look at an image.

Secondary Level of Perception: A sustained visual examination of an image to discern its visual content, either formal, symbolic, or narrative, singularly or in combination.

Symbolic Content: Visual unit forms represent something beyond their appearance, that is, a dove represents peace.

Visual Content: The message communicated by a visual image. It may be formal, symbolic, narrative, or a combination of the three.

Visual Information: The image one sees and its constituent forms.

Variety: Difference; design elements that provide relief from sameness in visual images.

Unity/Harmony: The agreement between the visual unit forms that comprise a visual image. Unity/Harmony creates a visual whole or oneness.

In this section of the *Analysis Outline*, we will begin the process of discerning the *visual content* of the image under our consideration. Our *bracketed observation* will bear a resemblance to the first section of the *Outline, Shape Type* and *Distribution*. The *Analysis* started with the identification of the *shapes* that comprise the image. Familiarity with the objects we see may very often obscure our observation of them. When looking at visual forms, we may see them and not be aware of the element's *shape* or the *shapes* of which it is composed. The more familiar the element, the less we notice its form. *To form or view as a unit apart* is to separate. The separation of an objects's form from what we recognize it to be enables the viewer to better see the *shapes* that form the parts and the whole of the visual image that was achieved in the first section of the *Analysis Outline*. As with the visual form, conceptual forms may also be obscured through our familiarity with them.

The process of the *bracketed observation* will allow one to focus on an element's conceptual content by *naming* the element, its *function*, and its *condition*. *Naming* the element is to identify it for what we, the viewer, recognize it to be. The *element function* is its purpose. What is it for? That is, a candle is for giving light by a flame of fire. A precise dictionary definition of the *element* will be of great help in naming its *function*. *Element condition* is a description of the form's appearance; that is, the candle has burned to a wax stub covered in wax drippings, or an environment is a large room with high ceilings, heavy molding, tall windows reinforcing a formal appearance. Morning sunlight is shining through the windows, filling the room with bright light The information discerned through the naming of a form's *element function* and *condition* may provide *narrative* and *symbolic* content information.

The *bracketed observation* inventory will take the form of three columns. The *element* will be written in the left column, *element function* in the middle column, and the *element condition* in the right column. All the visual elements that comprise an image are to be observed, starting with the largest (most likely the environment), then proceeding by quadrant (if possible) through the picture plane. The image environment may encompass all the quadrants, that is, a landscape or architectural interior. The *element function* of rolling green fields may be for crop production, or a rugged mountain wilderness a habitat for wildlife. The *element condition* may (describing the *elements* appearance) include a description of the time of day, lighting conditions, season of the year, location if possible, weather, and so on.

It will be necessary to review your *bracketed inventory* frequently, as it should be kept in mind while conducting and reviewing the *image research* and *conceptual association* sections of the *Outline*. This information will also play an important role in the concluding section of the *Analysis*, which will be a summation and synthesis of your *visual content* observations.

The Process: Re-read Chapter 11

The *bracketed observation* consists of three parts. Part 1: *Name* the element. What is it? Do not describe it. Part 2: *Name* the *element function*. *What* does it do? What is it for? Part 3: *Describe* the *element conditon*, its appearance. What does it look like?

1. Divide a left page of the rough book page into three columns; left column 1.125", middle column 2", right column 4." Make sure to keep the right-facing page blank as *contextual association* will be conducted on this page (fig. 20.1).

ELEMENT	ELEMENT FUNCTION	ELEMENT CONDITION
A. ROOM	FOR DINING, ENTERTAIMENT AND WORK AREA.	THE ROOM IS VERY DARK. THERE IS A SMALL AMOUNT OF LIGHT EMANATING FROM THE LEFT HAND SIDE.
B. HUMAN SKULL	PROTECTS THE BRAIN AND ADDS STRUCTURE TO THE FACE AND HEAD	THE SKULL IS YELLOWED AND CRACKED INDICATING IT IS OF CONSIDERABLE AGE. MANY TEETH ARE MISSING AND THE EDGES ARE WORN AND TATTERED.
C. WINE GOBLET	USED FOR DRINKING AND TASTING WINE.	THE OVERTURNED GLASS WINE GOBLET IS EMPTY AND RESTING WITH ITS RIM ON THE TABLE. IT LOOKS CLEAN AND PRISTINE.
D. OIL LAMP	ILLUMINATES A DARKENED AREA WITH OIL, WICK AND FLAME	THE OIL LAMP IS EMPTY WITH A SMALL AMOUNT OF SMOLDERING ASH BURNING ON THE LEFT EDGE. THE LAMP LOOKS TO BE OF CONSIDERABLE AGE AND WELL USED. THERE ARE STAINS AND THE EDGES OF THE LAMP HAS MANY IMPERFECTIONS.
E. BOOK, PAPERS	USED FOR READING, INTELLECTUAL DOCUMENTING INFORMATION OF MANY KINDS — ACCOUNTING AND BUSINESS.	THE BOOKS LOOK WORN AND TATTERED. SOME OF THE PAGES ARE TURNED UP AND THE PAGES OF THE BOOK APPEAR YELLOW AND AGED.

Figure 20.1 Divide the left page of the gridded rough book into three columns, making sure to leave the right page blank. The right page will contain a different layout for the *contextual association*. Column one (on the left) should be labeled *Element*. The second column should be labeled *Element Function* and the third *Element Condition*. *Note:* The rough book would be handwritten, not typed.

2. Name the element: Start with the largest element first, which in many cases will be the image environment (name it), and write it in the left column, that is, an architectural interior, a dining room (fig. 20.2).

3. Use a dictionary to define the element. Identify the *(element) function* of the environment, that is, a room reserved for eating meals and formal entertainment (fig. 20.3).

4. Identify the *(element) condition* of the environment, that is, the room is dark with a slight amount of light on the left side (fig. 20.4).

5. Proceed with Steps 2–4, identifying largest to smallest visually important design elements by quadrant.

6. Review and polish the information gathered in Steps 2–5 in preparation for the final version of the analysis.

7. Divide 1/8-inch grid paper into three columns: first column 1.5", second column 2.5", third column 4.5". Write the final version of the *Bracketed Inventory* (see the completed Visual Analysis).

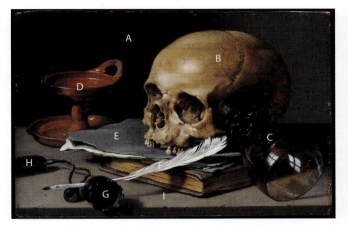

Figure 20.2 To begin the *bracketed observation,* name each element in the composition. (A) dark room; (B) human skull; (C) glass wine goblet; (D) oil lamp; (E) book and papers; (F) feather quill writing pen; (G) Ink container; (H) quill case; (I) table top. At this stage of the *observation,* there is no description or interpretation.

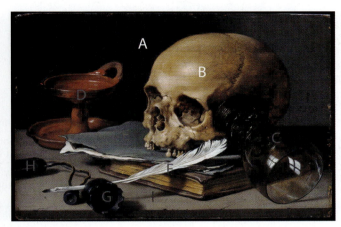

Figure 20.3 Starting with the room (the largest element in the composition), define its *function* (consulting a dictionary will be helpful). Room (A): The function of a room is for dining, entertainment, or study. Skull (B): The function of a skull is to protect the brain and add structure to the face and head. Proceed with identifying the function of the rest of the elements in the composition.

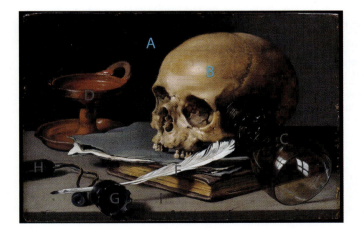

Figure 20.4 After finishing the *function* of the *element,* do the *condition* section of the *observation.* Room (A): The room is dark with a slight amount of light on the left side. Skull (B): The skull is yellowed, indicating it is of considerable age. There are teeth missing and the edges seem worn. Continue describing the condition of the remaining elements.

Completed Bracketed Observation, Section 8 of the Analysis Outline

Still Life with a Skull and a Writing Quill, by Pieter Claesz

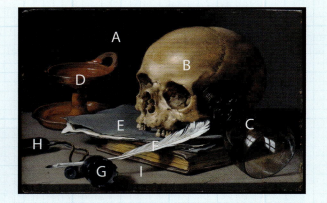

Element	Element Function	Element Condition
A. Room	For dining, entertainment, and work area.	The room is very dark. There is a small amount of light emanating from the left-hand side.
B. Human skull	Protects the brain and adds structure to the face and head.	The skull is yellowed and cracked, indicating it is of considerable age. Many teeth are missing, and the edges are worn and tattered.
C. Wine goblet	Used for drinking and tasting wine.	The overturned glass wine goblet is empty and resting with its rim on the table. It looks clean and pristine.
D. Oil lamp	Illuminates a darkened area with oil and a wick.	The oil lamp is empty, with a small amount of smoldering ash burning on the left edge. The lamp looks to be of considerable age and well used. There are stains, and the edges of the lamp have many imperfections.
E. Book, papers	Used for reading and documenting information.	The books look worn and tattered. Some of the pages are turned up, and the pages of the book appear yellowed and aged.
F. Quill pen	Used for writing with ink.	The feather quill pen looks to be well used. The tip of the pen is blackened from the ink, and the feathers look slightly tattered.
G. Ink container	Holds ink used for writing.	The ink container is lying on its side and appears to be empty.
H. Quill case	Holds writing quills.	The ink holder appears to be worn. The leather straps show age, and it appears to be well used.
I. Tabletop	Used for dining, work area, or storing objects.	The tabletop is cracked and chipped on the edges. There are horizontal lines that indicate the table may be made of wood planks.

Contextual Information, Section 9

Chapter Reference: CHAPTER 11

Objectives: Discern and research nonvisual information relevant to the work.

Note: The contextual information will be correlated with the bracketed observation to enhance the understanding of the visual content of the image. It is not an end in itself.

VOCABULARY

Bracketed Observation: The process discerning a visual element, the element's function and condition.

Conceptual Depth: The layering of ideas in the vessel of visual form.

Element Condition: The outward appearance of a visual element. The third step in bracketed observation.

Contextual Association: The relating of a work's contextual information to its visual information.

Contextual Information: Visual or nonvisual information associated with a work that is not part of its form.

Formal Content: Information that relies on the visual nature of the unit forms and their interaction.

Element Function: The purpose (being) of a visual element. The second step in bracketed observation.

Narrative Content: Image that tells a story. This may include commercial imagery.

Primary Level of Perception: One's initial look at an image.

Secondary Level of Perception: A sustained visual examination of an image to discern its visual content, either formal, symbolic, narrative singularly or in combination.

Symbolic Content: Visual unit forms represent something beyond their appearance, that is, a dove represents peace.

Visual Content: The message communicated by a visual image. It may be formal, symbolic, narrative, or a combination of the three.

Visual Information: The image one sees and its constituent forms.

In this section of the *Analysis Outline*, we will discern and research nonvisual, and, if relevant, visual information that is not directly part of the visual image under consideration. The *contextual information* should acquaint our *Gestalt* with more possibilities for *narrative* and *symbolic* significance in the visual elements that compose the work.

Nonvisual *contextual information* may be found in many forms across a number of academic disciplines: history, art history, literature, religion, sociology, to name just a few. One should always start with the work's title, letting it furnish the directions to other areas of study. *The contextual information* is gathered with the intent of its correlation with the *bracketed observation.* Avoid including scholarly commentaries on the image as the purpose of the *Analysis Outline* is to develop one's ability to read and glean content from the work. Processing the research material by writing a brief synopsis and a hierarchical breakdown will help to internalize its content and facilitate its correlation with the *bracketed observation* in the *Contextual Association* section of the *Analysis Outline* (fig. 21.1).

There may possibly be instances where visual context will be important. An image in an architectural situation might be placed near other images that are part of the same visual *narrative,* that is, two adjacent frescos representing different sequences from the same story or event.

The Process: Re-read Chapter 11

1. Read and consider the title of the work. Titles may vary in the amount and kind of information they provide. If the title, for example, provides no narrative information, research the artist, artistic era, subject matter of the painting or genre. Write a list of subjects for research in your rough book.

2. Conduct research, making notes of the most important information.

3. Document websites and books used in research.

4. Write a brief synopsis of your contextual information.

5. Identify the three most important items in the contextual information. List them, starting with the dominant, then subdominant, and, if appropriate, subordinate (fig. 21.1).

RESEARCH

WWW.WIKIPEDIA.ORG/WIKI/VANITAS
WWW.WIKIPEDIA.ORG/WIKI/MEMENTO/MORI
WWW.WIKIPEDIA.ORG/WIKI/PIETER_CLAESZ
WWW.METMUSEUM.ORG/TOAH/WORKS-OF-ART/49.107/
WWW.VISUAL-ARTS-CORK.COM/OLD-MASTERS/PIETER-CLAESZ.HTM

CONTEXTUAL INFORMATION

ITEMS TO RESEARCH: PIETER CLAESZ, GENRE OF PAINTING,
SYMBOLISM, OBJECTS IN THE PAINTING (SKULL, OIL LAMP, GLASS
WINE GOBLET, BOOKS, QUILL PEN AND INK CONTAINER).

THROUGH RESEARCH I DISCOVERED THAT THE PAINTING "STILL
LIFE WITH WRITING QUILL" BY PIETER CLAESZ WAS PAINTED
IN THE MEMENTO MORI GENRE. THE MEMENTO MORI GENRE
OF PAINTING DEALT WITH THE INEVITABILITY OF DEATH,
MORTALITY, AND THE FLEETING NATURE OF EARTHLY
POSSESSIONS AND PURSUITS. THIS WAS THE DOMINANT
CONTEXTUAL INFORMATION I ACQUIRED. THIS INFORMATION
MADE IT EASIER TO UNDERSTAND THE SYMBOLISM OF
THE ELEMENTS IN THE PAINTING.

THE SUB DOMINANT CONTEXTUAL INFORMATION I DISCOVERED
THROUGH RESEARCH WAS THE DIFFERENT SYMBOLIC
ELEMENTS THAT WERE USED REPEATEDLY BY DIFFERENT
ARTISTS WORKING IN THE MEMENTO MORI GENRE. SKULLS,
BOOKS, WRITING QUILLS, AND WINE GOBLETS SHOW UP IN
OTHER MEMENTO MORI PAINTINGS BY VARIOUS OTHER
ARTISTS. THESE ELEMENTS BECAME UNIVERSAL SYMBOLS
THAT HELPED COMMUNICATE THE MESSAGE THE ARTIST
WAS TRYING TO DELIVER.

SYNOPSIS

"STILL LIFE WITH WRITING QUILL" BY PIETER CLAESZ IS ONE OF
HIS EARLIEST DATED STILL LIFE PAINTINGS. IN HIS EARLY STILL
LIFE PAINTINGS CLAESZ USED A VERY DARK MONOCHROMATIC
COLOR SCHEME THAT AIDED IN HIS DEVELOPMENT OF THE
MEMENTO MORI GENRE. THE COLOR SCHEME CREATED AN
AURA OF DARKNESS, EMPTINESS AND IMPENDING DOOM. IN
HIS LATER PAINTINGS CLAESZ BEGAN TO BE MORE BOLD
WITH COLOR AND THE ELEMENTS HE USED TO COMMUNICATE
HIS IDEAS.

Figure 21.1 Write a synopsis and a hierarchical breakdown of the image research in the *rough book*. Research sources are cited at the top of the page, and should include websites, books, periodicals, and so on.

Completed *Contextual Information*, Section 9 of the *Analysis Outline*

Still Life with a Skull and a Writing Quill, by Pieter Claesz

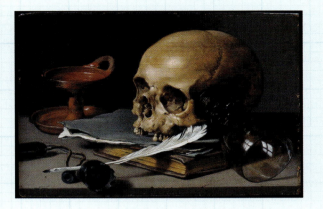

Contextual Information

Research

www.wikipedia.org/wiki/vanitas
www.wikipedia.org/wiki/memento/mori
www.wikipedia.org/wiki/pieter_claesz
www.metmuseum.org/toah/works-of-art
www.visual-arts-cork.com/pld-masters/pieter-claesz
Items to research: Pieter Claesz, genre of painting, symbolism of genre

Synopsis

Pieter Claesz, Dutch 17th-century artist, specialized in still life paintings and was an important proponent of the *ontbijt* or dinner piece. *Still Life with a Skull and a Writing Quill* is one of his earliest dated paintings, in which he used a dark, limited, value-based color scheme to create an atmosphere of somber reflection and contemplation.

Dominant Contextual Information

Still Life with a Skull and a Writing Quill is an example of the memento mori genre of painting that deals with the inevitability of death, mortality, and the fleeting nature of earthly possessions and pursuits. This information will inform our understanding of the symbolism within the work.

Subdominant Contextual Information

Research revealed that skulls, books, writing quills, and wine goblets were standard symbolic elements used by artist (Dutch 17th-century artists) working in the still life and memento mori genres, and became universal symbols of its message.

CHAPTER 22

Contextual Association, Section 10

Chapter Reference: CHAPTERS 11 AND 20

Objectives: Correlate bracketed observation with contextual information.

VOCABULARY

Bracketed Observation: The process discerning a visual element, the element's function and condition.

Element Condition: The outward appearance of a visual element. The third step in bracketed observation.

Contextual Association: The relating of a work's contextual information to its visual information.

Contextual Information: Visual or nonvisual information associated with a work that is not part of its form.

Formal Content: Information that relies on the visual nature of the unit forms and their interaction.

Element Function: The purpose (being) of a visual element. The second step in bracketed observation.

Narrative Content: Image that tells a story. This may include commercial imagery.

Secondary Level of Perception: A sustained visual examination of an image to discern its visual content, either formal, symbolic, narrative singularly or in combination.

Symbolic Content: Visual unit forms represent something beyond their appearance, that is, a dove represents peace.

Visual Content: The message communicated by a visual image. It may be formal, symbolic, narrative, or a combination of the three.

Visual Information: The image one sees and its constituent forms.

In this section of the *Outline*, we will correlate the information in the *Bracketed Observation* and *Contextual Information* sections to determine their *narrative* and *symbolic* significance. We recall that *narrative* information refers to the elements of a story, or sequence of events, and *symbolic* information is meaning that is beyond the appearance of a visual element.

The *bracketed observation* has been written on the left pages of the *rough book,* as we have reserved the blank right-facing pages for the current exercise. The blank facing pages (right) will be divided into two columns: the left labeled *symbol,* the right labeled *narrative* at the top of the columns (fig. 22.1 and fig. 22.2).

It will be necessary to consider the findings for the *element, element function,* and *condition* in light of the *Contextual Information* section of the *Analysis.*

The information gleaned from the correlation of the *bracketed observation* and the *contextual information* will form the basis for your conclusions, and the justification for the points to be presented, in the concluding section of the *Analysis Outline.*

The Process: Re-read Chapters 11 and 20

1. In the rough book, divide the right-page, that faces the *bracketed observation* pages (left) into two columns of equal width. At the top of the columns, label the left *symbolic,* and the right *narrative.*

2. Review the *Contextual Information* section of the *Analysis Outline.* Carefully re-read the information summary and list of main points (fig. 22.1).

3. Review each item in the *bracketed observation* pages of the rough book in light of the *contextual information.* Record your thoughts regarding the *symbolic* and *narrative* content of visual elements under review, placing them in the appropriate column (fig. 22.2).

4. Write a brief synopsis of your contextual associations.

Note: It is best to write more information rather than less, and then editing and refining the writing for the final version of the *Analysis Outline.*

PAGE 1

ELEMENT	ELEMENT FUNCTION	ELEMENT CONDITION	SYMBOLIC	NARRATIVE
A. ROOM	FOR DINING, ENTERTAINMENT AND WORK AREA	THE ROOM IS VERY DARK. THERE IS A SMALL AMOUNT OF LIGHT EMANATING FROM THE LEFT HAND SIDE.	THE ROOM IS DARK, DARKNESS IS A SYMBOL FOR MYSTERY, FEAR, EVIL OR DEATH.	CLAESZ PAINTS THE ROOM IN A VERY DARK, ALMOST MONOCHROMATIC HUES, INDICATING THE HUMAN INHABITANTS HAVE LEFT, AND THAT HELPS DEVELOP THE DEATH AND DYING NARRATIVE.
B. HUMAN SKULL	PROTECTS THE BRAIN AND ADDS STRUCTURE TO THE FACE AND HANDS.	THE SKULL IS YELLOWED AND CRACKED INDICATING IT IS OF CONSIDERABLE AGE. MANY TEETH ARE MISSING AND THE EDGES ARE WORN AND TATTERED	THE SKULL (SKELETON) IS ALL THAT PHYSICALLY REMAINS OF A PERSON AFTER DYING AND IS USED TO SYMBOLIZE DEATH AND MORTALITY.	THE SKULL IS A SYMBOL THAT WAS USED IN MEMENTO MORI PAINTINGS TO REPRESENT DEATH AND MORTALITY. THE YELLOWING AND WELL WORN CONDITION CREATES A NARRATIVE THAT DEATH IS AN ETERNAL CONDITION.
C. WINE GOBLET	USED FOR DRINKING AND TASTING WINE	THE OVERTURNED GLASS WINE GOBLET IS EMPTY AND RESTING WITH ITS RIM ON THE TABLE. IT LOOKS CLEAN AND PRISTINE.	A GLASS WINE GOBLET IS USED TO SYMBOLIZE WEALTH AND LUXURY. BECAUSE OF ITS HOURGLASS SHAPE GOBLETS HAVE ALSO BEEN USED TO SYMBOLIZE TIME.	THE WINE GOBLET MARKS BACK TO BETTER, HAPPIER TIMES. THE PRISTINE CONDITION, COUPLED WITH THE OVERTURNED GOBLET, COMMUNICATES THE IDEA THAT HAPPIER TIMES ARE FLEETING AND DEATH IS ETERNAL.
D. OIL LAMP	ILLUMINATES AN AREA WITH OIL, WICK AND FRAME.	THE OIL LAMP IS EMPTY WITH A SMALL AMOUNT OF SMOLDERING ASH BURNING ON THE LEFT EDGE. THE LAMP LOOKS TO BE OF CONSIDERABLE AGE AND WELL USED. THERE ARE STAINS AND THE EDGES OF THE LAMP HAS MANY IMPERFECTIONS.	OIL LAMP'S FLAME PROVIDES THE LIGHT TO READ AND WRITE AT NIGHT SYMBOLIZING REASON, LIFE OR A BEGINNING. THIS LAMP IS BURNED DOWN AND IS BARELY SMOLDERING WHICH WOULD SYMBOLIZE DEATH OR AN END.	THE SMOLDERING OIL LAMP IS REPRESENTING TIME PASSAGE, MUCH LIKE AN HOURGLASS. HERE, CLAESZ PAINTS THE OIL LAMP AT THE MOMENT THAT THE LIFE OF THE OIL LAMP IS EXTINGUISHED. THIS IS REPRESENTING THE VERY END OF LIFE.

Figure 22.1 Completed Rough Book (left page): *Bracketed observation.* This illustrates the form and the recorded information for an *element, element function,* and *element condition* in the bracketed observation.

PAGE 2

ELEMENT	ELEMENT FUNCTION	ELEMENT CONDITION	SYMBOLIC	NARRATIVE
E. BOOKS, PAPERS	USED FOR READING, INTELLECTUAL SPECULATION DOCUMENTING INFORMATION OF MANY KINDS - ACCOUNTING AND BUSINESS.	THE BOOKS LOOK WORN AND TATTERED. SOME OF THE PAGES ARE TURNED UP AND THE PAGES OF THE BOOK APPEAR YELLOW AND AGED.	BOOKS ARE A SYMBOL FOR TRUTH, KNOWLEDGE, GROWTH AND WISDOM. THESE BOOKS ARE CLOSED, THEIR INFORMATION IS NOT ACCESSIBLE, WHICH COULD SYMBOLIZE AN ENDING.	CLAESZ PAINTS THE BOOKS AS CLOSED AND VERY WORN. THIS COULD BE ADDING TO THE NARRATIVE THAT WITH DEATH, LIFE AS WE KNOW IT, IS OVER. THE PURSUIT OF KNOWLEDGE IS DONE.
F. QUILL PEN	USED FOR WRITING WITH INK	THE FEATHER QUILL PEN LOOKS TO BE WELL USED. THE TIP OF THE PEN IS BLACKENED FROM THE INK AND IN NEED OF SHARPENING, THE FEATHERS LOOK SLIGHTLY TATTERED.	FEATHER QUILL PEN IS USED FOR TRANSMISSION OF THOUGHT AND THE RECORDING OF BUSINESS TRANSACTIONS. A QUILL PEN COULD SYMBOLIZE INTELLECTUALISM AND THE PURSUIT OF KNOWLEDGE AND COMMERCE	THE FEATHER QUILL PEN IS WELL WORN AND PRECARIOUSLY BALANCED BETWEEN THE BOOKS AND INK CONTAINER. THIS VISUALLY CONNECTS THE TWO ELEMENTS AND IS STRENGTHENING THE IDEA THAT LIFE, AND THE PURSUIT OF KNOWLEDGE AND COMMERCE IS FLEETING. THE FEATHER PEN IS EXTREMELY FRAGILE AND COULD BE BLOWN OFF WITH THE SLIGHTEST BREEZE.
G. INK CONTAINER	HOLDS INK USED FOR WRITING	THE INK CONTAINER IS LAYING ON ITS SIDE AND APPEARS TO BE EMPTY.	THE INK CONTAINER IS EMPTY AND LAYING ON ITS SIDE COULD SYMBOLIZE THAT THE BLOOD OF INTELLECTUAL PURSUITS HAS RUN OUT.	THE INK CONTAINER IS EMPTY AND LAYING ON ITS SIDE AND NO LONGER FULFILLS ITS ROLE IN THE WRITING PROCESS.
H. INK HOLDER	HOLDS INK CONTAINER	THE INK HOLDER APPEARS TO BE WORN. THE LEATHER STRAPS SHOW AGE AND APPEARS TO BE WELL USED.	THE WORN INK HOLDER (INTELLECTUAL BLOOD) IS NO LONGER ABLE TO PERFORM ITS DUTIES SYMBOLIZING THE FRAILTY THAT COMES WITH AGE.	THE WORN INK HOLDER HELPS TO STRENGTHEN THE NARRATIVE THAT KNOWLEDGE AND TRUTH IS A LIFE LONG PURSUIT.
I. TABLE TOP	USED FOR DINING, WORK AREA, OR STORING OBJECTS	THE TABLE TOP IS CRACKED AND CHIPPED ON THE EDGES. THERE ARE HORIZONTAL LINES THAT INDICATE THE TABLE MAY BE MADE OF WOOD PLANKS.	THE TABLE TOP IS A SYMBOL FOR EARTH OR THE MATERIAL WORLD. ALL OF THESE EARTHLY POSSESSIONS ARE ARRANGED AND CONTAINED WITHIN THE EDGES OF THE TABLE.	THE USE OF THE TABLE TOP IN THE NARRATIVE IS VERY SUBTLE. THE TABLE TOP IS WORN, OLD AND HAS CRACKED PLANKS. THE SKULL AND THE WOOD WERE BOTH LIVING THINGS THAT ARE NOW DEAD AND DECAYING. THIS IS THE END OF ALL LIVING THINGS AND NOTHING CAN ESCAPE DEATH.

Figure 22.2 Completed Rough Book (right page): *Contextual Association.* This illustrates the possible *symbolic* and *narrative content* gained through their consideration in light of the *contextual information* (*contextual association*).

Completed *Contextual Association*, Section 10 of the *Analysis Outline*

Still Life with a Skull and a Writing Quill, by Pieter Claesz

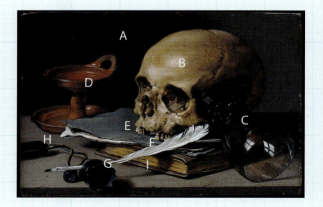

Contextual Association

Element	Symbolic	Narrative
A. Room	The darkened room represents its emptiness (no humans), mystery, fear, evil, or death.	The room is no longer inhabited, its (the room's) inhabitants have left. Recent activities (smoldering lamp) have ceased.
B. Human skull	The skull represents the death of the human body, for what was flesh covered and alive is no longer.	The skull is resting on a book and papers, like a paperweight, seemingly holding them down. It also appears to contribute to the overturned position of the wine goblet.
C. Wine goblet	A goblet represents joy, wealth, luxury, an excess of pleasure. Its shape is similar to an hourglass, representing the passage of time.	The goblet is tipped over, resting on its fragile glass rim, no longer able to hold wine. The skull is supporting its base, keeping it in its current position.
D. Oil lamp	Oil lamps are a source of light. Light allows us to see and function in dark environments, with all that entails. The light of the mind is reason. Light is a thing, darkness is the absence of a thing.	The smoldering oil lamp indicates that it was emitting light just moments ago, implying human activity that has recently ended. The room's inhabitants have left, and it is left in darkness.
E. Book, papers	Books represent recorded, knowledge, reasoning, and wisdom.	These books are closed, as they are weighted shut by the human skull, and their information is not accessible, which could represent an ending.
F. Quill pen	Feather quill pen is used for transmission of thought, and could symbolize intellectualism, the pursuit of knowledge, business law, governance, and so on.	The feather quill pen looks well worn and is precariously balanced between the books and ink container. This visually connects the two elements and strengthens the idea that life, and the pursuit of knowledge, are fleeting. The feather pen is extremely fragile and could be blown away with the slightest breeze.
G. Ink container	The ink container is empty and lying on its side unable to fulfill its function, meaning a cessation of writing and all that the recording of thought represents.	The empty ink container, lying on its side, is precariously close to the table's edge and in danger of falling off. The active pursuit of knowledge is over.
H. Quill case	The quill case is worn, and a good portion cropped view. It could be empty or full. It is not possible to assign symbolic significance to it.	The quill case presents a bit of a mystery. Most of the case is cropped, hiding its status in fulfilling its function.
I. Tabletop	The tabletop represents the earth or material world. All these earthly possessions are arranged and contained within the edges of the table.	The tabletop is ground, or immediate environment, on which the elements of the painting rest, the place where they no longer function.

Visual Content Summary, Section 11

Objectives: Identify (narrative, symbolic, formal) and synthesize visual content information.

VOCABULARY

Bracketed Observation: The process discerning a visual element, the element's function and condition.

Element Condition: The outward appearance of a visual element. The third step in bracketed observation.

Contextual Association: The relating of a work's contextual information to its visual information.

Contextual Information: Visual or non-visual information associated with a work that is not part of its form.

Curvilinear Shapes: Shapes composed of rounded flowing edges.

Formal Content: Information that relies on the visual nature of the unit forms and their interaction.

Element Function: The purpose (being) of a visual element. The second step in bracketed observation.

Narrative Content: Image that tells a story. This may include commercial imagery.

Non-Representational Shape: A shape that does not replicate or refer to an object in the real world.

Rectilinear Shapes: Shapes composed of straight edges.

Secondary Level of Perception: A sustained visual examination of an image to discern its visual content, either formal, symbolic, narrative singularly or in combination.

Symbolic Content: Visual unit forms represent something beyond their appearance, that is, a dove represents peace.

Visual Content: The message communicated by a visual image. It may be formal, symbolic, narrative, or a combination of the three.

Visual Information: The image one sees and its constituent forms.

In this final section of the *Analysis Outline,* we will synthesize our findings for the *visual content* of the image in three summary paragraphs: for *narrative, symbolic,* and *formal content.* The *Visual Content Summary* is similar to the *Unity and Variety* section of the *Outline* in that it requires careful examination of the image and reflection of the information gathered in previous sections of the *Analysis.* The *contextual association* is of particular importance as it contains *visual content* discerned in the *bracketed observation* in relationship to the *contextual information.* This will provide the foundation for the conclusions reached in this section of the *Analysis Outline.*

The summary objective is to determine the roles played by the three types of visual content information *(narrative, symbolic, formal).* Most images will be a mix of the three, as seen in Chapter 11; there are images that are strictly *formal* in their visual content. It will be important to present a reasoned summary of the information, as a conclusion may be anything but a straightforward matter. Much of the *visual information* under consideration may be open to different interpretations. A clear explanation of one's reasoning will facilitate the veracity of the opinions rendered. Designating the dominant, subdominant, and subordinate content categories should be based on the type of visual information represented by the elements as a *whole.* Individual elements may vary in the category of content they provide to the work. The paragraphs are to be written in a hierarchical order, with the dominant (most prominent) type of visual content appearing first and the following paragraphs in descending order of importance.

We will start with the *narrative* category although the dominant category will appear first, which may or may not be the *narrative* paragraph. *Narrative content* tells a story, which is made up of a sequence of events. Most often a picture's narrative content will take its form from a single sequence in the story's events. Through the *bracketed observation,* the *element, element function,* and *condition* have been cataloged with the purpose of gleaning potential *symbolic* and *narrative content* of the visual elements that comprise the work. The association of these findings with the image's *contextual information* should yield the element's *narrative* and/or *symbolic content.*

If a work's title indicates a storyline for the image, be it literary, religious, historical, and so on, the image should be considered, under most circumstances, to be primarily *narrative* in content. This still may not be as straightforward as we would like it to be. *The Birth of Athenae from the Head of Zeus* (fig. 23.1) when viewed without its title information could only be considered to be a *non-representational formal* image composed of geometric *shapes.* The title provides a mythological *narrative* and a *symbol-producing* matrix as the *rectilinear* and *curvilinear* forms are easily identifiable as male (*rectilinear*) and female (*curvilinear*) shapes.

Symbolic visual elements represent meaning beyond what their appearance indicates they are. The element *function* and *condition* in the *bracketed observation* may provide *symbolic* information, though it is the image's association with the *contextual information* that will provide extra layers of meaning to the image forms. Primarily *symbolic* images may contain *narrative* elements that do not interfere with their dominant designation as *symbolic* works, that is, a still life painting featuring a table laden with highly symbolic elements such as partially filled wine glasses, snuffed out candles, half empty plates of food also implies a past narrative, the *narrative* action of a dinner party (fig. 23.2). The *symbols* convey to the viewer the most significant *visual information,* with the *narrative* action supporting the *symbolism* in the work.

Figure 23.1 *The Birth of Athenae from the Head of Zeus.*
The title to this image imbues it with a strong storyline and charges the geometric *shapes* with *narrative* and *symbolic* content by informing the viewer's *Gestalt* with recognition cues, allowing one to anthropomorphize the main form into the *symbolic* figure of Zeus. The progression of large circles to small ones in the ULQ represents the *abstracted narrative* action of Athenae's birth.

Figure 23.2 *Still Life with Oysters, a Silver Tazza, and Glassware,* Willem Claesz Heda.

Every image is *formal*, regardless of its visual resolution, and some are expressive of only a purely *formal* message. Most *representational* works will be a mix of the three content categories. Those images that are primarily *symbolic* or *narrative* are only able to communicate to the viewer through their visual form (Fig. 23.3). More passive *formal content* acts in the role of a film's musical score to more dominant *symbolic* or *narrative content*, which is not to imply that movie music cannot be powerful and compelling. George Bellow's lithograph *Stag at Sharkey's* (fig. 23.4) demonstrates an interplay of opposing diagonal forces that creates the drama of the boxing match. All the elements of design lend themselves at the service of *narrative* and *symbolic content*.

Figure 23.3 *An Extensive Wooded Landscape*, Philips Koninck.
Koninck provides the viewer with a broad, vast panoramic image of a river, fields, wooded areas, buildings, and a large sky filled with billowing clouds. The human figures in the *foreground, mid-ground,* and *background* are dwarfed by their environment, appearing antlike in their surroundings, symbolizing the overwhelming expanse of nature and humankind's insignificance in comparison. The human figures are involved in a variety of activities that lend a *narrative* quality to the image, which is subordinate to its *symbolic content.*

a

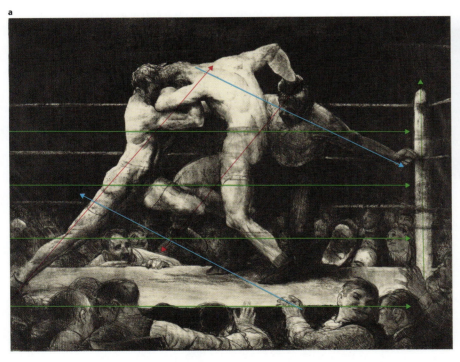

b

Figure 23.4a (above), and 23.4b (above right) *Stag at Sharkey's* George Bellows.
Bellows makes use of strong *compositional dynamics* that enliven the action of the boxers and referee. The force of the opposing diagonals (shown in red and blue) is stabilized by the vertical ring post and repeating horizontal ropes (shown in green).

The Process: Re-read Chapter 11, 20–23

1. In the *rough book*, draw three vertical columns approximately 2.375" in width. Write the three content categories (*narrative, symbolic, formal*) as headings for each column (fig. 23.5).

2. Review, carefully, the *Bracketed Observation, Contextual Information,* and *Contextual Association* sections of the *Analysis Outline.* The *formal content* category will require a review of the first half of the *Outline.* Write in relevant information within the content category columns in the rough book, focused on answering the following questions (fig. 23.5).

NARRATIVE CONTENT:

a. What is the storyline of the image?
b. Identify the story's key visual elements.
c. How does the image express the storyline (by high-lighting one of the story's characters, sequences, etc.)?
d. How has the artist interpreted the story, that is, visually emphasizing a particular aspect or point of view?

SYMBOLIC CONTENT:

Consider the three most important elements:
a. Identify the *symbolic* elements.

b. Explain the *symbolism* of the elements.
c. How do the *symbolic* elements relate to the *narrative* content?

FORMAL CONTENT:

a. Consider the three most important elements from Section 7 of the Analysis Outline (the Unity, Variety, and Balance paragraphs).
b. Do the image's *formal* components contribute to its *symbolic* or *narrative content?*
c. Explain the relationship between the *formal, symbolic,* and *narrative content.*

After reviewing the material, determine which content category (*narrative, symbolic, formal*) is dominant. Write the paragraphs in descending order of importance (dominant, subdominant, subordinate).

Label each paragraph with a heading stating: content category (*symbolic,* etc.), position in the hierarchy (dominant, subdominant, subordinate).

3. Write a paragraph outline for each of the content categories.

4. Write a rough draft for each of the three required paragraphs.

5. Revise and polish the paragraphs, writing the final version of this, the concluding section of the *Visual Analysis Outline,* on 1/8-inch grid paper.

Figure 23.5 Step 1 & 2. Divide a rough book page into three columns, labeling them *Narrative, Symbolic,* and *Formal.* Record relevant information from the completed sections of the *analysis.*

Completed *Visual Content Summary,* Section 11 of the *Analysis Outline*

Still Life with a Skull and a Writing Quill, by Pieter Claesz

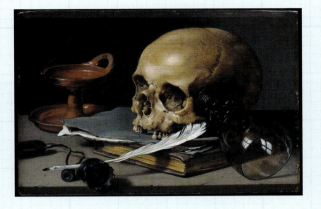

Visual Content

Symbolic, Dominant Visual Content

The still life painting *Still Life with a Skull and a Writing Quill* by Pieter Cleasz is predominantly symbolic in its visual content. The most important symbolic elements in order of importance are the skull, quill and ink bottle, wine glass, book with papers, and oil lamp. The human skull, the largest and most striking visual element, is symbolic of death, as it represents our earthly remains after passing from this life. This particular skull is yellowed, and missing teeth (suggesting it's old), also symbolizes death's perennial nature, one that no person can avoid. Its dominance informs the other symbolic elements in the painting, suggesting a certain permanence to their condition. The overturned (empty) ink bottle with quill along with the book and papers is symbolic of the demise of our intellectual life, as the skull (death) is resting heavily on the books and papers, and the ink for recording our thoughts has run out. The overturned wine glass rests on its fragile rim and is empty (like the ink bottle), of the social relationships and joy of life that wine can bring. Finally, the oil lamp with its smoldering wick no longer provides a light-producing flame or the light of life. This still life is an example of the *memento mori* (Latin for "remember death") genre of still life painting that calls on the viewer to consider the fleeting nature of life on earth.

Narrative, Subdominant Visual Content

Claesz's still life features a close-cropped view of a table in a darkened room. There are no human figures though it appears, from the smoldering wick of the oil lamps, that people were recently in this scene. The viewer is presented with evidence of past narrative actions that occurred just moments ago. The lamp's wick has been snuffed, the ink bottle and wine glass have been knocked over, the book and folder of paper are closed. The visual residue of narrative action plays a supporting role in the painting's symbolic content.

Formal, Subordinate Visual Content

The formal elements and their arrangement communicate the painting's symbolic and narrative content through the low value, low chromatic hues and limited lighting, creating a melancholy atmosphere for the composition of the still life's objects. The largest element and most prominent symbol is the image's focal point, which lends an additional symbolic dimension to the other objects in the work. Repeating oval and circular shapes in the skull, ink bottle, wine glass, and oil lamp visually relate those symbols through their shared similar shapes, and create a rhythmic line of site through the composition by their repetition.

Appendix

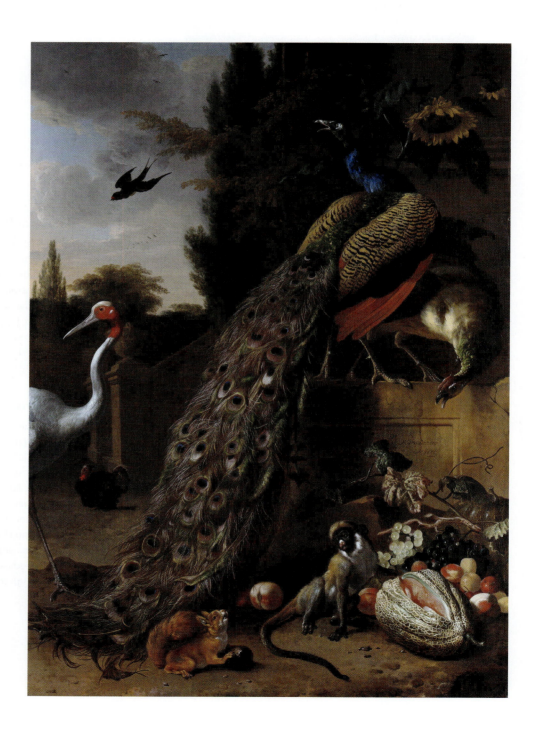

Previous page: *Peacocks,*
Melchior d' Hondecoeter

CONTENTS

APPENDIX

Suggested Artists and Artworks

The following is a list of suggested artists and artworks to be used with the Visual Analysis Outline (Chapter 12):

Osias Beert
- *Still Life*
- Still Life with Artichoke
- Still Life with Roasted Chicken

Michelangelo Caravaggio
- *David and Goliath*
- *The Calling of St. Matthew*
- *The Conversion of St. Peter*
- *The Deposition*
- *The Inspiration of St. Mathew*

Pieter Claesz
- *Still Life with Nautilus Cup, Skull, Roemer, and Incense Chain*
- *Still Life with Herring, Wine, and Bread*
- *Still Life with Salt Tub*

Georges de La Tour
- *The Cheat with the Ace of Clubs*
- *The Fortune Teller*
- *St. Jerome*

Willem Kalf
- *Still Life with Holbein Bowl, Nautilus Cup, Glass Goblet, and Fruit Dish*
- *Still Life with Drinking Horn*
- *Pronk Still Life with Holbein Bowl, Nautilus Cup, Glass, Goblet, and Fruit Dish*

Henri Fantin-Latour
- *Still Life, Primroses, Pears, and Pomegranates*
- *Still Life with a Carafe, Flowers, and Fruit*
- *Still Life*

Suggested Websites

The following list of websites can be used to download images for the Visual Analysis Outline and/or to create a PowerPoint presentation:
www.getty.edu (The J. Paul Getty Museum)
www.metmuseum.org (The Metropolitan Museum of Art)
www.wikiart.org
https://commons.wikimedia.org/wiki/Main_Page (Wikimedia Commons)

Assignment Sequencing

The following chart outlines a suggestion for the assigning and sequencing of the readings in Part I, *Form & Content*; completion of the sections in the *Visual Analysis Outline (V.A.O.)*, Part II; and artists and artworks to consider for the process.

The initial sections of the *Visual Analysis Outline* are particularly important for the development of an *abstracting vision*. The paintings listed in the chart are only suggestions. Consider images rich in a variety of realistic elements when selecting works for analysis, as they facilitate the development of one's ability to perceive familiar objects as a configuration of *abstract* forms.

Assignment	Chapter	Chapter	V.A.O.	Suggested Artists and Artwork	
	Part I	Part II	Sequence		
#1	1–2	13	1	Jean-Baptiste Chardin	*Still Life with Brioche*
#2	3	14	1–2	Pieter Claesz	*Still Life with Ham*
#3	6	15	1–3	Osias Beert	*Still Life with Oysters*
#4	7	16	1–4	Willem Kalf	*Still Life with Oriental Rug*
#5	8–9	17	1–5	Pieter Claesz	*Tobacco Pipes and a Brazier*
#6	10	18	1–6	Georges de La Tour	*The Hurdy Gurdy Player*
#7	1–10	19	1–7	Caravaggio	*The Deposition*
#8	11	20–23	8–11	Caravaggio	*The Deposition*
#9	10–11	19–23	7–11	Georges de La Tour	*The Hurdy Gurdy Player*
#10	1–11	13–23	1–11	Caravaggio	*David and Goliath*

Assignment Sequencing

The column heads read *Assignment, Chapter Part 1, Chapter Part 2, V.A.O. (Visual Analysis Outline) Sequence, Suggested Artists and Artworks.* It is important to complete the formal analysis before attempting the visual content analysis, as form plays an integral role in an image's visual content. Assignment number 8 brings forward an image that has been analyzed for its formal qualities for visual content analysis, speeding up the process. Assignment 9 brings forward an image that is lacking one section of formal analysis that is to be completed with the visual content analysis.

Dynamic Symmetry and Related Proportions

Chapter 8, Proportion

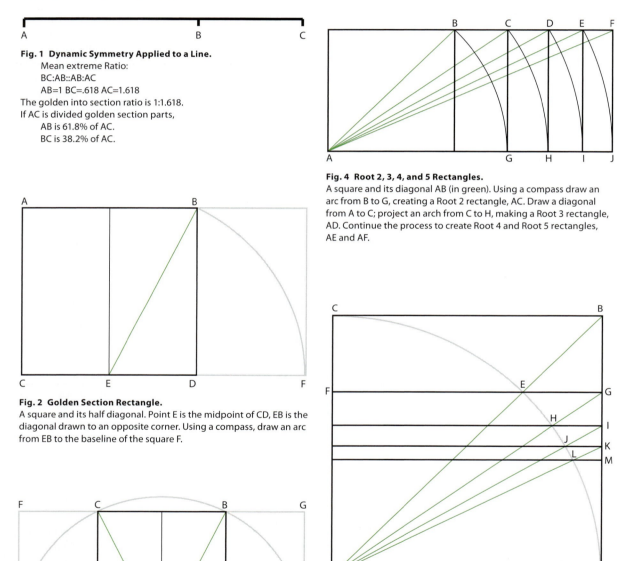

Fig. 1 Dynamic Symmetry Applied to a Line.
 Mean extreme Ratio:
 BC:AB::AB:AC
 AB=1 BC=.618 AC=1.618
The golden into section ratio is 1:1.618.
If AC is divided golden section parts,
 AB is 61.8% of AC.
 BC is 38.2% of AC.

Fig. 2 Golden Section Rectangle.
A square and its half diagonal. Point E is the midpoint of CD, EB is the diagonal drawn to an opposite corner. Using a compass, draw an arc from EB to the baseline of the square F.

Fig. 3 Root 5 Rectangle.
Created from a square and two half diagonals AB and AC. Using a compass draw an arc from AB to E and AC to D.

Fig. 4 Root 2, 3, 4, and 5 Rectangles.
A square and its diagonal AB (in green). Using a compass draw an arc from B to G, creating a Root 2 rectangle, AC. Draw a diagonal from A to C; project an arch from C to H, making a Root 3 rectangle, AD. Continue the process to create Root 4 and Root 5 rectangles, AE and AF.

Fig. 5 Subdivide a Square into Roots 2, 3, 4, and 5.
A square and its diagonal AB (in green). Using a compass draw an arc from A to C, ending at D (in grey). At the intersection of line AB and arc CD draw a horizontal line FG making the Root 2 rectangle, AG. Draw a diagonal line from A to G. At the intersection of line AG and arc CD draw a horizontal line, I, making the Root 3 rectangle, AI. Continue this process to make the Root 4 and Root 5 rectangles, AK and AM.

Constructing Golden Section Margins

Chapter 8, Proportion

The golden section proportion is used to create harmonic margins in a book or publication. You will need a T-square and 45° triangle to complete this exercise.

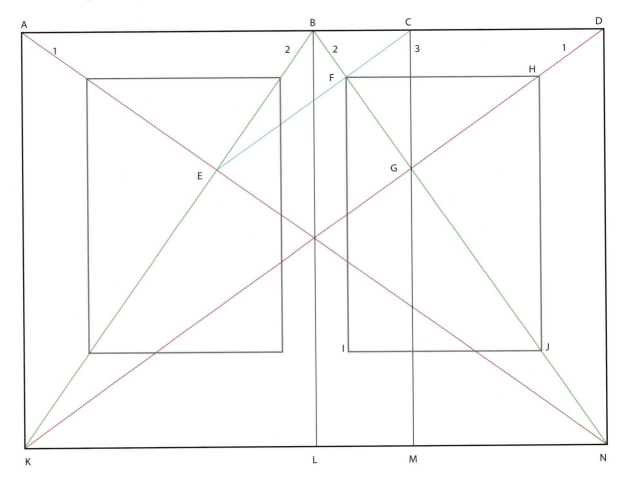

Using a T-square and 45° triangle, draw a diagonal line from point A to point N and point D to point K. These diagonal lines are shown in red. Second, draw a diagonal line from point B (top of gutter) to point K and point B to point N. These diagonal lines are shown in green. Third, draw a vertical line from point C that passes through point G and ends at point M. Fourth, draw a diagonal line from point C to point E. This line is shown in blue.

Using a T square draw a horizontal line from point F to point H. This line is shown in gray. Using a T-square, and triangle, draw a line from point H to point J. Project a vertical line down from point F and a horizontal line left from point J. The intersecting of these two lines will give you point I and completes the rectangle. Project a line from point F (top) and point I (bottom) to the left spread and complete the left rectangle shown in gray.

Handwriting Exercise

Chapter 12, Visual Analysis Outline

This exercise should be handwritten in black pen on 1/8-inch grid paper (the grid shown below is not to scale). All the final analyses and rough books should follow this handwriting format.

Capline
Meanline
Baseline

Constructing a Harmonic Armature

Chapter 9, Structure

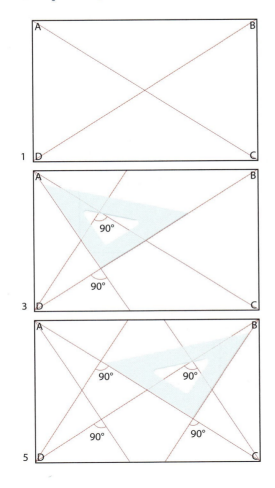

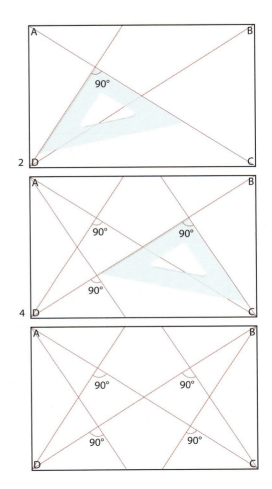

This series of illustrations demonstrates how to draw a harmonic armature in a long rectangle. The progression starts in the top left and moves right to left and top to bottom.

The armature consists of two diagonal lines projecting from the four corners of a long rectangle. The first two diagonals are drawn to connect the opposing corners of the rectangles. The second diagonal is drawn from each corner so it intersects the diagonal line opposite it (the corner) at a 90° angle.

1. Draw a diagonal line from point A to point C and from point D to point B.

2. Slide a 90° triangle along line AC until it intersects corner D. Draw a line to corner D and extend the line from D to intersect line AB.

3. Slide a 90° triangle along line BD until it intersects corner A. Draw a line to corner A and extend the line from A to intersect line CD.

4. Slide a 90° triangle along line BD until it intersects corner C. Draw a line to corner C and extend the line from C to intersect line AB.

5. Slide a 90° triangle along line AC until it intersects corner B. Draw a line to corner B and extend the line from B to intersect line CD.

Proportion Exercise for Rectangle

Chapter 8, Proportion

1. Measure the short side of the rectangle.
2. Measure the long side of a rectangle.
3. Divide the short side measurement into the long measurement.
4. This number represents the proportional expression of the rectangle's long side.
5. The short side's ratio is always 1.

Rubber-Cementing Instructions

The Process

1. Cut the printed image to its proper size. It should fit in the top third of the rough book and on 1/8-inch grid paper pages.

2. Cut a *Slip Sheet*, a blank piece of paper slightly larger than the printed image. The *Slip Sheet* will act as a shield between the printed image and the paper onto which the image is being glued.

3. With a pencil and straight edge, mark guide lines for placing the printed image. The guide lines will also define the space on which to put rubber cement.

4. Place the printed image face down on a paper towel and coat the back side with an even covering of rubber cement. Let the rubber cement dry completely.

5. Cover the area defined by the pencil guide lines (on the grid paper) with an even coating of rubber cement and let it dry completely.

6. Place the Slip Sheet between the printed image and grid paper. Align the top of the printed image with the top guide line on the grid paper.

7. Slowly pull the *Slip Sheet* downward, allowing the surfaces coated with dry rubber cement to come into contact with one another. Press down on the center of the printed image and then out to either side.

Constructing a Single and Double Rabatment of a Rectangle

Chapter 9, Structure

To complete this exercise, you will need a T-square, triangle, and compass.

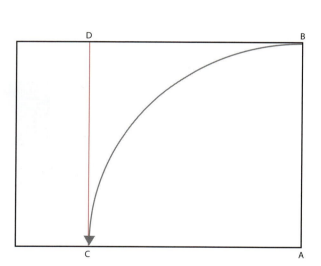

Single Rabatment

Using a compass, project the short side of a long rectangle (AB) onto the long side (C). Using a 90° triangle and T-square, project a line from point C to D. This creates a square within the long rectangle. The rabatment (shown in red) can be used as a container for design elements or in the placement of accent points on or near the square's interior edge (rabatment line).

Double Rabatment

In the construction of a double rabatment, the short side (AB) is projected on the long side of the rectangle (C). Using a T-square, project a line from point C to point D. This forms one rabatment (in red). Next project the short side of the rectangle (EF) onto the long side (G). Using a T-square, project a line from point G to point H (in red). This forms two squares (top and bottom) within the long rectangle.

Visual Analysis Layout

Artwork Title, Artist's Name

Your Name Date

1 of 2

One Square Cell Space

Section Head (underline section head)

One Square Cell Space

Write an appropriate description for each of
the relevant sections assigned from the
analysis sheet.

Two Square Cell Spaces
Between Sections

Section Head

One Square Cell Space

Note: This handout should be used for
Chapter 12, Visual Analysis Outline. The
final analysis should be handwritten
using black ink.

Measurement Height

Color Copy of Artwork
(proportion of artwork may vary)

One Square Cell Space

Measurement Width

Completed *Shape Type and Distribution, Section 1* of the *Analysis Outline*

Still Life with a Skull and a Writing Quill, by Pieter Claesz

This painting is representational.

Most of the shapes are curvilinear.

ULQ

Curvilinear
- Bowl of candle stick holder (oval)
- Shadow in bowl (arc)
- Handle of candlestick holder (arc)
- Inside shape of handle (arc)
- Top half of stem of candle stick holder
- Part of the forehead of skull
- Eye socket of skull
- Top half of nasal cavity

Rectilinear
None

LLQ

Curvilinear
- Quill case
- Leather straps for quill case
- Shadow of quill case
- 3/4 of writing quill (arc)
- Shadow in bowl of candle stick holder
- Bottom of stem of candlestick holder
- Small round part of ink container
- Larger oval base of ink container
- Top portion of ink container
- Shadow of ink container
- Teeth of skull (3)
- Bottom half of candle stick holder
- Lip of skull
- Cheek bone of skull

Rectilinear
- Pages of paper (2)
- Book cover
- Shadow of writing quill

URQ

Curvilinear
- Top arc of skull
- Shadow of back of skull (arc)
- Eye socket in skull
- Temple shadow on skull
- Bottom foot of goblet
- Small section of goblet stem

Rectilinear
None

LRQ

Curvilinear
- Stem of goblet
- Detail ovals on goblet (5)
- Bowl of goblet (oval cut in half)
- End of writing quill
- Shadow on book of writing quill
- Small section of goblet foot
- Bottom of eye socket
- Left cheek of skull
- Teeth
- Very small piece of skull (right side)

Rectilinear
- Back cover of book
- Cover of book
- Table edge
- Table edge (top)
- Paper pages (3)
- Highlight on goblet (8)

Completed *Gestalt, Section 2* of the *Analysis Outline*

Still Life with a Skull and a Writing Quill, by Pieter Claesz

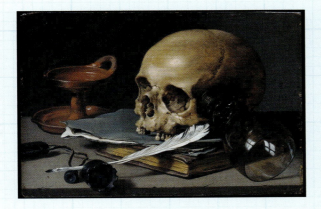

Gestalt

Proximity

The dominant (largest group) in the painting is formed by the objects on the table as they are all in close proximity. The skull, goblet, book, and papers form the subdominant group (a subgroup) in the URQ and LRQ. The subordinate group (another subgroup) is formed by the feather quill pen and ink container in the LLQ, as they overlap in the foreground of the composition. The reddish-colored lamp is a prominent object within the dominant group, standing in back of the subdominant and subordinate groups.

Continuation

A real line is created by the front of the table. It extends from the LLQ through the LRQ in the foreground. The rear edge of the table continues behind most of the elements, from the LLQ to through the LRQ, forming another real line. A strong diagonal suggested line is created by the alignment of the oval shape of the reddish lamp, ovals of the skull's eye sockets, and the oval form of the wine goblet. The alignment of these elements is enhanced by the similarity of their shapes. A parallel diagonal suggested line extends from the bottom of the book in the LLQ through the base of the reddish oil lamp (LLQ). A counter diagonal suggested line is created by the alignment of the feather quill pen and the back bottom of the skull in the LLQ and LRQ. It is paralleled by a suggested line running from the

quill case, in the LLQ, through the edge of the greenish papers (LLQ) extending through the nasal cavity to the fissure in the back of the skull (URQ).

Closure

There are a few examples of closure in this composition created by the disappearing edges of the bowl, stem, and base of the wine goblet located in the LRQ, as well as in the base of the skull in the LRQ. Closure is also seen in the edge of the book that is barely visible through the glass wine goblet in the LRQ. The contours of the ink container and ink container handle located in the LLQ are lost in the black of the shadows.

Similarity

The dominant examples of similarity in this composition are the repeating ovals. The ovals appear in the bowl and base of the glass wine goblet (LRQ, foreground), the eye sockets of the skull (centrally located and in the middle ground of the composition), the black ink holder (foreground, LLQ), and in the top and base of the red-glazed earthenware oil lamp. The oil lamp is the ULQ of the composition and is similar in size and shape to the wine goblet.

The subdominant examples of similarity is the repeating diagonals. There is a strong diagonal that is created through the use of ovals that runs from the handle of the oil lamp in the ULQ (background) to the skull's eye sockets in the center of the composition and ends with the bowl of the wine goblet located in the LRQ in the foreground. This diagonal is repeated in the edge of the book that is located beneath the skull in the LRQ, and the ink holder and leather strap that are located in the LLQ. Strong counter diagonals are created by the quill pen and shadow that runs from the LLQ to the LRQ. This diagonal is repeated in the book that is located beneath the skull in the LRQ, the back of the pages that sits below to the left of the skull in the LLQ, the quill case that is located in the LLQ, the lip and handle of the oil lamp that is in the ULQ. This diagonal also appears in the skull, running from the nostril cavity to the eye socket and ending with the base of the wine goblet.

The subordinate similarity is the repeating ocher hue seen in the skull, and the pages of the book in the ULQ, LRQ, as well as in the table top in the LLQ and LRQ.

Completed *Balance,* Section 3 of the *Analysis Outline*

Still Life with a Skull and a Writing Quill, by Pieter Claesz

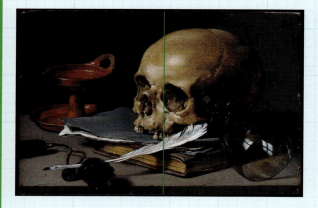

Balance

Asymmetry/Near-Symmetry/Symmetry

This painting is asymmetrically balanced. The largest visual mass is the skull, book, papers, and wine goblet (subdominant group of the proximity portion of Gestalt, Section 2) located in the URQ and LRQ (pound of feathers). The skull is the largest and most highly contrasting member of the group, with high value contrast within its eye and nose cavities. This most visually attractive portion of the skull rests on the *A.S.,* placing its visual weight in a more neutral part of the picture plane with regard to visual balance.

The ink container, container top, quill case, and quill tip (subordinant group of the proximity portion of Gestalt, Section 2) are located in the LLQ of the picture plane, forming a group of objects high in value contrast and located significantly to the left of the *A.S.* (pound of lead). The lower portion of the ink bottle overhangs the table edge, creating visual tension and adding to its visual attractiveness. The contrasting red hue of the clay oil lamp in the ULQ and its similarity of shape to the wine goblet help to complete the image's asymmetrical balance. At first glance, the red color may appear to be an isolated element, but the repeating hints of red in the back of the skull and the reflection of the goblet serve to integrate it into the compositon.

A suggested line created by the gaze of the skull directs the viewer's line of sight to the left side of the picture plane, further aiding image balance. It is tempered by a counter directional line made by the writing quill.

Completed *Focal and Accent Point,* Section 4 of the *Analysis Outline*

Still Life with a Skull and a Writing Quill, by Pieter Claesz

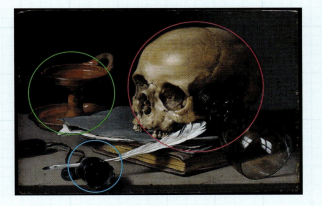

Focal and Accent Points

Dominant/Subdominant/Subordinate

In this painting by Pieter Claesz, there are three distinct accent points. The skull in the URQ and LRQ is the focal point (highlighted in red) due to contrasts of scale, value, and color. The color of the skull is a saturated ocher that is light in value and contrasts with the dark value behind it. The texture of the teeth, nose, and eye cavities, along with value contrasts within the skull, heightens its visual attraction.

The subdominant accent point is the ink container in the LLQ (highlighted in blue) due to contrasts of position, value, shape, and scale. The container overhangs the front edge of the table and is very close to the bottom edge of the picture plane, causing a good deal of visual tension. It is black (with a very dark value) and contrasts with the lighter (approximately 40% gray) table top. The shape of the ink container is round with a textured rim that adds to its contrast and it is one of the smallest elements in the composition.

The subordinate accent point is the red lamp in the ULQ and LLQ (highlighted in green) due to contrasts of color, position, and shape. The lamp is placed away from other elements in the composition, seemingly isolating its red color, which attracts the viewer's attention. Even though the color may feel isolated, it is subtly integrated into the composition, appearing on the surfaces of the glass goblet, skull, and book pages. The silhouette of the lamp is fairly complex and contrasts with the other objects in the painting.

There is a clear triangulation of dominant (focal point), subdominant, and subordinate accent points in this composition. The viewer's line of sight starts with the skull (focal point) and moves left (foreground) to the ink container (subdominant accent point), and then to the lamp (subordinate accent point), moving the viewer's gaze through the four quadrants of the picture plane.

Completed *Geometry, Section 5* of the *Analysis Outline*

Still Life with a Skull and a Writing Quill, by Pieter Claesz

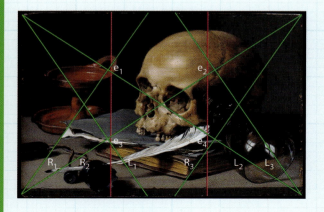

Geometry

Rabatment/Harmonic Armature Proportion

This painting measures 111.5 millimeters by 75.5 millimeters. The ratio of the painting is 1:1.47. This ratio is very close to a $\sqrt{2}$, rectangle.

Rabatment

The left rabatment line (shown in red) intersects two of the three accent points, the red lamp (ULQ) and the ink container (LLQ), which aide in the harmonic placement of each object. The right rabatment line (shown in red) runs through the center of the skull, which is the focal point of the composition, and also creates a spot for its harmonic placement. The ink bottle and lamp are housed in the left rabatment container. The goblet, skull, book, and papers, representing the largest visual mass, are in the right rabatment container.

Armature

Eyes of the Rectangle

The red oil lamp is placed on (e_1); the skull, book, and papers (focal point) rest on eyes (e_2) and (e_3). There are no prominent elements placed on (e_4).

Echo Lines

R_1, R_3:

No suggested lines.

R_2:
- LLQ-pen container–top edge papers-ULQ
- LLQ-inkcontainer–nasal and left eye cavity skull-URQ
- LLQ-ink container–feather quill–lower back edge skull-URQ
- LLQ-ink container bottom–bottom edge books–goblet-LRQ

L_1, L_3:
- LLQ-ink container–leather straps–quill case–bottom edge lamp-ULQ
- LLQ-long axis goblet-LLQ

L_2:
- LRQ-goblet rim–bottom left eye cavity and top nasal cavity skull-ULQ

Completed *Compositional Dynamics*, Section 6 of the *Analysis Outline*

Still Life with a Skull and a Writing Quill, by Pieter Claesz

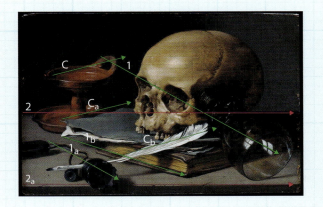

Compositional Dynamics

The dominant dynamic contour in this painting is indicated in green (1). It is a suggested line, created by the repetition of ovals, that extends through the handle of the red lamp, both eye sockets of the skull, and ends at the mouth of the glass goblet. This diagonal is repeated in the angle of the leather straps and reservoir of the black ink container (1_a), the book, and pages (1_b). The strong diagonal dynamic is a visual force that creates a more exciting composition. The counter dynamic contour is indicated in green (C, C_a, C_b), and is repeated in the red lamp, the back edge of the book and quill case, the front edge and book pages, and the feather

quill pen. This dynamic balances the strong dominant dynamic (shown in green), and prevents the composition from being overwhelmed by the visual force created by the dominant dynamic.

The subdominant dynamic contour (shown in red) is the real line that runs horizontally and is overlapped by the lamp, book, skull, and goblet (2). This horizontal is repeated in the foreground (2_a). This horizontal is also the real line that runs across the bottom near the edge of the picture plane. These two horizontal dynamics help to stabilize the stronger dominant dynamic.

Completed Unity and Variety, Section 7 of the Analysis Outline

Still Life with a Skull and a Writing Quill, by Pieter Claesz

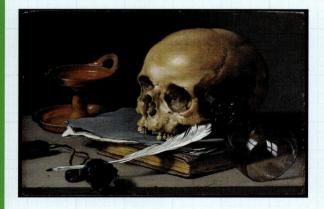

Unity and Variety

Unity

The dominant unifying elements in this composition are repeating ovals/circles: the bowl and base of the wine goblet (LRQ), the skull (URQ, ULQ, LRQ, LLQ), skull eye sockets and nasal cavities (centrally located), two circles in the ink container (LLQ), and the top and base of the red oil lamp (ULQ, LLQ). These shapes are found in each quadrant of the composition. The subdominant unifying elements are two horizontal dynamic contours (real lines). The first horizontal contour (LLQ, LRQ), formed by the back of the table, extends through the oil lamp, books, and skull. The second horizontal contour, formed by the front edge of the table, is parallel to the bottom edge of the picture plane.

The subordinate unifying elements in the composition are the repeating ocher hues (ULQ, URQ, LLQ, LRQ) that appear in the skull (high saturation and light value), book pages (similar in value and saturation as the skull), and tabletop (similar color saturation but lower value than the skull) as well as in the highlights of the oil lamp, feather quill pen, and glass wine goblet, and they are repeated in each quadrant of the composition.

The repeating shapes, dynamic contours, and colors act to integrate the elements of the composition and lend commonality to the quadrants of the picture plane.

Variety

The dominant elements that contribute to variety in this work are repeating diagonal dynamic contours. The first diagonal contour is created through the alignment of repeating ovals, making a suggested line that extends from the handle of the red oil lamp through the two eye sockets of the skull to the mouth of the glass goblet. The diagonal is repeated in the books (medium-length real line), ink container, and leather straps (medium-length real line). Repeating counter-diagonals are created by the quill pen, oil lamp handle, and the top and bottom edges of the book and papers; they are medium in length, and appear in the ULQ, LLQ, and LRQ. Asymmetrical balance is the subdominant factor in creating variety in this composition. The varying changes in scale (large skull, medium lamp and goblet, and smaller ink container) are placed so there is an unequal distribution of visual mass on either side of the picture plane, creating visual tension. The composition is brought into balance because the higher-contrast, smaller elements on the image's left side (pound of lead) are of equivalent visual weight to the lower-contrast larger elements (pound of feathers) on its right side.

The subordinate elements that contribute to variety are the variations in the repeating shapes (curvilinear) and hues (ocher variations) mentioned in the unity paragraph.

Unity and Variety

Pieter Claesz has created a good balance of unity and variety in this composition. He has used a clear repetition of similarly shaped objects, repeating colors and angles (horizontal and diagonal) to create unity, and is balancing this repetition with the change in scale (large, medium, and small), counter-diagonals to the dominant dynamic diagonals, and change in value of the repeating color. These differences add variety to the composition and create a more exciting design to hold the viewers' attention.

Completed Bracketed Observation, Section 8 of the Analysis Outline

Still Life with a Skull and a Writing Quill, by Pieter Claesz

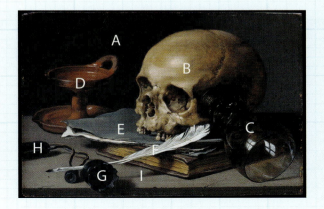

Element	Element Function	Element Condition
A. Room	For dining, entertainment, and work area.	The room is very dark. There is a small amount of light emanating from the left-hand side.
B. Human skull	Protects the brain and adds structure to the face and head.	The skull is yellowed and cracked, indicating it is of considerable age. Many teeth are missing, and the edges are worn and tattered.
C. Wine goblet	Used for drinking and tasting wine.	The overturned glass wine goblet is empty and rests with its rim on the table. It looks clean and pristine.
D. Oil lamp	Illuminates a darkened area with oil and a wick.	The oil lamp is empty, with a small amount of smoldering ash burning on the left edge. The lamp looks to be of considerable age and well used. There are stains, and the edges of the lamp have many imperfections.
E. Book, papers	Used for reading and documenting information.	The books look worn and tattered. Some of the pages are turned up, and the pages of the book appear yellowed and aged.
F. Quill pen	Used for writing with ink.	The feather quill pen looks to be well used. The tip of the pen is blackened from the ink, and the feathers look slightly tattered.
G. Ink container	Holds ink used for writing.	The ink container is lying on its side and appears to be empty.
H. Quill case	Holds writing quills.	The ink holder appears to be worn. The leather straps show age, and it appears to be well used.
I. Tabletop	Used for dining, work area, or storing objects.	The tabletop is cracked and chipped on the edges. There are horizontal lines that indicate the table may be made of wood planks.

Completed *Contextual Information,* Section 9 of the *Analysis Outline*

Still Life with a Skull and a Writing Quill, by Pieter Claesz

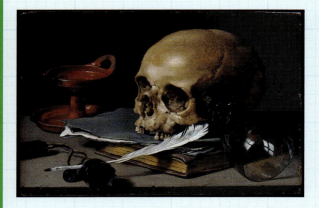

Contextual Information

Research

www.wikipedia.org/wiki/vanitas
www.wikipedia.org/wiki/memento/mori
www.wikipedia.org/wiki/pieter_claesz
www.metmuseum.org/toah/works-of-art
www.visual-arts-cork.com/pld-masters/pieter-claesz
Items to research: Pieter Claesz, genre of painting, symbolism of genre

Synopsis

Pieter Claesz, Dutch 17th-century artist, specialized in still life paintings and was an important proponent of the *ontbijt* or dinner piece. *Still Life with a Skull and a Writing Quill* is one of his earliest dated paintings, in which he used a dark, limited, value-based color scheme to create an atmosphere of somber reflection and contemplation.

Dominant Contextual Information

Still Life with a Skull and a Writing Quill is an example of the memento mori genre of painting that deals with the inevitability of death, mortality, and the fleeting nature of earthly possessions and pursuits. This information will inform our understanding of the symbolism within the work.

Subdominant Contextual Information

Research revealed that skulls, books, writing quills, and wine goblets were standard symbolic elements used by artists (Dutch 17th-century artists) working in the still life and memento mori genres, and became universal symbols of its message.

Completed *Contextual Association,* Section 10 of the *Analysis Outline*

Still Life with a Skull and a Writing Quill, by Pieter Claesz

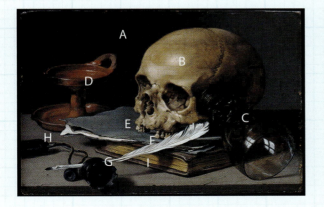

Contextual Association

Element	Symbolic	Narrative
A. Room	The darkened room represents its emptiness (no humans), mystery, fear, evil, or death.	The room is no longer inhabited, its (the room's) inhabitants have left. Recent activities (smoldering lamp) have ceased.
B. Human skull	The skull represents the death of the human body, for what was flesh covered and alive is no longer.	The skull is resting on a book and papers, like a paperweight, seemingly holding them down. It also appears to contribute to the overturned position of the wine goblet.
C. Wine goblet	A goblet represents joy, wealth, luxury, an excess of pleasure. Its shape is similar to an hourglass, representing the passage of time.	The goblet is tipped over, resting on its fragile glass rim, no longer able to hold wine. The skull is supporting its base, keeping it in its current position.
D. Oil lamp	Oil lamps are a source of light. Light allows us to see and function in dark environments, with all that entails. The light of the mind is reason. Light is a thing, darkness is the absence of a thing.	The smoldering oil lamp indicates that it was emitting light just moments ago, implying human activity that has recently ended. The room's inhabitants have left, and it is left in darkness.
E. Book, papers	Books represent recorded knowledge, reasoning, and wisdom.	These books are closed, they are weighted shut by the human skull, and their information is not accessible, which could represent an ending.
F. Quill pen	Feather quill pen is used for transmission of thought, and could symbolize intellectualism, the pursuit of knowledge, business law, governance, and so on.	The feather quill pen looks well worn and is precariously balanced between the books and ink container. This visually connects the two elements and strengthens the idea that life, and the pursuit of knowledge, are fleeting. The feather pen is extremely fragile and could be blown away with the slightest breeze.
G. Ink container	The ink container is empty and lying on its side, unable to fulfill its function, meaning a cessation of writing and all that the recording of thought represents.	The empty ink container, lying on its side, is precariously close to the table's edge and in danger of falling off. The active pursuit of knowledge is over.
H. Quill case	The quill case is worn and a good portion cropped view. It could be empty or full. It is not possible to assign symbolic significance to it.	The quill case presents a bit of a mystery. Most of the case is cropped, hiding its status in fulfilling its function.
I. Tabletop	The tabletop represents the earth or material world. All these earthly possessions are arranged and contained within the edges of the table.	The tabletop is ground, or immediate environment, on which the elements of the painting rest, the place where they no longer function.

Completed *Visual Content Summary,* Section 11 of the *Analysis Outline*

Still Life with a Skull and a Writing Quill, by Pieter Claesz

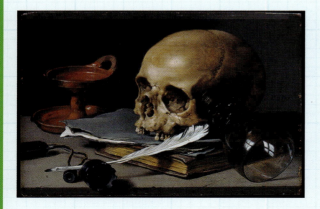

Visual Content

Symbolic, Dominant Visual Content

The still life painting *Still Life with a Skull and a Writing Quill* by Pieter Cleasz is predominantly symbolic in its visual content. The most important symbolic elements in order of importance are the skull, quill and ink bottle, wine glass, book with papers, and oil lamp. The human skull, the largest and most striking visual element, is symbolic of death, as it represents our earthly remains after passing from this life. This particular skull is yellowed and missing teeth (suggesting it's old), it also symbolize death's perennial nature, one that no person can avoid. Its dominance informs the other symbolic elements in the painting and suggests a certain permanence to their condition. The overturned (empty) ink bottle with quill along with the book and papers is symbolic of the demise of our intellectual life, as the skull (death) is resting heavily on the books and papers, and the ink for recording our thoughts has run out. The overturned wine glass rests on its fragile rim and is empty (like the ink bottle), of the social relationships and joy of life that wine can bring. Finally, the oil lamp with its smoldering wick no longer provides a light-producing flame or the light of life. This still life is an example of the *memento mori* (Latin for "remember death") genre of still life painting that calls on the viewer to consider the fleeting nature of life on earth.

Narrative, Subdominant Visual Content

Claesz's still life features a close-cropped view of a table in a darkened room. There are no human figures although it appears, from the smoldering wick of the oil lamps, that people were recently in this scene. The viewer is presented with evidence of past narrative actions that occurred just moments ago. The lamp's wick has been snuffed, the ink bottle and wine glass have been knocked over, the book and folder of paper are closed. The visual residue of narrative action plays a supporting role in the painting's symbolic content.

Formal, Subordinate Visual Content

The formal elements and their arrangement communicate the painting's symbolic and narrative content through the low value, low chromatic hues and limited lighting; these create a melancholy atmosphere for the composition of the still life's objects. The largest element and most prominent symbol is the image's focal point, which lends an additional symbolic dimension to the other objects in the work. Repeating oval and circular shapes in the skull, ink bottle, wine glass, and oil lamp visually relate those symbols through their shared similar shapes, and create a rhythmic line of sight through the composition by their repetition.

Glossary

Abstraction: Rendering a visual element or image less realistic through the elimination of visual information and simplification of form.

Accent Point: A design element of high contrast in a visual image.

Additive Color: Nonreflected colored light.

Aerial Perspective: A system for creating the illusion of three-dimensional space based on the perceptual changes of size, color, and value contrasts as seen in the natural world.

Alternating Rhythm: The regular, unchanging repetition of a design element.

Asymmetrical Balance: The equivalence of the design elements' visual weight but not their form, on either side of the vertical axis of symmetry. A pound of feathers equals a pound of lead.

Atmospheric Perspective: Another name for aerial perspective.

Axis of Symmetry: A vertical or horizontal line dividing the picture plane into two equal portions.

Background: Spatial plane that appears farthest from the viewer in a visual image.

Bracketed Observation: The process discerning a visual element, the element's function and condition.

Bright Color: Highly saturated hues.

Color Spectrum: Light passed through a prism, yielding Red, Orange, Yellow, Green, Blue, Indigo, and Violet.

Cool Colors: Feels cold; Yellow-Green, Green, Blue-Green, Blue, Blue-Purple.

Closed Composition: All the visual unit forms are contained within the image format.

Closure: The completeness of sense information in the perception of objects and environment.

Color Temperature: Hues associated with atmospheric conditions of warmth and coolness.

Columnar Grid: A typographic grid in which the primary guidelines are organized into columns, ranging from one or more.

Compositional Dynamics: The distribution of diagonal, vertical, and horizontal design elements in a visual image.

Conceptual Depth: The layering of ideas in the vessel of visual form.

Continuation: 1. A real line connecting design elements. 2. A suggested line created through the alignment of unconnected forms.

Contrast: The amount of difference between a visual unit form and its immediate surroundings.

Counter-Diagonals: Diagonal elements, either real or suggested lines, that are positioned crosswise to a dominant diagonal dynamic, offsetting its visual force.

Curvilinear Shapes: Shapes made up of rounded flowing edges.

Custom Grid: Structural networks built from a graphic element in the design.

Dark-Valued Color: Hues that have a dark grayscale equivalency.

Diagonal: Diagonal lines drawn from opposing corners of a square, used to project root rectangles.

Dominant Dynamic: The most significant diagonal, vertical, or horizontal design elements in a pictorial composition.

Dull Color: Hues of low saturation.

Dynamic Hierarchy: The ordering of design elements by the amount of visual energy they display, with diagonals at the top of the hierarchy, verticals in the middle, and horizontals at the bottom.

Dynamic Orientation: The spatial orientation (diagonal, vertical, horizontal) of a design element in a visual image.

Dynamic Rectangles: Rectangles that are generated from a square and its diagonal and a square and its half diagonal; possessing the qualities of dynamic symmetry.

Dynamic Symmetry: The just balance of variety in symmetry (as proposed by Hambridge).

Dynamically Neutral Forms: Design possessing dimensional axes of equal length.

Echo Lines: Diagonal lines within the harmonic armature to which design elements approximate themselves.

Element Condition: The outward appearance of a visual element. The third step in bracketed observation.

Element Function: The purpose (being) of a visual element. The second step in bracketed observation.

Eyes of a Rectangle: The 90° intersections of diagonal lines within the harmonic armature. These are places of harmonic rest.

Figure: Another name for positive space.

Focal Point: The design element of the highest contrast, or the primary point of emphasis in a visual image.

Foreground: Spatial plane that appears closest to the viewer in a visual image.

Forest: An analogical term meaning a broad or general view of a visual image.

Four Aspects of Color: Hue, value, saturation and temperature.

Form: An abstract quality or property expressed in matter.

Formal Balance: Symmetrical balance.

Formal Content: Information that relies on the visual nature of the unit forms and their interaction.

Formal Structure: A structural network that requires strict adherence to its guidelines.

Format/Frame of Reference: The outside edge of the picture plane. The format, or frame of reference, defines the overall size and shape of the image or design. It may be any shape but is most commonly a rectangle.

Gestalt: The whole is different than the sum of its parts.

Gestalt Function: The faculty that organizes objects into wholes and promotes the understanding of sense information.

Golden Section Rectangle: A rectangle produced from the projection of a square's half diagonal with a proportional ratio of 1:1.618.

Grid Cell: The smallest compartment in which to place design elements in a structural grid.

Ground: Another name for negative space. *Note:* The terms are used in pairs, positive/negative space, or figure/ground.

Half Diagonal: The diagonal line drawn from the midpoint of a square's side to an opposite corner.

Hierarchy of Visual Weight: The ordering of visual weight from the top of the picture plane to the bottom, or from the bottom to top, based on the conditioned expectations of the viewer.

Horizon Line: The line established by the viewer's gaze from a fixed vantage point, used in linear perspective.

Horizontal Axis of Symmetry: A horizontal line running through the middle of the picture plane, dividing it vertically into two equal portions.

Horizontal Balance: The equivalence of the visual weight of design elements on either side of the axis of symmetry.

Hue: The name of the color.

Informal Balance: Asymmetrical balance; *a pound of feathers equals a pound of lead.*

Integrative Repetition: An unrhythmic recurrence of a design element or portion of a design element lending commonality to different parts of the picture plane.

Light-Valued Color: Hues that have a light grayscale equivalency.

Line of Sight: A visual pathway or direction through an image.

Line Weight: The value of a line; how light or dark it is.

Linear Perspective: A system for creating the illusion of deep space from a fixed point of view, where the receding edges of forms meet at points on a horizon line.

Long Rectangle: A rectangle with unequal sides.

Major Axis: The long dimension of a form.

Mid Ground: The spatial plane that is beyond the foreground and before the background.

Minor Axis: The short dimension of a form.

Narrative Content: Image that tells a story. This may include commercial imagery.

Negative Space: Any part of the picture plane not covered by positive space. Negative space is also referred to as ground.

Non-Representational Shape: A shape that does not replicate or refer to an object in the real world.

Open Composition: Visual unit forms appear to extend beyond the edge of the picture plane. They are cut by the format.

Orthogonal Lines: Lines that recede to vanishing points in linear perspective.

Pictorial Hierarchy of Visual Weight: The distribution of visual weight, with the most attractive design elements at the bottom of the composition, ascending to the least attractive design elements at the top of the composition.

Picture Plane: The area to be designed. The picture plane can be paper, canvas, or other materials.

Positive Space: Any design element in the picture plane whether it be a large shape or the smallest dot or dash.

Primary Colors: Parent colors; Red, Yellow, and Blue in subtractive color and Red, Green, and Blue in additive color.

Primary Level of Perception: One's initial look at an image.

Progressive Rhythm: The regular repetition of a design element that changes with each occurrence or iteration.

Proportion: A comparison of a part of the design to the whole or to another part.

Proximity: The spatial distance between design elements.

Rabatment: The projection of the short sides of a long rectangle onto a long side of the long rectangle. Each projection will form a square within it.

Rabatment Container: The squares created within a long rectangle by the projection of its short sides onto a long side. Unity (Square) within the long rectangle provides a harmonic resting place for design elements.

Rabatment Lines: Lines created by the projection of the short sides of a long rectangle onto a long side, forming the interior side of the rabatment containers. They provide harmonic resting places for accent points.

Ratio: The numerical expression of a proportion.

Real Line: A line or edge of a form as it actually exists in a visual image.

Rectangle: A four-sided figure with four sides that meet at 90°.

Rectilinear Shapes: Shapes composed of straight edges.

Repetition: The recurrence or iteration of a design element in a visual image. Repetition may be rhythmic or non-rhythmic.

Representational Shape: A shape that replicates or refers to an object in the real world.

Rhythm: The repetition of a design element that occurs in a regular predictable way.

Root Rectangle: Rectangles with a side that is the numerical expression of the square root of a number.

Saturation: Also known as chroma and intensity; the purity of a hue.

Secondary Colors: The hues achieved by mixing primary colors; Orange, Green, Purple.

Secondary Level of Perception: A sustained visual examination of an image to discern its visual content, either formal, symbolic, narrative singularly or in combination.

Shading: The addition of black to a hue to make it darker.

Shape: A clearly defined area that one can see. It may be defined by a line or a change in value or color.

Spatial Planes: Fields of varying depth in the illusion of three-dimensional space.

Square: A rectangle with four equal sides.

Structure: A network of guidelines that promotes harmony and organization in design.

Stylization: Emphasis or the exaggeration of visual form.

Subtractive Color: Colored light reflected from pigmented surfaces.

Suggested Line: A line that is implied through our Gestalt's sense of continuation. These lines are created through the alignment of forms or their edges, or by the gaze of human or animal forms within an image.

Symbolic Content: Visual unit forms represent something beyond their appearance, that is, a dove represents peace.

Symmetrical Balance: Design elements are exactly the same in their formal appearance and placement on each side of the axis of symmetry, forming a mirror image of one another.

Tertiary Colors: The hues achieved by mixing primary and secondary colors; Yellow-Orange, Red-Orange, Red-Purple, Blue-Purple, Blue-Green, Yellow-Green.

Texture: A visually complex, detailed surface imparting a tactile feel to the viewer.

Tinting: The addition of white to a hue to make it lighter.

Toning: The addition of gray or the color's complement to diminish its saturation, or brightness.

Trees: An analogical term meaning a close detailed inspection of a visual image.

Triangulation: A visual pathway from a focal point to accent points of lessening contrast, forming a triangular eye movement.

Typographic Grid: Formal structural networks used in graphic design. The columnar grid is the most common example.

Typographic Hierarchy of Visual Weight: The distribution of visual weight, with the most attractive design elements at the top descending to the least attractive design elements at the bottom.

Unit Form/Design Elements: Visual elements that comprise the parts of a visual image.

Unity/Harmony: The agreement between the visual unit forms that comprise a visual image. Unity/Harmony creates a visual whole or oneness.

Value: Light and dark; black, white, and gray.

Variety: Difference; design elements that provide relief from sameness in visual images.

Vertical Axis of Symmetry: A vertical line running through the center of the picture plane, dividing it horizontally into two equal portions.

Visual Attractiveness: The ability of a visual unit form to draw attention to itself based on its degree of contrast.

Visual Content: The message communicated by a visual image. It may be formal, symbolic, narrative, or a combination of the three.

Visual Hierarchy: An ordering of visual unit forms from greater to lesser based on the visual attractiveness of the unit forms. An element or unit form's degree of contrast determines its place on the visual hierarchy.

Visual Image: A picture that one can see.
Visual Information: The image one sees and its constituent forms.
Visual Literacy: The ability to see a visual image and understand its form and content.

Visual Weight: The visual attractiveness of a design element based on its degree of contrast with its surroundings.
Warm Colors: Feels warm; Yellow, Yellow-Orange, Red-Orange, Red, and Red-Purple.

Bibliography

Bernet, Rudulf, Iso Kern, and Eduard Marbach, *An Introduction to Husserilian Phenomenology,* gen. ed. James Edie, assoc. ed. John McLumber. Evanston, IL: Northwestern University Press, 1993.

Bringhurst, Robert, *Elements of Typographic Style, 2nd ed.* Point Roberts, WA, Hartley & Marks, 1999.

Bowers, John, *Introduction to Two-Dimensional Design, Understanding Form and Function.* Hoboken, NJ: John Wiley & Sons, 2008.

Carter, Robert, Ben Day, Philip Meggs, *Typographic Design, Form and Communication, 4th ed,* Hoboken, NJ: John Wiley & Sons, 2007.

Conisbee, Philip, *Georges de La Tour and His World.* Washington, DC: National Gallery of Art, New Haven, CT, London: Yale University Press, 1996.

Elam, Kimberly, *Geometry of Design, Studies in Proportion and Composition.* New York: Princeton Architectual Press, 2001.

Elam, Kimberly, *Grid Systems.* New York: Princeton University Press, 2004.

Enstice, Wayne, and Melody Peters, *Drawing, Space, Form, and Expression.* Upper Saddle River, NJ: Pearson Education, 2003.

Fletcher, Rachel, *Infinite Measure, Learning to Design in Geometric Harmony with Art, Architecture, and Nature.* Staunton, VA: George F. Thompson, 2013.

Fraser, Pamela. *How Color Works.* NY: Oxford University Press, 2019.

Hambridge, Jay, *Practical Applications of Dynamic Symmetry,* ed. Mary C. Hambridge. New York: Devin-Adair, 1960.

Hambridge, Jay, *The Elements of Dynamic Symmetry.* New York: Dover, 1967.

Held, Julius S., and Donald Posner, *17th and 18th Century Art: Baroque Painting, Sculpture, Architecture.* Englewood Cliffs, NJ: Prentice-Hall, New York: Harry N. Abrams, 1972.

Hemenway, Priya, *Divine Proportion, Phi in Art, Nature, and Science.* New York: Sterling, 2005.

Howells, Richard, and Joaquim Negreiros, *Visual Culture, 2nd ed.* Malden, MA: Polity Press, 2012.

Hurlburt, Alan, *The Grid.* New York: John Wiley & Sons, 1978.

Jacobs, Michael, *The Art of Composition: A Simple Application of Dynamic Symmetry.* Rimsford, NJ: Prismatic Art, 1956.

Kane, John, *A Type Primer.* Upper Saddle River, NJ: Prentice Hall, 2003.

Köhler, Wolfgang, *The Task of Gestalt Psychology.* Princeton, NJ: Princeton University Press, 1969.

Lawson, Philip J., *Practical Perspective Drawing.* New York: McGraw-Hill, 1943.

Lauer, David, Stephen Pantak, *Design Basics, 6th ed.* Belmont, CA: Wadsworth/Thomson Learning, 2005.

Leborg, Christian, *Visual Grammar.* New York: Princeton Architectural Press, 2001.

Maritain, Jacques, *Creative Intuition in Art and Poetry,* Bollingen Series xxxv 1. New York: Pantheon Books Inc., 1953.

McLean, Ruari, *Thames & Hudson Manuel of Typography,* gen. ed. W.S. Taylor. New York: Thames & Hudson, 1992.

Mendelowitz, Daniel M., David L. Farber, and Duane L. Wakeham, *A Guide to Drawing, 7th ed.* Belmont, CA: Thomson Learning, 2007.

Nooteboom, Cees, *Zurbarán, Selected Paintings 1625–1664.* Munich: Schirmer/Mosel, 2011.

Perfect, Christopher, and Jeremy Austin, *The Complete Typographer.* Englewood Cliffs, NJ: Prentice Hall, 1992.

Powell, William F., *Perspective.* Laguna Hills, CA: Walter Foster, 1989.

Sale, Teel, and Claudia Betti, *Drawing, A Contemporary Approach, 5th ed.* Belmont, CA: Wadsworth Thomson Learning, 2004.

Squire, Victoria, Hans Peter Willberg, and Friedrich Forssman, *Getting it Right with Type.* London: Laurence King, 2006.

Woodworth, Robert S., *Contemporary Schools of Psychology.* New York: Ronald Press, 1931.

Zelenski, Paul, Mary Pat Fisher, *Color, 3rd ed.* Upper Saddle River, NJ: Prentice Hall Inc., 1999.

Image Sources

Book Frontispiece Luis Egidio Melendez via The Metropolitan Museum of Art

Part I
Frontispiece *The Afternoon Meal (La Merienda)*, Luis Meléndez, ca. 1772, https://www.metmuseum.org/art/collection/search/437053

Frontispiece, Part I *The Pearl*, © Brad Holland

Chapter 1
Figure 1.1 Baseball photo and grape photo by Keith Vanderlin

Figure 1.2 *Composition*, Piet Mondrian, 1921 http://www.metmuseum.org/art/collection/search/490012 [Public domain], Piet Mondrian via The Metropolitan Museum of Art

Figure 1.3 *Untitled*, Paul Klee, 1914 https://www.metmuseum.org/art/collection/search/483169 [Public domain], Paul Klee via The Metropolitan Museum of Art

Figure 1.4 *Still Life with Apples and Pears*, Paul Cézanne, ca. 1891–92 https://www.metmuseum.org/art/collection/search/435866 [Public domain], Paul Cézanne via The Metropolitan Museum of Art

Figure 1.5 *Vanitas Still Life*, Edwaert Collier, 1662 https://www.metmuseum.org/art/collection/search/435918 [Public domain], Edwaert Collier via The Metropolitan Museum of Art

Figure 1.6 *The Crucifixion of St. Peter*, Caravaggio, 1601 https://commons.wikimedia.org/wiki/Michelangelo_Merisi_da_Caravaggio#/media/File:Michelangelo_Caravaggio_038.jpg Michelangelo Caravaggio [Public domain], via Wiki Commons

Chapter 2
Figure 2.1 *Shoes*, Vincent van Gogh, 1888 http://www.metmuseum.org/art/collection/search/436533 [Public domain], Vincent van Gogh via The Metropolitan Museum of Art

Figure 2.2 *A Basket of Flowers*, Jan Brueghel the Younger, probably 1620s http://www.metmuseum.org/art/collection/search/435814 [Public domain], Jan Brueghel via The Metropolitan Museum of Art

Figure 2.3 *Madame Cézanne in a Red Dress*, Paul Cézanne, 1888–90 http://www.metmuseum.org/art/collection/search/435876 [Public domain], Paul Cézanne via The Metropolitan Museum of Art

Figure 2.4 *Doctor*, Paul Klee, 1930 http://www.metmuseum.org/art/collection/search/483172 [Public domain], Paul Klee via The Metropolitan Museum of Art

Figure 2.5 *Kleine Welten V*, Vasily Kandinsky, 1922 http://www.metmuseum.org/art/collection/search/369096 [Public domain], Vasily Kandinsky via The Metropolitan Museum of Art

Figure 2.6 *Untitled*, Arthur Dove, ca. 1927 http://www.metmuseum.org/art/collection/search/488547 [Public domain], Arthur Dove via The Metropolitan Museum of Art

Figure 2.7 *Two Soldiers*, Anonymous, 19th century http://www.metmuseum.org/art/collection/search/390172 [Public domain], Anonymous via The Metropolitan Museum of Art

Figure 2.8 *Jean-Marie Fruchard*, Honoré Daumier, 1832/1835, http://images.nga.gov/?service=asset&action=show_zoom_window_popup&language=en&asset=20470&location=grid&asset_list=150769,19345,18851,40266,40334,150726,118160,89591,19092,150746,18850,108054,100970,40335,19091,19348,19344,18852,19093,113973,141469,93498,42343,20470,87898&basket_item_id=undefined

Figure 2.9 *Untitled*, Paul Klee, 1914 http://www.metmuseum.org/art/collection/search/483169 [Public domain], Paul Klee via The Metropolitan Museum of Art

Figure 2.10 *Bell Pepper* by Ainsley Bennett (small)

Figure 2.11 *Bell Pepper* by Ainsley Bennett (large)

Chapter 3
Figure 3.1a Chaos graphic, Brian Flynn

Figure 3.1b Unified graphic, Brian Flynn

Figure 3.2 *Composition in Red, Yellow, Blue, and Black* by Piet Mondrian https://commons.wikimedia.org/wiki/Piet_Mondrian#/media/File:Piet_Mondriaan,_1921_-_Composition_en_rouge,_jaune,_bleu_et_noir.jpg [Public domain], Piet Mondrian via Wiki Commons

Figure 3.3 Alternating Rhythm, Brian Flynn

Figure 3.4 Progressive Rhythm, Brian Flynn

Figure 3.5 *After Sir Christopher Wren*, Charles Demuth, 1920 http://www.metmuseum.org/art/collection/search/483297 [Public domain], Charles Demuth via The Metropolitan Museum of Art

Figure 3.6 *Colorful Architecture*, Paul Klee, 1917 http://www.metmuseum.org/art/collection/search/483126 [Public domain], Paul Klee via The Metropolitan Museum of Art

Figure 3.7a Random circles graphic, Brian Flynn

Figure 3.7b Unity circles, Brian Flynn

Figure 3.8 *Free Curve to the Point–Accompanying Sound of Geometric Curves*, Vasily Kandinsky, 1925 http://www.metmuseum.org/art/collection/search/480895?sortBy=Relevance&ft=kandinsky&offset=0&rpp=20&pos=3 [Public domain], Vasily Kandinsky via The Metropolitan Museum of Art

Figure 3.9 *Bronze Horse*, 8th century B.C http://www.metmuseum.org/art/collection/search/251050 [Public domain], The Metropolitan Museum of Art

Figure 3.10 Groovy Frog Logo, Eliza Whyman

Figure 3.11 *Still Life with Swan and Game before a Country Estate*, Jan Weenix, 1685 http://images.nga.gov/?service=asset&action=show_zoom_window_popup&language=en&asset=149519&location=grid&asset_list=149519&basket_item_id=undefined [Public domain], Jan Weenix via National Gallery of Art

Figure 3.12 *The Holy Family with the Infant Saint John the Baptist*, Perino del Vaga, ca. 1524–26 http://www.metmuseum.org/art/collection/search/441227 [Public domain], Perino del Vaga via The Metropolitan Museum of Art

Figure 3.13 *Julia Jackson*, Julia Margaret Cameron, 1867 http://www.metmuseum.org/art/collection/search/267426 [Public domain], Julia Margaret Cameron via The Metropolitan Museum of Art

Figure 3.14 Gund Logo © Enesco, LLC, used with permission

Chapter 4
Figure 4.1 Color wheel, Brian Flynn

Figure 4.2 Red ball photo, Mark Wilson

Figure 4.3 *Black and White and Color Design*, Meredith Long

Figure 4.4 *The Arrest of Christ*, Simon Bening, about 1525–1530 http://www.getty.edu/art/collection/objects/3977/simon-bening-the-arrest-of-christ-flemish-about-1525-1530/ [Public domain], Simon Bening via The J. Paul Getty Museum

Figure 4.5 *The Harvesters*, Pieter Bruegel the Elder, 1565 http://www.metmuseum.org/art/collection/search/435809 [Public domain], Pieter Bruegel via The Metropolitan Museum of Art

Chapter 5
Figure 5.1 *May Day Celebrations at Xeuilley*, Jacques Callot, 1624–25 http://www.metmuseum.org/art/collection/search/418394 [Public domain], Jacques Callot via The Metropolitan Museum of Art

Figure 5.2 *The Adoration of the Magi*, Simon Bening, mid-1520s http://images.nga.gov/?service=asset&action=show_zoom_window_po

pup&language=en&asset=152051&location=grid&asset_list=152051,110848&basket_item_id=undefined [Public domain], Simon Bening via National Gallery of Art

Figure 5.4 *Antiquities of Dacca,* George Chinnery, 1814/1827 http://images.nga.gov/?service=asset&action=show_zoom_window_popup&language=en&asset=94168&location=grid&asset_list=60512,94168,61251,107613,60818,76184&basket_item_id=undefined [Public domain], George Chinnery via National Gallery of Art

Figure 5.5 Three still life line drawings, Brian Flynn

Figure 5.6 Two cup line drawings, Brian Flynn

Figure 5.7 One-Point Perspective graphic, Brian Flynn

Figure 5.8 *Court of Palazzo Pitti Decorated with Candelabra,* from an Album with Plates Documenting the Festivities of the 1589 Wedding of Ferdinand I and Christine of Lorraine, Orazio Scarabelli, 1589–1592 http://www.metmuseum.org/art/collection/search/387821 [Public domain], Orazio Scarabelli via The Metropolitan Museum of Art

Figure 5.9 and **5.10** Perspective graphics, Brian Flynn

Figure 5.11 *Giovanni in Laterano,* main façade, with Palace and Scala Santa on the right, Giovanni Battista Piranesi, ca. 1749 http://www.metmuseum.org/art/collection/search/363887 [Public domain], Giovanni Battista Piranesi via The Metropolitan Museum of Art

Figure 5.12 *William S. Moorehead Federal Building, Pittsburgh, Pennsylvania,* Carol M. Highsmith, 2015 https://www.loc.gov/item/2015646049/ [Public domain]via Library of Congress

Chapter 6

Figure 6.1 *Birth,* Keith Vanderlin

Figure 6.2 *The Sisters,* Berthe Morisot, 1869 http://images.nga.gov/?service=asset&action=show_zoom_window_popup&language=en&asset=149217&location=grid&asset_list=148668,98777,149907,149168,115095,148669,104934,41218,149217,149451,149276,147685,95023,41251,43065,110037,79434,149543,151490,65169,80607,148667,93518,152007,43068&basket_item_id=undefined

Figure 6.3 *Neo-Classical Building, Anonymous,* 18th century http://www.metmuseum.org/art/collection/search/343661[Public domain], Anonymous via The Metropolitan Museum of Art

Figure 6.4 *Still Life with Fruit and Roemer,* Pieter Claesz, 1644, https://www.wikiart.org/en/pieter-claesz/still-life-with-fruit-and-roemer-1644 [Public domain], Pieter Claesz via National Gallery of Art

Figure 6.5 *The Raising of Lazarus,* Rembrandt (Rembrandt van Rijn), 1642 http://www.metmuseum.org/art/collection/search/391965 Rembrandt (Rembrandt van Rijn) via The Metropolitan Museum of Art

Figure 6.5 *The Raising of Lazarus,* Rembrandt (Rembrandt van Rijn), 1642 http://www.metmuseum.org/art/collection/search/373072 [Public domain], Rembrandt van Rijn via The Metropolitan Museum of Art

Figure 6.6 *Clio,* by Anatole France, illustrations by Alphonse Marie Mucha. http://images.nga.gov/?service=asset&language=en&action=show_zoom_window_popup&language=en&asset=144161&location=grid&asset_list=68643,71729,95896,85462,146025,144161&basket_item_id=undefined [Public domain], Alphonse Marie Mucha via National Gallery of Art

Figure 6.7 *Big Bomb Little Bomb,* © Brad Holland

Figure 6.8 *East Hampton Beach, Long Island,* Winslow Homer, 1874 http://images.nga.gov/?service=asset&action=show_zoom_window_popup&language=en&asset=148858&location=grid&asset_list=35325,100072,56259,83686,56514,151449,44832,55155,56340,57728,148858,100071,50451,96170,56358,57724,151882,117987,103898,56362,65260,95405 [Public domain], Winslow Homer via National Gallery of Art

Figure 6.9 Pictorial hierarchy graphic, Brian Flynn, David Moyer

Figure 6.10 Typographic hierarchy graphic, Brian Flynn, David Moyer

Figure 6.11b Line drawing of van Dyke's *Portrait of Lucas van Uffel* by Brian Flynn, David Moyer

Figures 6.11a and 6.12 *The Portrait of Lucas van Uffel,* Anthony van Dyck , ca. 1622 http://www.metmuseum.org/art/collection/search/436253 [Public domain], Anthony van Dyck via The Metropolitan Museum of Art

Chapter 7

Figure 7.1 *The Gulf Stream,* Winslow Homer, 1899 http://www.metmuseum.org/art/collection/search/11122 [Public domain], Winslow Homer via The Metropolitan Museum of Art

Figure 7.2 *Virgin and Child with Saint Catherine of Alexandria,* Anthony van Dyck, ca. 1630 http://www.metmuseum.org/art/collection/search/436262 [Public domain], Anthony van Dyck via The Metropolitan Museum of Art

Figure 7.3 Plate 53 from *Los Caprichos:What a golden beak!,* Goya (Francisco de Goya y Lucientes), 1799 http://www.metmuseum.org/art/collection/search/380701[Public domain], Francisco de Goya y Lucientes via The Metropolitan Museum of Art

Figure 7.4 *Fantômas,* Juan Gris, 1915 http://images.nga.gov/?service=asset&action=show_zoom_window_popup&language=en&asset=148862&location=grid&asset_list=153181,153775,151918,147270,65139,148862,147277,147276&basket_item_id=undefined [Public domain], Juan Gris via National Gallery of Art

Figure 7.5 *Design* 2017, exhibition poster, Andrea Neff

Chapter 8

Figures 8.1–8.7 Proportion graphics, Brian Flynn Brian, David Moyer

Figure 8.8 Golden section margin graphic, Brian Flynn, David Moyer

Chapter 9

Figure 9.1 Grid layout graphic, Brian Flynn

Figure 9.2 *Leaves from a Beatus Manuscript: Bifolium with part of the Genealogy of Christ and the Adoration of the Magi,* ca. 1180 http://www.metmuseum.org/art/collection/search/466197 [Public domain] via The Metropolitan Museum of Art

Figure 9.3 William Morris, Mark Wilson

Figure 9.4 *Optima* Poster, Brittany Maise

Figure 9.5 Custom grid graphic, Brian Flynn

Figure 9.6 *Young Ladies of the Village,* Gustave Courbet, 1851–52, https://www.metmuseum.org/art/collection/search/438820 [Public domain], Gustave Courbet via The Metropolitan Museum of Art

Figures 9.7 and 9.8 Rabatment graphics, Brian Flynn

Figures 9.8 and 9.9 Armature graphics, Brian Flynn

Figure 9.10 *The Collector of Prints, Edgar* Degas, 1866 http://www.metmuseum.org/art/collection/search/436122 [Public domain], Edgar Degas via The Metropolitan Museum of Art

Figure 9.12 *Wolf and Fox Hunt,* Peter Paul Rubens, ca. 1616 http://www.metmuseum.org/art/collection/search/437536 [Public domain], Peter Paul Rubens via The Metropolitan Museum of Art

Figures 9.13, 9.14 *The Holy Family with Saints Francis and Anne and the Infant Saint John the Baptist,* Peter Paul Rubens, early or mid-1630 http://www.metmuseum.org/art/collection/search/437528 [Public domain], Peter Paul Rubens via The Metropolitan Museum of Art

Chapter 10

Figure 10.1 *Still Life with Apples and Pitcher,* Camille Pissarro, 1872 http://www.metmuseum.org/art/collection/search/437317 [Public domain], Camille Pissarro via The Metropolitan Museum of Art

Figure 10.2 *The Thinker,* Auguste Rodin, model 1880, cast 1901 http://images.nga.gov/?service=asset&action=show_zoom_window_popup&language=en&asset=150401&location=grid&asset_list=150401,19620,19619,150665,150484,112396,92938,19722,19667,150400,65828,19727,33430,150558,88709,48584,19621,34170,150381,82810,150565,71192,33431,60552,106211&basket_item_id=undefined [Public domain], Auguste Rodin via National Gallery of Art

Figure 10.3 *Tennis Players,* Eugen Kirchner, 1896 http://www.metmuseum.org/art/collection/search/369133 [Public domain], Eugen Kirchner via The Metropolitan Museum of Art

Figure 10.4 *Note in Pink and Brown,* James McNeill Whistler, ca. 1880 http://www.metmuseum.org/art/collection/search/13215 [Public domain], James McNeill Whistler via The Metropolitan Museum of Art

Figure 10.5 *Tableau I,* Piet Mondrian, 1921 https://commons.wikimedia.org/wiki/File:Tableau_I,_by_Piet_Mondriaan.jpg [Public domain], Mondrian via Wiki Commons

Figure 10.6 *St. Sebastien Attended by St Irene,* Georges de La Tour, 1649 https://commons. wikimedia.org/wiki/File:Georges_de_La_ Tour_-_St_Sebastien_Attended_by_St_ Irene_-_WGA12342.jpg [Public domain], La Tour via Wiki Commons

Figure 10.7 Line drawing of Georges La Tour's *St. Sabastian,* Brian Flynn

Figure 10.8 Harmonic armature of La Tour's *St. Sebastian,* Brian Flynn, David Moyer https://commons.wikimedia.org/wiki/ File:Georges_de_La_Tour_-_St_Sebastien_ Attended_by_St_Irene_-_WGA12342.jpg [Public domain], La Tour via Wiki Commons

Chapter 11
Figure 11.1 *George Washington,* Gilbert Stuart, ca. 1798–1800 http://www.metmuseum.org/art/ collection/search/12665 [Public domain], Gilbert Stuart via The Metropolitan Museum of Art

Figure 11.2 *One Who Understands, Paul Klee,* 1934 http:// www.metmuseum.org/art/ collection/search/489986 [Public domain], Paul Klee via The Metropolitan Museum of Art

Figure 11.3 *Rich Man, from the Dance of Death,* after Hans Holbein, Wenceslaus Hollar, 1651 http://www.metmuseum.org/art/collection/ search/361587 [Public domain], Wenceslaus Hollar via The Metropolitan Museum of Art

Figure 11.4 Hands graphic, Brian Flynn

Figure 11.5 *Floating World,* Gretchen Heinze Moyer

Figure 11.6 *The Penitent Magdalen,* Georges de La Tour, ca. 1640 http://www.metmuseum.org/ art/collection/search/436839 [Public domain], Georges de La Tour via The Metropolitan Museum of Art

Figure 11.7 *Approaching Thunderstorm,* Martin Johnson Heade, 1859 http://www.metmuseum .org/art/collection/search/11050 [Public domain], Martin Johnson Heade via The Metropolitan Museum of Art

Figure 11.8 *Birth of Athenae from the Head of Zeus,* David Moyer, Brian Flynn

Figure 11.9 *Composition in Red, Yellow, Blue and Black,* Piet Mondrian, 1926 https:// commons.wikimedia.org/wiki/Piet_Mondrian# /media/File:Piet_Mondriaan,_1921_-_ Composition_en_rouge,_jaune,_bleu_et_noir. jpg [Public domain], Piet Mondrian via Wiki Commons

Figure 11.10 *The Fall of Richmond, Virginia, on the Night of April 2nd,* Currier & Ives, 1865, http://www.metmuseum.org/art/collection/search/ 380478 [Public domain], Currier & Ives via The Metropolitan Museum of Art

Figure 11.11 *The Nativity,* Lorenzo Lotto, 1523 http://images.nga.gov/?service=asset& action=show_zoom_window_popup&lang uage=en&asset=20013&location=grid&ass et_list=20013&basket_item_id=undefined [Public domain], Lorenzo Lotto via National Gallery of Art

Figure 11.12 *Aesthetics of Fundraising,* Ed Wong-Ligda

Figure 11.13 *The Steps to the Steps,* © Brad Holland

Figure 11.14 *David with the Head of Goliath,* Pietro Novelli, about 1630s http://www.getty. edu/art/collection/objects/619/pietro-novelli- david-with-the-head-of-goliath-italian-about- 1630s/ [Public domain], Pietro Novelli via The J. Paul Getty Museum

Figure 11.15 *David with the Head of Goliath,* Guido Cagnacci, about 1645–1650 http:// www.getty.edu/art/collection/objects/244695/ guido-cagnacci-david-with-the-head-of-goliath- italian-about-1645-1650/[Public domain], Guido Cagnacci via The J. Paul Getty Museum

Figure 11.16 *You See We Are Blind,* Odd Nerdrum, Nerdrum Museum

Part II
Frontispiece, Part II *Still Life with Flowers and Fruit,* Henri Fantin-Latour, 1866 http://www .metmuseum.org/art/collection/search/436293 [Public domain], Henri Fantin-Latour via The Metropolitan Museum of Art

Chapter 12
Figure 12.1 Three-ring binder photo, Ashley Tate

Figure 12.2 Three-ring binder photo, Minh Thu Nguyen

Chapter 13
Figure 13.1 Rough book photo, Hailie Montgomery

Figure 13.2 Analysis flap graphics *Still Life with a Skull and a Writing Quill,* Pieter Claesz, 1628, https://www.metmuseum.org/art/ collection/[Public domain], Pieter Claesz via The Metropolitan Museum of Art

Chapter 14
Figures 14.1–14.5 Gestalt graphics imposed on Claesz' *Still Life with a Writing Quill*

Chapter 15
Figures 15.1–15.3 Scales graphics, Brian Flynn

Figuress 15.4–15.6 Graphics imposed on Claesz' *Still Life with a Skull and a Writing Quill*

Chapter 16
Figures 16.1-16.4 Focal graphics imposed on Claesz' *Still Life with a Skull and a Writing Quill*

Chapter 17
Figures 17.1–17.2 Geometry graphics, Brian Flynn

Figures 17.3–17.6 Geometry graphics imposed on Claesz' *Still Life with a Skull and a Writing Quill*

Figure 17.7 Armature graphic, Brian Flynn

Figures17.8–17.9 Geometry graphics imposed on Claesz' *Still Life with a Skull and a Writing Quill,* Brian Flynn

Chapter 18
Figures 18.1–18.3 Compositional dynamics graphics imposed on Claesz' *Still Life with a Skull and a Writing Quill,* Brian Flynn, David Moyer

Chapter 19
Figures 19.1–19.3 Unity and variety graphics imposed on Claesz' *Still Life with a Skull and a Writing Quill,* Brian Flynn, David Moyer

Chapter 20
Figure 20.1 Bracketed observation graphics imposed on Claesz' *Still Life with a Skull and a Writing Quill,* Photo, Brian Flynn

Figure 20.2 Bracketed observation rough book Photo, Brian Flynn

Figures 20.3–20.4 Bracketed observation graphics imposed on Claesz' *Still Life with a Skull and a Writing Quill,* Brian Flynn

Chapter 21
Figure 21.1 Contextual information rough book photo, Brian Flynn, David Moyer

Chapter 22
Figures 22.1–22.2 Contextual association rough book photos, Brian Flynn, David Moyer

Chapter 23
Figure 23.1 *Birth of Athenae from the Head of Zeus,* David Moyer, Brian Flynn

Figure 23.2 *Still Life with Oysters, a Silver Tazza, and Glassware,* Willem Claesz Heda, 1635 https://www.metmuseum.org/art/ collection/search/438376 [Public domain], Willem Claesz Heda via The Metropolitan Museum of Art

Figure 23.3 *An Extensive Wooded Landscape,* Philips Koninck, 1670s, https:// www.metmuseum.org/art/collection/ search/436831 [Public domain], Philips Koninck via The Metropolitan Museum of Art

Figure 23.4 *A Stag at Sharkey's,* George Bellows, 1917 http://images.nga.gov/?service= asset&action=show_zoom_window_popup& language=en&asset=151872&location=gr id&asset_list=149500,112912,149385,1471 70,95954,40172,58955,149302,152005,57 904,151872,147174,56621,140031,147252, 57942,147196,115857,147564,57903,14719 8,151528,108756,151493,57898&basket_item_ id=undefined [Public domain], George Bellows via National Gallery of Art

Figure 23.5 Three-column roughbook, Brian Flynn, David Moyer

Appendix
Appendix Frontispiece, Melchior d'Hondecoeter via The Metropolitan Museum of Art

Dynamic Symmetry, Brian Flynn, David Moyer

Constructing Golden Section Margins, Brian Flynn, David Moyer

Handwriting Exercise, Brian Flynn, David Moyer

Constructing a Harmonic Armature, Brian Flynn, David Moyer

Proportion Exercise for Rectangle, Brian Flynn, David Moyer

Rubber-Cementing Instructions, Brian Flynn, David Moyer

Constructing a Single and Double Rabatment, Brian Flynn, David Moyer

Visual Analysis Outline Layout, Brian Flynn, David Moyer

Visual Analysis Outline, *Shape Type and Distribution,* Chapter 13, Brian Flynn, David Moyer

Visual Analysis Outline, *Gestalt,* Chapter 14, Brian Flynn, David Moyer

Visual Analysis Outline, *Balance,* Chapter 15, Brian Flynn, David Moyer

Visual Analysis Outline, *Focal and Accent Points,* Chapter 16, Brian Flynn, David Moyer

Visual Analysis Outline, *Geometry,* Chapter 17, Brian Flynn, David Moyer

Visual Analysis Outline, *Compositional Dynamics,* Chapter 18, Brian Flynn, David Moyer

Visual Analysis Outline, *Unity and Variety,* Chapter 19, Brian Flynn, David Moyer

Visual Analysis Outline, *Bracketed Observation,* Chapter 20, Brian Flynn, David Moyer

Visual Analysis Outline, *Contextual Information,* Chapter 21, Brian Flynn, David Moyer

Visual Analysis Outline, *Contextual Association,* Chapter 22, Brian Flynn, David Moyer

Visual Analysis Outline, *Visual Content Summary,* Chapter 23, Brian Flynn, David Moyer

Index